TURNER'S RIVERS, HARBOURS AND COASTS

Eric Shanes

CHATTO & WINDUS · LONDON · 1981

for Mark, and mark

Designed and produced by Breslich & Foss, London

Chatto & Windus Ltd
40 William IV Street London WC2N 4DE

Clarke, Irwin and Co Ltd, Toronto

British Library Cataloguing in Publication Data
Shanes, Eric
 Turner's rivers, harbours and coasts.
 I. Title II. Turner, J. M. W.
 759.2'1 ND1929.T8

ISBN 0 7011 2569 1

Colour plates originated in Great Britain
by Dot Gradations Limited, Essex
Filmset by Modern Text Typesetting, Essex
Printed in Great Britain
by W. S. Cowell Limited, Ipswich

CONTENTS

ACKNOWLEDGMENTS

PREFACE

Primarily I must thank the private owners of a number of these drawings for allowing me access to their pictures both for study and photography. I should also like to express my gratitude to Evelyn Joll for his endless patience in dealing with my enquiries. John Gage has been his usual immensely encouraging self and I would especially like to thank him for his moral support on one rather fraught occasion. He has also been extremely helpful in reading the manuscript and suggesting a number of small improvements.

I am profoundly grateful to Richard Leworthy for helping me elucidate a number of the finer points of sailing in some of the pictures. His eagerness and interest have been particularly inspiring. I would also like to thank Iain Bain for lending me some recent impressions that he has taken from 'The Rivers of England' plates.

Others to be thanked are John Munday, F.S.A., of the National Maritime Museum for going to considerable trouble to identify details in *Dover Castle* and *Rochester;* Mrs. Clifford (also at Greenwich) for her attempt to identify the enigmatic flag in *Dover Castle;* Miss Grace Ritchie; Mrs. Virginia Murray for her gracious help with the John Murray archives; John Bird; David Posnett of the Leger Galleries; Edward Cassasa of the Fine Art Society; Sue Valentine of Thos. Agnew and Sons, Ltd; Robin Griffith Jones and Imogen Craddock of Messrs. Christie, Manson and Woods; Reginald Williams and

Martin Tillyer of the British Museum Department of Prints and Drawings; the staff of the West Country Studies Library, Exeter; and the local history (or reference) librarians of: Dover, Mrs. S. J. Corrall; Chatham, Jean Lear; Margate, G. M. Wyatt; Plymouth, Mrs. Wilson; Leeds, Mrs. Heap; Portsmouth, Mr. King; and Deal, Mr. Collier. In addition I should like to thank Richard Green of York City Art Gallery; Mr. Honey of Deal Maritime Museum; Mr. Bagley of Rye Museum; Rodney Burke and Steve Bury of Chelsea School of Art library; Nicholas Robinson; and Jacqueline Darville and Judith Savage who had the last word.

E.S.

The pictures discussed and reproduced on the following pages embrace a far wider range of subjects than the necessarily narrow title of this book implies. It brings together over one hundred watercolours made for engraving in nine separate series. Included are the large Sussex drawings commissioned by Jack Fuller, some of which were reproduced as coloured aquatints and some as line-engravings under the titles of **Views in Sussex** and **Views at Hastings and its vicinity;** the forty or so drawings made for the **Picturesque Views on the Southern Coast of England;** the drawings intended for **The Rivers of Devon** and **Marine Views;** those constituting **The Rivers of England** and **The Ports of England;** and a group of gouaches created for a projected (and unrealised) series of **Picturesque Views on the East Coast of England,** a scheme Turner probably intended to publish himself.

This may seem a rather disparate body of work, mingling as it does, views of landscapes, rivers, ports and coastal scenes. Yet every one of these watercolours is essentially linked, for Turner made them on behalf of just four men. These men form our key to relating and understanding this intricate nexus of pictures.

MESSRS FULLER, COOKE AND LUPTON

Mr. Fuller, member for [Sussex][1] has engaged Turner to go into that county to make drawings of three or four views. He is to have 100 guineas for the <u>use</u> of his drawings which are to be returned to him.

So wrote Joseph Farington in his diary on 21 April, 1810. 'Mr. Fuller' was John Fuller of Brightling Park, Sussex, a member of Parliament for that county. Although it is not known exactly when Turner and Fuller first met, it is known that Fuller was in London in March 1810 to make one of his rare appearances at the House of Commons. This was to participate in a debate on slavery. Fuller was bitterly opposed to its abolition but the vehemence of his feelings on the subject led him to make a personally disastrous intervention. He insulted the Speaker and was carried bodily from the House by four attendants and locked up for two days. He was only released after receiving a severe reprimand. This especially unruly behaviour led to his being dropped by his party at the next election in 1812. The party decision was not contested. The 1807 election had cost Fuller over £20,000, an enormous sum which he had been forced to spend because he was so strongly opposed by the Sussex freeholders who resented his open approval of slavery.

The watercolours that Fuller commissioned from Turner were all to be views in the eastern part of Sussex where he lived. As Farington makes

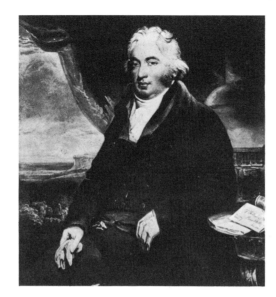

1 Jack Fuller, Portrait by H. Singleton, signed and dated 10 June, 1806

clear, by emphasizing[2] that they were to be made '<u>use</u> of', it was Fuller's intention from the beginning that the drawings should be transcribed as prints. He wished to distribute these prints amongst his relatives, friends and important acquaintances in the county and most of the Sussex drawings ordered by him are of properties associated with them.

Fuller must have visited Turner privately to have given him this commission before 21 April. The Royal Academy exhibition only began that year on 30 April and Turner's own gallery in Harley Street did not open to the public until 7 May. That Fuller did visit Turner's gallery when it opened is certain for he bought one of the seventeen paintings on display, a picture entitled *Fish Market*.[3] Fuller purchased the work for 200 guineas and paid for it on 26 July.[4] During this period he also asked Turner to make him an oil-painting of Rosehill, his house in Sussex.

Fuller was very wealthy and very eccentric.

Born in 1756 and educated at Eton, he was a bluff man with straightforward Tory views. During the Napoleonic wars he had raised his own company of militia. He built a number of landmarks in Sussex, including several follies which still exist today. His wealth and estates were inherited from his uncle, Thomas Fuller. He liked to be known as 'Honest Jack' on account of his down-to-earth ways (later, however, he was more popularly called 'Mad Jack' because of his eccentricities). Characteristically he refused a peerage from Pitt declaring 'I was born Jack Fuller and Jack Fuller I will die'. When he did die in 1834 he was buried in a pyramidical tomb in Brightling churchyard, reputedly seated in an armchair wearing a silk top-hat, with a glass of wine in his hand and surrounded by an assortment of his favourite clarets. His estates in Sussex comprised some 6,000 acres and his activities there centred around the local iron-smelting industry. He also owned sugar plantations and rum distilleries in Jamaica where he was an important slave-owner.

Turner travelled down to Sussex in the early summer of 1810 and made a considerable number of sketches. Initially, of course, he used them to develop the watercolours specified in the original commission (see Nos. 2-5). At Fuller's expense these were then reproduced as coloured aquatints[5] by J. C. Stadler, a German engraver who worked in England between 1780 and 1820. He executed a large number of aquatints after works by De Loutherbourg and Farington, including twenty-six plates for Farington's 'History of the River Thames' published by Boydell. The coloured aquatints after Turner's drawings were distributed privately amongst Fuller's circle.

Turner painted the commissioned oil-painting of Rosehill between 1810 and 1811 (Ill. 2). Fuller obviously toyed with the idea of also having that work reproduced by Stadler, for Farington records seeing it[6] at Stadler's workshop on 10 June, 1811. Nothing came of this idea however.

Turner's delivery of the painting was often fondly recalled by Fuller. He had invited Turner to breakfast at his London residence in Devonshire Place and told him to bring the picture with him. A

2 **Rosehill Park, Sussex,** oil on canvas, 88.9 × 119.5cm (35 × 47in), Private Collection, U.K. Turner painted this oil for Fuller between 1810-1. The house can be seen in the distance on the left with the Rotunda down the hill on the right. The picture depicts the scene in the late afternoon.

cheque would be handed over in exchange.

To this Turner consented. He took the picture in a hackney coach, breakfasted, received the cheque, thanked the purchaser and left. He had not gone above five minutes, when a knock was heard at the door. The painter was back—'I must see Mr. Fuller.' He was shown in, 'Oh, I'd forgotten; there is three shillings for the hackney coach.' The sum was paid. Fuller, who was laughing all the while, loved to relate this story to his friends.[7]

Fuller may indeed have humoured Turner's odd behaviour but he was undoubtedly impressed by his work and especially by the watercolours. Instead of merely hiring the four 1810 drawings he bought them outright and later commissioned others, including another picture of Rosehill (8), this time in watercolour. For the purpose of sketching the building in detail Turner again visited the house in 1815. Yet with the exception of that work all of Fuller's Sussex drawings were developed from the 1810 sketches (see Concordance). Even-

tually he owned thirteen large and complex watercolours that Turner made for him after 1810. One of them, *Pevensey Castle* (15), may date from after 1820. Five of these later drawings were subsequently engraved and published as the 'Views in Sussex' (see below).

The watercolours were proudly displayed both at Rosehill and at Devonshire Place. These surroundings were later recorded by a friend of Fuller's:

... A dinner ... of taste and magnificence, a superb service of plate, a pack of lacquays in rich liveries, a French cook of £150 wages, a splendid dessert, pictures of the Sussex Domains by Turner, some, as Joseph [the writer's son] said, Turner must have been paid £500 for.[8]

Indeed, Fuller must have expended a considerable sum of money on Turner's work over the years simply judging from the size of the hire-charges of 1810. In 1811 alone Turner recorded payments of some £417 from Fuller.[9]

By this time, however, Turner had additionally made the acquaintance of two other men who were also to be instrumental in the commissioning or engraving of virtually all the pictures in this book. These were the brothers William Bernard and George Cooke, the sons of a wholesale-confectioner who had emigrated to London from Frankfurt-on-Main.

William Bernard Cooke was born in 1778 and studied under the engraver William Angus. His younger brother George was born in 1781 and he also took up engraving, being apprenticed to James Basire. Basire worked extensively with Turner between 1799 and 1811, reproducing Turner's drawings for the 'Oxford Almanack'. It may have been Basire who introduced George Cooke to Turner.

After completing his apprenticeship George Cooke engraved a number of plates for Brewer's 'Beauties of England and Wales'. He engraved pictures by Dayes and works by various artists for Byrne's 'Brittania Depicta' (to which Turner also contributed). Between 1808 and 1811 he was

involved in engraving a series of plates for Pinkerton's 'Collection of Voyages and Travels'.

During this period William Cooke was similarly engaged in engraving pictures for a work illustrating the Isle of Wight. He was also interested in becoming a print-promoter and publisher as well as an engraver, and to this end he and his brother sponsored a scheme entitled 'Views on the river Thames' after drawings by De Wint, Clennel, Havell and others. They divided the engraving between them.

The ultimate aim of their endeavours, however, was to collaborate in some way with Turner for whom they had the highest regard:

... the brothers seldom met without discussing their favourite topic, and many a scheme was formed and abandoned, before their wishes could be achieved.[10]

By 1811 they were ready. They invited Turner to contribute some twenty-four drawings to a publication entitled 'Picturesque Views on the Southern Coast of England'.[11] It was envisaged that eventually this would form part of an even larger scheme to depict the entire coastline of mainland Britain. Other artists were to contribute to the series including De Wint, Owen and Westall. Turner was to be paid £7.10s for his watercolours and the Cooke brothers twenty-five guineas for engraving the pictures on copper. W. B. Cooke put up the entire initial capital and a syndicate was formed with John Murray as the major shareholder.[12] Murray agreed to publish, promote and sell the engravings either singly, in parts, or in their ultimate bound form. The work was to be published in sixteen parts, each part containing three quarto plates and two vignettes.

The idea of producing a series of views of the English coast was a timely one. Although there had been countless schemes devoted to inland scenery, very little attention had been paid to the shores of Britain. Turner was very attracted by the idea and wasted no time in finding subjects for the watercolours, setting off for this purpose in the summer of 1811 on an extensive tour of the west

country. Before leaving he made a number of enquiries about suitable places to visit and noted them down on the cover and first page of a sketchbook[13] that he took with him. In it he noted such facts as the market days in Melcombe Regis, the height of Portland lighthouse, the chemical constituents of the waters at Nottington spring and the date of King William III's landing at Brixham. He left London in the second week of July and travelled to Poole in Dorset via Salisbury. Thereafter he made his way westwards along the coast to Land's End and then traversed the north of Cornwall and Devon into Somerset. He returned to London via Stonehenge and was back in town by the middle of September. It was a very productive journey as over forty works were eventually developed from sketches made on it. One sketchbook alone (the 'Devonshire Coast No. 1') contains the antecedent sketches of upwards of nineteen finished watercolours (see Concordance).

Turner probably made the first group of 'Southern Coast' watercolours (19-23, 100-102 and 104) in the winter of 1811-2. However, more than two years were to elapse before they appeared as engravings. There are reasons to account for this hiatus. During 1811 and 1812 Turner was tremendously busy. He had to give much thought to the preparation of his annual series of perspective lectures. He had been appointed Royal Academy Professor of Perspective in 1807 and gave the first lecture in January 1811. The second set of six lectures took place in the winter of 1812. In addition Turner was working on a number of major paintings. These included the *Snow Storm: Hannibal and his Army crossing the Alps,* a work that marks a turning-point in his development. He had been engaged on this picture since 1810 and he displayed it at the Royal Academy exhibition in 1812 along with three other paintings. During the following summer much of his time was taken up with the building of a house in Twickenham. He designed it himself and oversaw every aspect of the construction down to the tiniest detail. This, too, was an enormous drain on his creative energy. Accordingly he would have had little time to develop the 'Southern Coast' series in 1812, especially as during that winter he was devoting his artistic efforts to completing another four major paintings for the Academy the following year. They included *Frosty Morning,* a superb wintry dawn scene whose genesis lay in a view he had witnessed in Yorkshire.

After the Royal Academy exhibition opened in the late Spring of 1813 the pressure must have eased up considerably and Turner clearly renewed his enthusiasm for the project. He was joined in this attitude by W. B. Cooke. A letter from Cooke to John Murray (dated 9 June, 1813) tells us of another reason for the delay:

I take the earliest opportunity of informing you of my return to London from the West of England, and have the pleasure of stating that my health is so far improved by the mild Air of Cornwall during the Winter, that I mean immediately to proceed with the work of The Coast of England, the Prospectus of which was published some time since . . . I hope with my Brothers assistance to get a sufficient number of Plates ready by the Winter that any future delay in the publication may be prevented and propose publishing the first part of the work in January 1814.

W. B. Cooke[14]

To prepare new drawings Turner made another West Country trip in August 1813. This time he based himself in Plymouth where he stayed with Cyrus Redding, a young journalist whom he had met in London the previous year.[15] Redding lived near Plymouth in a cottage at Mutley on the Tavistock road with fine views over the Sound to Mount Edgcumbe. Turner also stayed with John Collier, later the M.P. (1832-41) for Plymouth and with Ambrose Johns, a local painter.

Turner was at his most relaxed during this visit. He and his friends made excursions around Plymouth, visiting Saltram and Cotehele, Saltash and Trematon Castle and enjoying picnics in the famous park on Mount Edgcumbe. They also made a memorable boat journey down the coast to Burgh Island in Bigbury bay. This was an extremely rough trip with high seas running. Turner was unperturbed, as Redding witnessed he was an excellent sailor. Other members of the party were violently seasick but Turner was delighted by it all. Redding observed him studying the movement of the waves with intense concentration, muttering 'that's fine—fine!'[16] When they finally arrived at the island Turner wasted no time in making some sketches whilst freshly caught lobsters (the object of the expedition) were being prepared. Finally he and Redding elected to spend the night in nearby Kingsbridge as Turner could not see the point of returning home through a rising gale at night, when he would not be able to observe anything. They walked most of the twenty miles back to Plymouth the next day. In all Turner spent three weeks in Plymouth.

This too was an inspiring tour. Turner painted a number of oil-studies in the open air and again made many sketches which formed the basis of later works. The most important of these was the painting *Crossing the Brook* of 1813-5.

Turner again made some 'Southern Coast' drawings on his return to London and spent much time supervising the engravings. Unfortunately, the long period that elapsed between the floating of the original scheme and its publication left the way open to competition. William Daniell had undertaken a voyage around Britain in 1813 and he announced the forthcoming publication of a topographical part-work similar to Cooke's scheme. His series, moreover, would be illustrated with coloured plates. This naturally caused the Cooke brothers much concern. William Cooke (who by now was in charge of the business side of their affairs) attempted to hurry Turner along[17] so as to bring out the first part of the 'Southern Coast' on 10 December, 1813, the same day as Daniell's work was to appear. In the event this did not prove possible.

Part I of the 'Southern Coast' finally appeared on 1 January, 1814. It contained two engravings after drawings by Turner and others by Westall, Owen and Clennel. Thereafter three more parts were published in 1814, containing five other

engravings after Turner.

As Farington recorded[18] in his diary in 1811, the Cooke brothers had originally asked John Landseer to write the text accompanying the engravings. He had declined as he felt that in order to do so he would have to make an extensive tour for which he was not prepared. On being told this Turner himself offered to write the letterpress in poetic form. He made extensive drafts for it on his 1811 tour in the 'Devonshire Coast No.1' Sketchbook (TBcxxiii) and some extracts from this poem are quoted elsewhere (see the commentaries to *Poole, 19, Bridport, 32* and *Corfe Castle, 102*). When he did supply the copy to William Cooke in 1813, Cooke submitted it to the writer William Combe[19] for editing. Combe was horrified. He found the poem virtually incomprehensible and totally inappropriate. As a result Cooke suggested to Turner that Combe should 'improve' it. Turner would not hear of it and withdrew the poem completely. Combe thereafter was entirely responsible for the text that accompanied the plates —and a very dull affair it is too. After Combe's death in 1823 an equally dull letterpress was contributed by Mrs Barbara Hofland, a noted authoress of the day.

However, if Turner's poetry left a lot to be desired, Cooke was in no doubt that Turner's pictures were of an extraordinary quality. Moreover, it became apparent towards the end of 1814 that it was these works that were largely responsible for attracting public interest in the project. As a result, after the fourth part had appeared in December 1814, Cooke re-negotiated with Turner the number of watercolours that he was to make for the series and the amount he was to be paid for them. Turner was now to contribute forty pictures and to be paid ten guineas for each watercolour instead of the seven and a half pounds paid formerly. At the same time the Cooke brothers remuneration for engraving each plate was increased from twenty-five guineas to forty pounds.[20]

Another important reason for re-evaluating the extent of Turner's participation in the 'Southern Coast' series was the commitment he was clearly bringing to the engraving. Since he had first grasped the potential of line-engraving in 1811 Turner had taken an ever-increasing interest in the medium.[21] The results showed. His close supervision of every stage of the preparation and printing of the plates was apparent in the new depth and richness of tone that the final engravings displayed. Rather than accept line-engraving as a poor substitute for the original picture, Turner was increasingly exploring it as an expressive alternative in its own right. Naturally, changes would have to be made in translating effects from one medium to another, but given his creative supervision the outcome was very gratifying. The result was to afford Turner an entirely new dimension of expression. The engravings reached a far larger public than the individual pictures ever could and Turner must have welcomed both this widening of his audience and the concomitant furtherance of his reputation.

The greater emphasis given to Turner within the 'Southern Coast' scheme from 1815 onwards undoubtedly added to its success. By this time, though, W. B. Cooke had already agreed with Turner to produce another series entitled 'The Rivers of Devon'. Turner either assigned or made four drawings for this venture.[22] Two of them were views of Plymouth Sound sketched in the summer of 1813, *Plymouth Citadel* (98) and *Plymouth Sound* (99). In the event the engravings of these two watercolours did not appear until the early 1820s. In 1824 Cooke republished them under the title of 'Two Views in Plymouth'. By that time he had given up the idea of 'The Rivers of Devon', probably because he simply did not have time to produce the engravings. *Ivy Bridge, Devonshire* (16) appeared in 1821 after the plate had already been worked on for over five years, and two others were not reproduced until the 1850s (one of them as a chromo-lithograph) and then by other publishers.

By the mid-1810s both the Cooke brothers were increasingly over-burdened with work and the increasing periods between the appearance of the parts of the 'Southern Coast' and their other schemes attest to this. It had originally been hoped that the parts of the 'Southern Coast', in particular, would appear six times a year, which meant that publication would have been completed by the middle of 1816. However, work was delayed and the parts appeared less and less frequently. By 1817 only eight of the projected sixteen parts had appeared and in the event it would be another nine and a half years before the scheme was finally finished. The Cooke brothers were so overworked in 1822 that they were unable to publish any engravings by Turner at all.

These delays, however, did not curb William Cooke's entrepreneurial instincts. In fact he took every opportunity to generate even more work. In the winter of 1818-9 he and Turner agreed to bring out a series of Rhine views for which Turner would supply thirty-six drawings.[23] Turner made a few watercolours for the project but it came to nothing as a rival scheme was published first by Rudolph Ackermann.

Earlier, probably around 1815, Jack Fuller had agreed to finance the engraving by W. B. Cooke of some of his further Sussex watercolours. Cooke undertook the work and discussed the project with John Murray. He followed up this idea with more specific details in a letter to Murray dated 21 December, 1818:

... I have informed you some time ago that Mr. Fuller of Rosehill had employed me some Years ago to engrave a Set of Plates for him from Drawings by Turner—Mr. Fuller has lent me Two Volumes of valuable MS copy on Sussex to extract from them the most interesting Notices on the Rape of Hastings [Sussex was divided into six Rapes, or administrative districts]—it is on this Rape that our present work will treat.—The work is to be divided in Three Parts—the first Part (Plates and all) is ready for the Press and Mr. Fuller urges me to publish the first of March next [in fact the publication date of the first group was 1 March, 1819]. As the Plates are done[24] I see no reason for Keeping the Work back when it can be realizing in cash.—I shall therefore send you in course of today a prospectus of the Work also, to insert into your list of Publications under the conviction that

you will publish them. . . Mr. Fuller's Work will be a <u>splendid thing</u>, and I trust will do credit to all the Parties concerned—Turner has made the Drawings in his first Style.[25] The Plates are much larger than the Coast and will be published in Imperial and Royal <u>Folio</u>.[26]

Three days later Cooke followed up this letter with another informing Murray of Fuller's agreement to foot the bill for the publication expenses and requesting Murray's speedy consideration of the work for publication.

Murray agreed to publish the work. The first part of the three-part scheme was to be called 'Views in Sussex'. Murray stipulated that he should have sole rights of distribution and that for an extra ten per cent commission he would introduce it on all his lists and advertise it in his *Quarterly Review*.[27]

Yet when the next *Quarterly Review* appeared the 'Views in Sussex' were not advertised. Murray had clearly changed his mind about the venture. This reversal was undoubtedly partly due to his disenchantment with Cooke's constant inability to meet deadlines for the 'Southern Coast' series. By now the tenth part of this scheme was over three years late in appearing and finally Murray withdrew from the project. The 'Views in Sussex' suffered in consequence.[28] Cooke complained bitterly of this to Turner:

no failure of Promises (which are in themselves physically impossible to perform, and which are dictated by an enthusiasm or too great confidence in one's own powers as to time) on my part can be any excuse for such malignity or littleness.[29]

He threatened Murray with legal action but in the event decided to cut his losses. Thereafter the 'Southern Coast' was published by John and Arthur Arch who owned a print-shop in Cornhill. Cooke and Murray, though, were reconciled[30] before 1822.

Messrs. Arch declined to take on the Sussex scheme so Cooke decided to go it alone. In 1820

he published the five engravings so far produced as Part I of a projected two-part work. This first part was still entitled 'Views in Sussex'. The cover had an emblematic design partially etched by Turner himself (Ill. 3, p. 18) and an extremely intelligent letterpress contributed by Richard Reinagle, a painter and Associate Royal Academician. It was planned that a sequel would follow soon. This was to be entitled 'Views at Hastings and its vicinity'.

Inevitably there were distribution problems. Without the type of organisation afforded by Murray or the Arch brothers it was difficult to promote the engravings in a way that was financially viable. Gradually the Sussex scheme petered out. Cooke went on hopefully advertising the sequel for another four years, but he made little headway. Eventually three engravings for the second part were left uncompleted. One of them was of a drawing of *Winchelsea* (12) that Cooke had obviously diverted from the 'Southern Coast' series.

In 1820 W. B. Cooke took the step of modernising and enlarging his own print-shop at 9 Soho Square in order to increase the chances of direct selling to the public. He installed a new, up-to-date frontage and a three-roomed picture gallery above.[31] Here, from 1821 onwards, he mounted annual exhibitions of watercolours and engravings. The first exhibition (held under Royal patronage) consisted entirely of the latter, some 405 in all, including 31 after subjects by Turner. The exhibition opened coincidentally, on Turner's birthday (23 April) but it was not a financial success.[32] As a result when Cooke put on a more ambitious show the following year he took the precaution of including in it works by Rembrandt, Watteau, Rubens, Giorgione and Michelangelo. Also on display were twenty-three watercolours by Turner. The exhibition opened on 1 February and ran until the beginning of August. It was sparsely reviewed, though *The London Magazine* (March) noticed it, mentioning both Turner's 'excellence' and his 'affectation'. Ackermann's *Repository of the Arts* (1 March), singled out the drawing of *Hastings* (13) as displaying 'great power and truth'.

Meanwhile, George Cooke had been engaged in engraving a number of works Turner had made for other projects.[33] One of the other ideas of both brothers though, was to involve Turner in a part-work on London. Turner discussed this with them in 1820-1 and made a few drawings for it around 1824-5, probably for engraving by J. C. Allen. Some of them were subsequently engraved.[34]

By 1822, anyway, William Cooke had had yet another idea for a work involving Turner. At the time Cooke was employing Thomas Goff Lupton, a mezzotint-engraver who was born in 1791, the son of a goldsmith. He had shown early signs of talent and had been apprenticed to the mezzotint-engraver George Clint A.R.A. On the completion of his training he began experimenting with different printing metals as he was aware of the limitations of copper (it was soft and produced relatively few impressions). He wished to find a material that would be more durable and hence give more (and therefore cheaper) impressions. After experimenting with nickel and a Chinese alloy called tutenag he finally found a successful way of using steel. For this technical invention he was awarded the gold 'Isis' medal of the Society of Arts in 1822. He and Turner had first met when Lupton executed four *Liber Studiorum* plates between 1816 and 1819. In 1822 he was employed by Cooke to engrave Girtin's famous *The white house, Chelsea,* and Cooke paid Turner two guineas to 'touch' the proofs of this mezzotint.[35]

As steel-faced mezzotint-engraving was clearly 'the coming thing', Cooke agreed with Turner on the inception of another series, a work to be entitled 'The Rivers of England', which was also known as 'River Scenery'. For this he commissioned new drawings from Turner which were promptly supplied (51-54 and 56). Also to be included in the series were four works by Girtin and one by William Collins, R.A. The scheme as originally projected was to consist of thirty-six plates mezzotinted on steel by various engravers including Lupton, Charles Turner and William Say, all men whom Turner had worked with on the *Liber.* Between 1822 and 1825 Turner produced seventeen or more drawings for 'The Rivers of

England' (although two of them are predominantly canal scenes—51 and 61). Turner did not sell these watercolours to Cooke, but charged him eight guineas instead for their loan while they were being engraved.

When Turner learned that Cooke was intending to include works by Girtin in the series he questioned him closely as to who would 'touch' the proofs. Upon being told it was hoped he would, the following conversation ensued:

Turner: 'I shan't'
Cooke: 'Oh! Mr. Turner'
Turner: 'I tell you, I shan't'
Cooke: 'But your long acquaintance with Girtin!'
Turner: 'I tell you, I shan't'
And so Cooke left him. A few days after, Cooke saw him again, when Turner began with:—
'Well, Cooke, I've thought that matter over, and I'll touch the plates for Poor Tom. Poor Tom!'
'Ah,' said Cooke, 'I thought you would'.
'Yes; I'll touch them for Poor Tom. Poor Tom!' and he continued repeating the words, 'Poor Tom' as if to himself. Cooke took the proofs to him, and he worked upon them for a long time, bestowing great care, and 'making them' as Cooke said, 'quite his own'; and, at last, after holding them individually at arm's length, throwing them on the floor, turning them upside down, and flinging them in every direction, he said, 'There, Poor Tom! That will do. Poor Tom!' and Cooke was about to take the impressions away, when Turner, clapping his arm upon them, exclaimed—'Stop! You must pay me two guines a piece first.'[36]

The Girtin plates in the 'Rivers' series (views of York Minster, Kirkstall Abbey, Ripon Minster and Bolton Abbey) proclaim the quality of Turner's work, for they are quite masterly mezzotints and are indeed amongst the best prints in the whole series.[37] In order to keep them company Turner also had an early Girtinesque drawing of his own included in the scheme (*Warkworth Castle*, 1). Although one of the steel plates broke down in the course of printing these problems were soon overcome and the production of 'The Rivers of England' proceeded smoothly thereafter.

In 1822 Cooke conceived still another idea for a project concerning Turner. Since 1817 he had had a very large drawing of the Eddystone lighthouse on his hands. His account book (see Appendix B) tells us that he had originally intended to 'place' this in 'The Rivers of Devon' scheme (though even he must have seen how inappropriate it was for that venture). At the same time he was unsuccessfully endeavouring to engrave the large drawing of *Hastings* (13) for the second part of the Sussex work. This picture possibly inspired him to propose to Turner a series of similarly large watercolours which would be reproduced in mezzotint and published under the title of 'Marine Views'. To this scheme the *Eddystone* could be allocated (as it was). Turner eventually made six major drawings expressly for the series. They constitute some of his finest marine watercolours, although until now five of them have not been recognised as belonging to the scheme. These drawings are *Folkestone from the sea* (66), *Dover Castle* (67), *A Storm (Shipwreck)* (68), *Fish-market, Hastings,* (115), and *Twilight — Smugglers off Folkestone fishing up smuggled gin* (116). The reason none of them have previously been connected with the 'Marine Views' is because they have been widely dispersed and because they were not engraved by W.B. Cooke. That they were intended for the series is demonstrated by three factors. All but one of them are known to have been made for Cooke, who only bought watercolours from Turner for engraving and who had no large-scale series other than the 'Marine Views' he could have assigned them to at that date. In addition, they are all exactly similar in size, which clearly suggests a series-relationship, and they also share common characteristics of content and handling. The work not bought by Cooke is *Folkestone from the sea* (66), dating from *circa* 1822-4, which has remained in the Turner Bequest. This picture shows gin being hidden at sea and thus forms a pendant to *Twilight — Smugglers off Folkestone fishing up smuggled Gin* (116) which *was* partially engraved for the series. Although

Folkestone from the sea is slightly larger than the other 'Marine Views' watercolours, extensive tears and irregularities along the edges mean that it would have been cut down for display or engraving purposes. Turner also made a small introductory vignette for the venture (see below).

On 1 January, 1823 Cooke opened another public exhibition of drawings and engravings. He took the unusual expedient of holding the private view on New Year's Eve and this ensured large crowds despite the gloominess of the weather.[38] Present were 'some of the more distinguished literary men and artists, male and female, of the day'.[39] Turner had nine watercolours on show. Included was a large drawing made for the 'Marine Views' series, the *Dover Castle* (67) which the catalogue (No. 26) tells us was 'drawn in December, 1822'.

Turner made another impressive work for the series in the spring of 1823. Cooke immediately put it on display together with a drawing of whiting fishing at Margate (114) made the previous year (which he represented as a new work). On 17 May he proudly advertised in *The Literary Gazette*:

Two superb drawings by J. M. W. Turner, R.A. will be added to this splendid collection on Monday next, May 19th, and will be placed in the centre of the rooms. A STORM [68] and A SUN-RISE [114]. These powerful productions from the pencil of Mr. Turner (being just finished) will continue a few weeks only for public inspection.

Cooke paid Turner sixty guineas for each of these drawings and the same amount for the *Dover* (67).[40]

Cooke lost no time in employing Lupton to engrave the sunrise at Margate for the 'Marine Views', where it appeared in 1825. He published the first engraving in this series, the *Eddystone Lighthouse,* in 1824. For the frontispiece of the new scheme Turner produced a vignette entitled *Neptune's Trident* (Ill. 7, p. 33). This was to be the source of a later dispute as Cooke was under the

impression he had been given the drawing by Turner and as a result he had presented it to his wife; ultimately he was forced to return it.[41] Lupton was responsible for engraving these works and W. B. Cooke etched the vignette.

A notion of how much pressure Cooke was putting on Turner at about this time is related by Thornbury:

it was his habit, Mr. Munro told me, to visit Turner on Sunday afternoons, when the painter was often at leisure. In the course of a pleasant chat . . . their social privacy was invaded by the irruption of Cooke, who, with all the air of a bullying tailor come to look after a poor sweating journeyman, wanted to know if those drawings of his were never to be finished. When the door presently closed behind him, the big salt tears came into Turner's eyes, and he murmured something about 'no holiday ever for me'.[42]

Cooke opened another exhibition on 8 April, 1824. A prominent feature of the show, which also included works by Titian, Poussin and Claude, was a collection of paintings on glass by Gainsborough. Among the 272 pictures on display were 17 watercolours by Turner including two new drawings made for the 'Marine Views' series, the *Twilight — Smugglers off Folkestone fishing up smuggled gin* (116) and *Fish-market, Hastings* (115).

By the middle of 1824 the end of the southern part of the 'Coast' scheme was clearly in sight and Turner gave some thought to continuing it up the eastern seaboard. He toured Sussex and Kent (to obtain material for the final 'Southern Coast' watercolours) and East Anglia, visiting Colchester and the coast from Aldeburgh to Yarmouth. In the late autumn he also went to Farnley,[43] and while he was there visited Kirkstall Abbey. He subsequently made two watercolours of the building for the 'Rivers of England': one of them was with Cooke[44] by 14 January, 1825. This was to be the last visit Turner ever made to Farnley. Its owner, his great patron and friend, Walter Fawkes, died the

following October.

By the middle of 1825 three parts of 'The Rivers of England' had appeared and the fourth part was well in hand. Encouraged by this Thomas Lupton also developed the idea of promoting a part-work with Turner, proposing yet another set of marine subjects. For the wrapper design Turner made a vignette drawing (Ill. 8, p. 34) which shows that the series was originally to be called 'The Harbours of England'. It appeared, however, under the title of 'The Ports of England'. Lupton sought and received permission to dedicate the work to George IV and issued a patriotically worded prospectus announcing the scheme. It was to appear in twelve parts with two pictures per part. Turner eventually made some fifteen of the twenty-five watercolours commissioned from him for the project (including the wrapper vignette). Some of them have previously been assigned elsewhere in his *oeuvre* (*Ramsgate*, 81, *Hastings*, 82, *Folkestone*, 83).

The first part of this series appeared in May 1826, as did the final part of the 'Southern Coast' scheme. Originally the Cookes had intended to engrave the entire 'Southern Coast' themselves but eventually they were forced to call upon outside help. As A. J. Finberg commented '. . . had not the assistance of these engravers been called on it is doubtful whether the work would have been completed.'[45] Amongst them were Edward Goodall, William Miller and Robert Wallis, engravers who were to continue working with Turner on other projects right up until the end of his life. After the scheme was completed Cooke had the prints bound (in a sequence corresponding to their topographical order, from Whitstable in the east to Watchet in the west) and republished them.

In 1825 Turner also became involved with another print-publisher, Charles Heath, on whose behalf he was to produce a series of 120 large watercolours for line-engraving and publication under the title of 'Picturesque Views in England and Wales'. It was to be the most ambitious of all of the schemes for reproducing his work by engraving.

Meanwhile he was simultaneously discussing with the Cooke brothers the notion of continuing the coastal survey. These talks led to violent quarrels in the autumn of 1826. W.B. Cooke wrote a long letter to Turner on 1 January, 1827 (see Appendix A) and the letter makes clear exactly why they were at loggerheads. Cooke had offered Turner twelve and a half guineas for each drawing for the new series. This was an increase of two and a half guineas over the sum paid for works in the 'Southern Coast' scheme. Turner, however, wanted this difference to be paid to him retroactively for the 'Southern Coast' drawings. The total would have come to one hundred and six pounds. Cooke could not accept this. Far more serious, though, was Turner's demand that he should be supplied with twenty-five of the finest India-paper proofs of each print. Cooke saw this as an unwarrantable claim since the number of good (and therefore saleable) impressions produced from copper-plates was severely limited by the softness of the metal. Each plate would probably only produce about two hundred impressions before it would have to be re-worked. If Turner were to siphon off the best prints Cooke's profits would have been seriously reduced.

Turner's demand for the retroactive payment of increased fees was not totally unreasonable as Cooke had obviously made a fair amount of money out of him over the years (though he also took the risks). In any case, Charles Heath was simultaneously paying Turner exactly double what Cooke had offered for each, admittedly smaller, drawing and Heath had had no objections to supplying Turner with thirty proofs.[46] In this respect W. B. Cooke shows himself to have been a better businessman than Heath for, unlike Heath, he never ruined himself.[47] That Turner felt seriously underpaid by Cooke is illustrated by his asking 'Do you imagine that I shall go to John O'Groat's House [i.e. continue up the east coast to the north of Scotland] for the same sum I received for the Southern part?'[48] Turner then threatened Cooke that he would produce the work himself and reap the rewards.

Both Turner and William Cooke refused to

make concessions and relations were acrimoniously broken off. It was probably at about this time that Turner also argued publicly with George Cooke over the proofs of an engraving[49] made for the 'Southern Coast' by Edward Goodall:

... he [Turner] caught sight of George Cooke ... and immediately began a very heated argument with him, claiming his right to the touched proofs. This claim George Cooke stoutly refused to concede.
'How can you justify such a demand? Tell me frankly why you asked for them?'
'Oh' said Turner, 'supposing it be only a whim?'
'I will humour no man in his whims,' answered Cooke.
'Then, sir,' retorted Turner, 'you shall have no work of mine to engrave.'
Hotter and hotter grew the dispute, till George Cooke gave it its finishing touches.
'Sir' quoth he, 'I'll not engrave another of your pictures as long as I live.' Turner flounced out of the room in a great passion ...[50]

George Cooke then approached Goodall and told him not to give in to Turner's demands. However, Goodall had to visit Turner the very next day about another plate he was engraving[51] and he and Turner also quarrelled about the proofs:

Goodall refused to give them up and even half thrust them into the fire when the blaze caught them. In terror of fire, Turner, whose chimney was never swept, ran with shovel and tongs to save the house, exclaiming, 'Good God! You'll set the house on fire'.[52]

These quarrels were to have a major repercussion. Turner almost certainly decided to publish the 'Picturesque views on the East Coast of England' himself. For the scheme he made a number of drawings in gouache on blue paper. He had them reproduced by the line-engraver J. C. Allen. Although Allen engraved six works (leaving two more unfinished) they all remained unpublished. Contrary to his declarations to Cooke, Turner obviously did not have the time or inclination to act as his own publisher anymore.

Turner also quarrelled with Lupton. As Ruskin tells us, 'they petted each other with reciprocal indulgence of delay'.[53] Lupton had been hit by the economic crash of 1826 and, in addition, he and Turner also argued over Lupton's engraving of *Calais Pier*.[54] Turner made incessant changes to this plate as he could not believe it was an accurately-proportioned reproduction of his painting. In the end Turner refused to collaborate any further and Lupton was forced to abandon the plate. As a result of their break Lupton was also unable to continue a mezzotint for the 'Marine Views' series of the 1824 *Twilight — Smugglers off Folkestone* and the further publication of 'The Ports of England' became impossible. By 1828 six works for the series and the title-page vignette had been completed. Lupton printed the plates he had in hand and sold most of the impressions.[55] He kept the plates and re-issued them in 1856 after Turner's death. At that time he also printed six other uncompleted plates exactly as he had left them in 1828. The reprint was produced in collaboration with Ruskin. Ruskin wrote a commentary for it and reverted to Turner's original title for the scheme, the 'Harbours (rather than the 'Ports') of England'.

Naturally, with the cessation of relations between Turner and the Cooke brothers in 1827, Turner's participation in the 'Rivers' series came to an end. W. B. Cooke bound all the unsold prints that had already been produced and published them in 1827 under the collective title of 'The River Scenery of England'. They were accompanied by a letterpress written by Mrs. Hofland who had assisted William Combe on the earlier 'Southern Coast' text. By then the work included fifteen engravings after Turner. Three additional plates were either uncompleted or cancelled due to imperfections in the metal.

Immediately after their break William Cooke attempted to float the idea of an east coast venture without Turner and advertised the scheme in the *Examiner*.[56] It was to consist of the 'Eastern and Western Coasts', to be published in alternate numbers. However, Messrs. Arch realised that without Turner the prospects of financial success for such a plan were bleak and they withdrew their support. As an alternative they put forward a work surveying 'The English Channel or La Manche' from drawings by Turner.[57] This too came to nothing.

So ended Turner's sixteen year-long relationship with the Cooke brothers. Between them they had commissioned and directly engraved some forty-nine pictures by Turner and had been additionally responsible for the commissioning and engraving (by others) of upwards of another forty of his works. It was perhaps inevitable that their collaboration should come to such an unfortunate end. W. B. Cooke was both unreliable and over-ambitious. Yet Turner's growing preoccupation with money and his desire to amass large numbers of the proofs of his engravings also contributed to the break in their relationship.

However, it was not all loss. Even if the joint venture did end badly their work together had enabled Turner to concentrate his range and produce some important groups of pictures that display a greater continuity of ideas and certainty of purpose than had his previous watercolours. Moreover, in 1811 Turner had only just begun to take a creative interest in the potential of line-engraving. By 1827 he had mastered its techniques and imbued the medium with a richness of expression hitherto absent from landscape subjects. The following decades were to see the full fruits of that involvement. By affording Turner the chance to test different forms of engraving and by constantly pressing him to produce new works on their behalf, the Cooke brothers had advanced the art of landscape engraving and unknowingly made a significant contribution to Turner's development as a watercolourist.

MR TURNER

Turner's art took an immense step forward between 1810 and 1827. He was enormously productive during the period, as some 55 major oil-paintings, over 350 elaborate watercolours and upwards of 150 engravings from his works testify. More especially, the five years after 1810 can be seen to constitute the most important phase of his artistic development. From the serene landscapes of 1810 he progressed to the *Hannibal* of 1812 and *Frosty Morning* of 1813. In 1815 he exhibited two especially key pictures, *Crossing the Brook* and *Dido building Carthage; or the Rise of the Carthaginian Empire.* Ever afterwards he called this latter work his 'chef d'oeuvre' and always refused to sell it. At one time he even seriously requested that he be buried rolled up in it upon his death, though fortunately he was dissuaded from having this macabre idea carried out. Instead he bequeathed the picture to the National Gallery to hang alongside *The Embarkation of the Queen of Sheba* by Claude. Turner was quite justified in holding *Dido* in high esteem for it marked the arrival of his artistic maturity and it contains a great number of innovative formal and expressive devices that were to reappear frequently in his work.

In 1817 he exhibited its pendant *The Decline of the Carthaginian Empire.* He followed this with masterpieces such as the *Dort* and *Raby Castle,* both of 1818, and the magnificent *England: Richmond Hill* of 1819. In this picture Turner summarised his achievement to date. Upon its completion he went to Italy for the first time. The 1820s saw him assimilating and building upon the Italian experience in pictures such as *Rome from the Vatican* (R. A. 1820) and *The Bay of Baiæ* of 1823. Much of 1823-4 was spent working on the largest of all his pictures, *The Battle of Trafalgar,* one of the most stupendous battle scenes ever painted.[58] This generally optimistic phase of Turner's life came to an end in the autumn of 1825 with the death of Walter Fawkes. Thereafter Turner was more profoundly aware of his own mortality, and his attempts to come to terms with it were to be an underlying pre-occupation of the following two and a half decades.

The rapidity of Turner's artistic growth during the early part of this period is not only evident in the oil-paintings. An ever greater assurance is apparent in both the 'Southern Coast' and the Sussex drawings. Comparing the first two groups of 'Southern Coast' watercolours dating from 1811 and 1813 respectively, the earlier works (19-23, 100-102 and 104) are uncomplicated, even somewhat reticent in their approach. The figuration is straightforward and the emotional tone subdued. Just two years later, though, (after the 1813 West Country tour) the drawings display a wider range of feeling, a more complex handling of figures and an altogether greater sureness of expression. The 1811 *Dartmouth* (104), for instance, is a simple statement of the town's character as displayed by its fishing industry. The drawing is loosely structured and seems emotionally tentative; it lacks complete confidence. By 1813, in *Plymouth Dock, from near Mount Edgecumbe* (26) we see a transformation. The figures are more clearly expressing the spirit of the place, they are better assimilated into the landscape and that landscape itself is better moulded to accommodate them. The whole work is imbued with greater certainty of purpose. Moreover, its exploration and expression of human motives is at once more particular and more universal.

A similar pattern of growth is also apparent in the Sussex drawings. The 1810 group (2-5) shows the use of a more restricted palette than the later works and the dramatic exposition of the landscape, while undeniably broad, still seems understated. By 1815 the watercolours (8-15) demonstrate a greatly enhanced dramatic sense as well as increased powers of observation, a much richer use of colour and a more confident use of detail throughout.

This progression can be discerned especially in the depiction of trees. The trees in the 1810 drawings display the naturalism that characterises much of Turner's work of the period.[59] Only a few years later, though, the trees underwent a subtle but profound alteration. They were imbued with a more personal sense of form and Turner took pains to suggest their inner process of development. The oak tree in the foreground of the 1810 *Beauport* (4), for instance, is still conceived primarily in terms of a mannered eighteenth-century stylization. The branches display those little curlicues and slight exaggerations that one sees throughout late eighteenth-century painting and in Turner's early work particularly. There also appears to be a dichotomy in that the form of the tree seems imposed upon the foliage. In *The Vale of Ashburnham* (11), however, this dichotomy has been resolved. The technique employed in drawing the trees on the right of the picture is still based upon the inherent transparency of watercolour, but Turner has married the trunks and branches to their foliage and they have an enhanced elegance of line that demonstrates their innate growth. In short, he has grasped the underlying structure and found a means of conveying that insight. Nature has been observed, its outward appearances assimilated and finally transformed: mannerism has disappeared and naturalism is now subordinated to the demands of artistic vision. Turner's forms are paradoxically both more stylish and natural, imaginative yet real.

An element that makes a significant contribution to the suggestion of the inner life of the trees is the new-found complexity of line that Turner attained during the 1810s. It is not only apparent in the forms of trees. *Rye* (37), for example, is filled with lines that endlessly counter the two underlying straight accents of the horizon and

roadway. These lines amplify the inrushing motion of the water and create a powerful sensation of ebb and flow throughout the picture. In the pall of smoke issuing from the steamer in *Dover Castle* (67), for example, Turner describes the movement of smoke with supreme accuracy and total understanding of the way it is affected by the wind. Apart from any reality it may represent, it is also an aesthetic entity, offering its own profound satisfaction as an abstract line. This linear grace is seen most often, of course, in the charged movement of water, but it is also encountered in the boughs of trees, the patterns of smoke, the shapes of sails and the curves of clouds or rocks. Turner's ability to impart an ever greater individuality and character to line was a major development of the decade.

In addition to these imaginative enhancements of form, Turner also achieved a greater control of colour during this period. The 1810 group of Sussex watercolours (2-5) demonstrates a limited palette of hot earth colours such as raw umber and burnt sienna, as well as green and Prussian blue. The general effect of the colour is slightly crude and it unintentionally suggests heat. By 1816, when Turner drew *Pendennis Castle* (28), we can see how far he had developed in a very short time. The earth colours are avoided. Turner sets off the cool greys and blues of the distance by filling his foreground with their complementaries, some of the hottest colours in the spectrum: gold-yellows, reds and pinks. Yet these colours do not evoke heat at all. Through greater purity and by achieving a better balance of colours Turner precisely evokes the sense of cold air coming off the sea. This transformation is merely one indication of how Turner began to direct colour to serve his artistic aims. His understanding of light, his use of colour as a vehicle for expression and his comprehension of its harmony developed immeasurably in these years. He continued to base a great number of his works (both in oils and watercolours) upon the concept of a unifying colour key to which all the constituent colours were subordinate. At the same time he also began to polarize colours (especially in watercolour) so

as to achieve the maximum contrast within a small space. Thus in many of the drawings we see opposing colours forced up to their highest values, as in *Norham Castle* (53) and *Dartmouth* (56). In the 'Rivers' and 'Ports' drawings especially, the concentration of colour within tiny dimensions produces a jewel-like brilliance. The wealth of colour is enhanced by the constant optical flux of minute stipplings across the surface. Between 1818 and 1822 Turner may even have subjected colour to a thorough scientific analysis as a result of his researches into optics for his perspective lectures at the Royal Academy.[60] Yet ultimately Turner's perception of colour was not theoretical but empirical, a solid understanding of theory providing him with a spring-board for his imagination. At the beginning of this period he was still a limited colourist: the restricted palette of the oils and watercolours of the 1806-10 period testifies to that. By 1827 he was one of the most wide-ranging, sensual and expressive colourists in the history of western painting. We can see the change taking place in the pictures in this book.

Inextricably linked with the development of colour was the development of tone. As Turner's range as a colourist grew, so too did his need to control tone with greater exactitude, and he was undoubtedly influenced in this by his collaboration with the Cookes and other engravers. The absence of colour in the engravings demanded a compensating emphasis upon tone and so eventually broadened the tonal range of both his watercolours and oils. Throughout the whole period, Turner was constantly searching for new means of expression, varieties of form and for ever-greater complexities of colour.

One particular, if tacit, requirement of the 'Southern Coast' project also contributed significantly to Turner's development. Topographical pictures were expected to include pictorial expositions of the human activity of the place depicted. These references would then be complemented and expanded by the accompanying letterpress. This was not a problem for Turner. Even in his very earliest work for engraving he had regarded such elaboration as a vital part of a landscape

painter's function. He had often taken great pains to invest his pictures with a thoroughly researched subsidiary account of the historical, economic and social background of a place. The 'Southern Coast' series was the most ambitious engraving scheme he had entertained so far and he responded accordingly. In *St. Michael's Mount* (100) he naturally surrounds the isolated rock with Mount's Bay trawlermen going about their business; in *Weymouth* (20) he depicts bathers, the economic prop of the town; and in *Land's End* (101) he intentionally leaves the scene devoid of figures to accentuate its lonely and dangerous location. This associative elucidation of landscape thoroughly reflected Turner's need to portray the world in terms of more than purely pictorial values. The most direct vehicle for this expression was the use of complex and vital figuration and to ignore this is to exclude wide areas of Turner's thinking. Occasionally, in his mythological or historical pictures, the emphasis placed upon the figures is paramount, and this may indeed account for the comparative neglect of these works within his *oeuvre*. Unfortunately, French Impressionism has conditioned us to look at the figures in landscape paintings as merely so much formal or subsidiary staffage. For Turner, however, this was not so. The appearance of a place was but one of its facets, for mankind's complex life in a particular setting was the element that gave the landscape its meaning. This was an attitude central to Turner's outlook: man was not of secondary importance to him but often the primary object of his concern. A careful examination of the figures and their activities is therefore crucial to a complete understanding of the pictures. Equally important is our understanding of the social context of humanity, the greater truth of landscape that the artist went to such lengths to investigate.

As the 'Southern Coast' and other series of drawings progressed, so Turner's elaboration of this awareness became more complex and rich in meaning. His ability to structure pictures around this meaning also became more assured. In *The Vale of Ashburnham* (11) Turner gathers together all the elements of the view noted in the original

sketch (see Concordance) and transforms them by a strong pictorial emphasis. He builds the whole picture upon a circular line that identifies the source of the wealth which supported Ashburnham Place, the picture's focal-point. In *Bridport* (32) he demonstrates the town's principal product *in action* and by doing so creates a line that unifies the work. In *Source of the Tamar and Torridge* (17) he elaborates the emergence and divergence of rivers in a picture whose loose structure enhances the landscape's sense of wilderness. In *Yarmouth Sands* (95) he composes the work around his knowledge of the battle of Trafalgar, an engagement that was celebrated by the monument it depicts. By the mid-1820s, therefore, Turner was able to invest his pictures with increasingly complex meanings. Almost everywhere he sought to establish a sense of *genius loci,* the essential nature of place that exists behind outward appearances. His observation and awareness of the history, behaviour and responses of mankind were a fundamental part of this process.

An obvious way of articulating this meaning was through the use of allusion. Turner of course, painted in an artistic milieu where such visual thinking was commonplace. Allegories and other kinds of symbolic representation were much in evidence on the walls of the Royal Academy and elsewhere throughout his lifetime. Not surprisingly, Turner also quite frequently resorted to symbolism as a method of extending meaning in his pictures. Again, our conditioning by Impressionism (and perhaps an over-exposure to amateur Freudianism) has led to a distrust of interpreting these meanings in Turner. Yet his contemporaries had no such inhibitions. They found it easy to understand what he was trying to say. *Battle Abbey, the spot where Harold fell* (96) is an example. Turner introduces a hound about to kill a hare to symbolize the spot where King Harold 'Harefoot' was killed in the battle of Hastings. We know for a fact that this is what Turner intended them to mean (see p. 42). Richard Reinagle, who wrote the letterpress accompanying the engraving,[61] had no difficulty in interpreting this symbolism either. Nor was he slow to understand the

other devices that Turner employed in the picture to enhance the melancholy subject. It was natural that such a thoughtful painter as Turner should resort to symbolism in order to extend his meaning, and this was another facet of his art that matured between 1810 and 1827.

Turner's penchant for making watercolours in series also advanced during this period. Even in his very earliest groups of pictures commissioned for engraving Turner had always imparted to these drawings a particular set of characteristics (e.g. similar size and handling). This differentiation was obviously a useful way of distinguishing groups of works, but one can also discern in it another important rationale. Each choice of size or type of paper imposed upon Turner a number of specific technical problems. To an artist who throughout his life demonstrated an avidity for challenge these problems of scale, technique and characterization must have seemed welcome. Landscape subjects had to be selected and tailored to fit each confine and every series had to be imbued with its own set of formal identifications and qualities. Finding this identity led to a continuous process of creative renewal.

The difference in size was also in each case a reflection of the purpose for which the drawings were made. For Jack Fuller, for example, Turner made consistently large watercolours. Their dimensions partially derived from the amount Fuller was willing to pay for them and from the fact that the wide Sussex vistas demanded such a scale. To emphasize the spaciousness of these scenes further almost all of them are sparsely populated. Their size also derived from Fuller's requirement that the aquatints of the initial group should be large (they are almost identical in size to their watercolours).[62] Likewise, the 'Southern Coast', 'Rivers' and 'Ports' watercolours were all geared in size to the specific needs of the engraver. They reflected the fact that the engravings from them were to be extremely small. To save the engravers trouble in scaling them down Turner made them to the correct dimensions (though again what the Cookes or Lupton were willing to pay for them undoubtedly determined their size). The special miracle of

the later 'Southern Coast' drawings, and of all the drawings in the 'Rivers' and 'Ports' series, is that they pack both a huge sense of scale and an exquisitely wrought amount of detail into an extremely small space.

As he matured, Turner imbued each series of pictures with a greater cohesion of meaning. This explains why he felt it imperative that these pictures should be seen in connection with one another. As Ruskin tells us:

The only thing he [Turner] would say sometimes was 'keep them together'. He seemed not to mind how much they were injured, if only the record of the thought were left in them, and they were kept in the series which would give the key to their meaning.[63]

The *Liber Studiorum* had already been an attempt to create a work which would mark Turner's achievement to date and establish a thematically categorised but complementary series of pictures. This tendency was to continue, without the internal categories of subject, in the 'Southern Coast', 'Rivers' and 'Ports' groups of drawings. The choice of subjects in the 'Southern Coast' series was principally determined by geographical considerations, though in the 'Rivers' and 'Ports' groups the connection between the works and the title of the series is sometimes rather tenuous. Thus the 'Rivers' includes depictions of castles, towns and cities as much as it does rivers and streams, and similarly, the 'Ports' series shows watering-places and fishing villages. Yet for Turner the prime consideration was inspiration and he refused to allow petty labels to impinge upon it. What he searched for in such series was a means of imposing a linking structure on his immense experience. In all of these sets of drawings up to and including the 'England and Wales' series, Turner was attempting to express a comprehensive but balanced view of the world.

Seeing these pictures in groups also clarifies the extent to which Turner used ship's models to supply details for his pictures. Two glazed cases of such models were found amongst his studio effects

after his death[64] and they explain why the same brigs, luggers, hoys, cutters and sloops appear in so many of his works. Such *aides-mémoires* were common among marine-artists at the time. This is not to say, however, that Turner relied primarily upon observation of models for his nautical information. His extensive knowledge of seamanship is shown by the understanding he demonstrates of the problems of navigation and ship-handling in the days of sail. Occasionally these problems even become a dominant part of the subject-matter of the pictures themselves, as in *Hastings* (13), *Boscastle* (43), *Mount Edgecomb* (109) and *Dover Castle* (67). Turner may sometimes make mistakes or employ artistic licence for the details of his shipping, but his grasp of essentials was exact.

The 'Southern Coast', 'Ports of England', 'Marine Views' and 'East Coast' watercolours are, of course, predominantly sets of seascapes, and marine subjects also appear in 'The Rivers of England' and 'The Rivers of Devon' series. By 1810 Turner was already a fully mature marine artist whose outstanding achievements in the genre were widely recognised. Although Ruskin maintained[65] that it was on the 1811 tour that Turner gained his unprecedented insight into the nature of the sea, in fact he had demonstrated this knowledge much earlier. Around the turn of the century he had exhibited a number of marine subjects at the Royal Academy which had helped to establish his reputation.

Between 1810 and 1825 Turner's response to the sea was generally optimistic, a reflection, indeed, of his wider outlook on life.[66] Conspicuously absent during this period was that concern with shipwrecks that had earlier contributed to his reputation. After painting *The Wreck of a Transport Ship* around 1809, ten years were to pass before Turner exhibited another painting of a shipwreck (*Entrance of the Meuse: Orange-Merchant on the Bar, going to Pieces,* R.A. 1819) and that picture merely displays the results of poor seamanship, its crew being in little danger. Drawings such as *A Storm (Shipwreck)* of 1823 (68) or *Loss of a man-of-war* (probably made for

Fawkes in 1818) are exceptional. Only one drawing in the 'Southern Coast' series depicts such a scene and that relegates suffering humanity to the distance (*Ilfracombe,* 103). There is, of course, plenty of stormy water around, but Turner prefers to take a more hopeful view of things, his ships either sailing past dangerous rocks with relative equanimity (*The Mew Stone,* 24) or being warped into the safety of harbour (*Boscastle,* 43 or *Bridport,* 32).

Turner saw the ocean as the arena for a great variety of events and activities. Shipping busily enters or leaves harbour (*Dover,* 71, *Ramsgate,* 72 and 108) and creates strange jumbles of form in passing (*Mouth of the River Humber,* 59, *Deal,* 76). In the sea Turner erects sexual metaphors *(Sidmouth,* 77); on it he sets impending collisions (*Dover Castle,* 67) or sudden squalls (*Lyme Regis,* 22) and surges of the tide (*Rye,* 37); above it he builds up masses of storm clouds (*Clovelly,* 38) or unleashes cataclysmic forces (*A Storm (Shipwreck),* 68). In all his depictions of the sea Turner demonstrates his incomparable understanding of its rhythmic motion and dynamic energy; he exults in its expressive power.

The nine series that form this book constitute a significant part of Turner's watercolour achievement in the two decades after 1810. In that time he made other important sets of drawings, such as the Rhine views of 1817, the 'Richmondshire' series of 1816-21 or the designs for Hakewill's 'Italy', but the pictures reproduced here represent the bulk of the watercolours made for engraving during the period and virtually all the marine watercolours of these years. The 'Southern Coast' series was, moreover, the longest-lasting of the many schemes for engraving Turner was ever to be involved in. The pictures are not merely views of rivers, harbours and coasts. They also show hills and vales in Sussex, stately country houses and impoverished villages, isolated inns and much-frequented tourist spots, castles and prisons, canals and estuaries, fortresses and monasteries, as well as lighthouses and the sea in all its moods. Mankind is always in the forefront, working and playing, living and dying. In these drawings

Turner also portrays contemporary advances in building and transport, he exposes the latest smuggling techniques and alludes to contemporary battles or wars of independence. Everywhere he exhibits the results of an insatiable curiosity. Together these works present a phenomenally exhaustive view of the England in which he lived. They all attest to Turner's extraordinary powers of observation and memory and they display the immense range of his responses both to man and to the natural world in all its infinite variety. In them are the seeds of later, even more momentous achievements in watercolour—but all are endowed with superb technical mastery and a profound sense of character. Among them are some of Turner's finest masterpieces. We are indeed fortunate that an unstable slave-owner and some small-minded engravers called them into being.

COMMENTARIES ON THE WATERCOLOURS

In order to assist the reader I have divided the following commentaries into sections which match their series and I have also provided a short introduction to each. These introductions are merely intended to save reference back to the main body of the text for information about groups of pictures. Where watercolours have disappeared, or were unavailable for reproduction, they are represented either by black and white photographs or by reproductions of engravings. The commentaries on those works form a separate section which follows the earlier sequence of series.

All of Turner's idiosyncratic titles (with their misspelt place names) have been retained. If the works were exhibited in his lifetime I have given the titles used on those occasions, and have corrected subsequent, inauthentic changes. If Turner's own title is unknown I have used the title of the corresponding engraving.

Many of the dates for the watercolours are necessarily inexact, but I have been able to establish a number of close approximations by reference to W. B. Cooke's account books. These have been largely neglected as a source of information on dating, and on the works in general, although they were published as long ago as 1862. They are reproduced as Appendix B.

As far as possible the pictures appear in the original sequence of the engravings although, because some works were not available for photography, alterations have had to be made. However, in the case of the Sussex drawings I have presented them according to their probable chronology of execution. This is because the chronology of the appearance of their aquatints and engravings is extremely uncertain and because they represent a clearly discernible stylistic development. I have also removed *Warkworth Castle* from the 'Rivers' series and placed it at the beginning of the colour plates as it ante-dates all but one other picture reproduced in this book by at least ten years (it was engraved more than twenty-six years after being made) and because it therefore looks anachronistic amid the 'Rivers' drawings.

A list of the engravings in their order of publication is appended after the commentaries, together with a list of the drawings exhibited during Turner's lifetime and their original catalogue numbers. I have also compiled a concordance relating the drawings to the sketches upon which they are based and a short glossary of the types of shipping painted by Turner. All the works are in watercolour on white paper unless otherwise stated. In all dimensions height precedes width and the number of each commentary corresponds to that of its reproduction. Where necessary I have appended the Turner Bequest (TB) inventory numbers. The captions of the pictures that were engraved, or are known to have been made for engraving, are accompanied by a reference to the series to which they belong.

1 WARKWORTH CASTLE, NORTHUMBERLAND – THUNDER STORM APPROACHING AT SUN-SET

52.1 × 74.9cm (20½ × 29½ in) 1799

Exhibited at the Royal Academy in 1799 with the following stanzas:

Behold slow settling o'er the lurid grove,
Unusual darkness broods; and growing, gains
The full possession of the sky; and yon baleful
cloud
A redd'ning gloom, a magazine of fate
Ferment

James Thomson, *The Seasons*

This drawing was engraved in 'The Rivers of England' series (see p.10) but its early date has presented a problem. Turner kept all the water-colours for 'The Rivers of England' series in his possession and they passed to the nation after his death. Missing from the group was the picture that was engraved under the title of 'Warkworth Castle, on the River Coquet'. It has therefore been assumed[1] that the watercolour that formed the basis of the engraving had subsequently been lost. That is not the case.

This 1799 picture was undoubtedly the basis of the 1826 'Rivers of England' engraving. The drawing and engraving are virtually identical and it is extremely unlikely that a quarter of a century after making this watercolour Turner would have created a replica simply to supply an engraver with material. Whenever Turner made new versions of earlier pictures they always involved an imaginative transformation, a widening of the picture's range of form and content. Had he decided to make another drawing of the subject for the 'Rivers' series he would certainly have taken the opportunity to vary his treatment of it. The engraving shows no evidence of this process whatsoever and we must reasonably conclude that the print was made from the 1799 drawing.

This watercolour was also displayed in 1824 in the Cooke Gallery exhibition. In the catalogue (No. 24) it was listed as being 'In the possession of Messrs. Hurst and Robinson (for sale)'. Hurst and Robinson were important London print-dealers who had already had extensive dealings with Turner. They had presumably bought the work from Turner intending to have it engraved and may have placed it with Cooke for this purpose. However, the fact that they offered it for sale suggests that they had changed their minds. It seems very likely that Cooke bought the work from them (possibly when they went into liquidation early in 1826) and assigned it to the 'Rivers'

scheme where it was engraved by Lupton. Cooke may have been influenced to take this decision by Turner himself. In any case, that Turner allowed such an early work to be included in the 'Rivers' scheme is intriguing.

The decision may well be connected with Turner's fond memories of one of the great friends of his youth, Thomas Girtin. This drawing has long been recognised[2] as particularly demonstrating Girtin's influence upon Turner, and Turner probably felt that, in addition to working on Girtin's plates for the series (see p. 10), it would be fitting to accompany them with a work of his own that was similar in style. By including such an early picture he would be ameliorating the slightly old-fashioned look that Girtin's pictures would have presented amid so many of his own recent pictures.

When the work was engraved in 1826 Turner clarified the image, giving more emphasis to structure and widening the tonal range of the sky. He also added some smoke to the chimney of the cottage near the castle. The castle itself was built

3 Emblematic frontispiece on the cover of the 'Views in Sussex', 1819. This design was engraved by Turner with assistance from J. C. Allen. It has previously been thought to be entirely the work of Turner himself (as the publication line shows) but a letter[3] in the Fitzwilliam Museum, Cambridge mentions the employment of Allen to prepare the preliminary etched state.

between the twelfth and fifteenth centuries on a bend almost at the mouth of the River Coquet. Turner visited the site on his extensive tour of the north of England in 1797 (see Concordance).

'Views in Sussex' and Related Drawings 1810-23

With the exception of Nos. 12, 13 and 14 all the drawings in the following section were originally owned by Jack Fuller.

Turner made an oil-painting of Rosehill (Ill.2) and four watercolours (2-5) for Fuller around 1810. The drawings were reproduced as coloured aquatints by J. C. Stadler and these prints were distributed privately. In the following years Turner made a further nine watercolours for Fuller. Around 1815 Fuller agreed to subsidise the engraving of some of them, and in 1820 W. B. Cooke, who had engraved them, published five of the engravings as 'Views in Sussex'. Turner contributed a vignette for the cover (see above). A sequel entitled 'Views at Hastings and its vicinity' was planned to follow, but this was not realised, although three works for it were partially engraved (6, 10 and 12). Turner made two other drawings for this second part (13 and 15). He also made a separate watercolour of Rosehill for Fuller (8).

2 ROSEHILL

39.4 × 56.5cm (15½ × 22¼ in) 1810

For the first of Jack Fuller's drawings Turner quite naturally took as his subject the fine view from the rear of Rosehill house itself. In the distance is Beachy Head with Martello towers ranged along Pevensey Bay on the left. On the right is the Rotunda designed for Fuller by Sir Robert Smirke, the architect of the British Museum. Turner expresses the simple beauty of the landscape and the labourers scarcely intrude on the peace of the afternoon.

This picture was clearly intended to complement the distant view of the house that Turner was making in oils for Fuller at the time (Ill.2, p. 6). In all four of the 1810 drawings the range of colours is more limited than it is in the subsequent aquatints

made from them. The prints are richer in colour and cooler in tone, employing greens and blues in place of the hot earth colours apparent in the drawings. Turner must have taken the opportunity to change their colour and widen their tonal range when they were reproduced.[4] The later drawings made for Fuller also display an enhanced colour range.

3 ASHBURNHAM

36.2 × 55cm (14¼ × 21⅖ in) 1810
Signed

Ashburnham Place was the country seat of the Ashburnham family (they were Fuller's next-door-neighbours) and Turner later drew the mansion from the hillside that appears beyond it (*The Vale of Ashburnham*, 11). A carriage and horses are drawn up before the house where some canopies are pulled down to keep out the afternoon sunlight. To the left is the Perpendicular tower of St. Peter's Church. A small expanse of Broad Water can be seen in front. On the distant skyline at the extreme left is a tiny point of light which represents Brightling Observatory on Jack Fuller's estate (it is much clearer in the aquatint). This was also to be the subject of a later picture by Turner (97). Rosehill itself is located to the right, behind the rainbow.

4 BEAUPORT

37.8 × 54.6cm (14⁹⁄₁₀ × 21½ in) 1810
Signed

Beauport House was built by General James Murray who named it after Beauport in Canada. Murray had been Governor of the colony between 1763 and 1767. The house was destroyed by fire in 1923, was rebuilt and is now an hotel. Although this picture has in recent years been known[5] as *Beauport, near Bexhill* the original title of the work was simply *Beauport*. In fact the property is on the outskirts of Hastings and is immediately

adjacent to Crowhurst Park (see *Pevensey Bay, from Crowhurst Park, 7*).

In the distance the coastline stretches around to Dungeness. In the foreground a traveller has just missed the Hastings coach.

5 BATTLE ABBEY

37.5 × 55.2cm (14¾ × 21¾in) 1810

Like the later picture (96) of the same subject made for Jack Fuller this drawing operates on both naturalistic and symbolic levels.

In the distance is Battle Abbey which was built by William the Conqueror on the site of the battle of Hastings to celebrate his victory there. In the foreground Turner creates a mood of aggression that suitably evokes the conflict by depicting boys stoning an adder. Midway between them is a tree-trunk whose circular, flat top resembles the pupil and iris of an eye. On the right is an oak sapling whose divided boughs also form the shape of an arrowhead. In addition Turner shows the snake slithering up the bank towards two rabbit burrows which are placed in a manner reminiscent of a pair of eyes and it will presumably disappear into one of the burrows. These are clearly all allusions to the fact that during the battle of Hastings King Harold was killed by an arrow piercing his eye.

The drawing shares the brown-blue bias typical of the other 1810 watercolours. The sky is handled with great freedom and Turner clearly worked his blues on to very damp paper. The oak appears to be an afterthought judging from its transparency. The detailing of the bank of the road is very fine and one can easily identify foxglove and yarrow among the wayside plants.

6 HURSTMONCEUX CASTLE, SUSSEX

38.1 × 55.9cm (15 × 22in) *c.*1812
Signed

It can reasonably be assumed that Turner kept in touch with Jack Fuller between 1810 and 1815

when he is known to have visited Rosehill again. Doubtless during this time Fuller added to his collection of drawings by Turner. These would have been worked up from the 1810 sketches (see Concordance). This watercolour is clearly such a picture for it seems more sophisticated than the 1810 drawings and may date from around 1812. Although it has recently been stated[6] that Turner dated the work *1817*, this is not the case and it merely bears the inscription *J.M.W. Turner RA.*

Hurstmonceux Castle was built in the fifteenth century and it now houses the Royal Greenwich Observatory. When Turner sketched the building in 1810 it was uninhabited, the interior having been entirely gutted by its owner in 1777 (it was restored in 1913). The castle stands about six miles from Rosehill. Turner draws the architecture with his customary fluency. The low-keyed approach to its setting is encountered in other topographical drawings and paintings of this period. Green is used here with great freshness and originality and the area of early morning mist in the distance on the right is conveyed with special subtlety.

7 PEVENSEY BAY, FROM CROWHURST PARK

36.9 × 55.9cm (14½ × 22in) *c.*1813

Like *Hurstmonceux Castle* (6) this drawing seems to have been made between 1810 and 1815. The increased richness of colour, quality of line and amount of detailing suggest that it dates from around 1813.

Crowhurst Park was the residence of Henry Pelham, the Crown Commissioner of Customs. Jack Fuller and Pelham were close neighbours and Fuller owned considerable property in the vicinity of Crowhurst Park. The house itself can be seen on the extreme left. Bexhill stands on the hillside beyond the central coppice of ash trees and a great number of Martello towers are dotted around Pevensey bay towards Beachy Head.

The summer morning sunlight is strong and warm and Turner underlines the sense of repose by making all the sheep recline in the heat. The

abandoned agricultural implements also add to this mood of tranquillity; doubtless the men have gone to their breakfast.

8 ROSEHILL, SUSSEX

37.9 × 55.6cm (14 9/10 × 21 9/10 in) *c.*1815

Rosehill (now known as Brightling Park) was built by Jack Fuller's great-uncle who named it after his wife's home at Rose Hill, Jamaica. It dates from the end of the seventeenth century and was extensively altered in the intervening years.

It seems natural that Jack Fuller should have wanted a view of his residence to augment the various depictions Turner was making for him of the houses, estates and castles in Sussex belonging to his neighbours and acquaintances. Indeed, in 1810 Turner had already painted Rosehill from a distance (Ill.2, p.6) so perhaps this unassuming architectural elevation was required to supply the close detail missing from that view.[7]

9 THE VALE OF HEATHFIELD

37.9 × 56.2cm (14 9/10 × 22 1/12 in) *c.*1815

By the mid-1810s Turner had invested the traditional country-house view with great sophistication through his gift for composition, his mastery of colour and his ability to express the character of a place. In this splendid drawing the spectator looks across Heathfield Park towards Heathfield Church, the Heathfield-to-Hailsham road and Beachy Head in the distance.

Heathfield House and Park were renowned in Turner's time as the former property of George Augustus Elliot (a distant relative of Jack Fuller's)[8] whose heroic defence of Gibraltar during the Spanish siege of 1779-82 had led to his enoblement as Lord Heathfield[9] in 1787. In his memory the subsequent owner of the property built the tower on the hillside at the extreme right.

Turner based this work upon a detailed pencil-study on pages 41a-42 of the 'Vale of Heathfield' Sketchbook (TBcxxxvii). The drawing follows

the study as far as topographical accuracy is concerned, but Turner has invested the scene with a wealth of tone and colour contrasts, particularly by using the passing shadows of the clouds to lend a rich variety of underlying rhythms to the landscape. The emphasis of the circular line of the wall around the estate lends unity to the composition, and the house and the considerably heightened Gibraltar tower act as the work's two principal focal points.

The richness of the cultivated estate is clearly contrasted with the empty heath and wild heath-plants in the foreground. Here Turner introduces the only occupants of the whole vista. As Reinagle commented in the letterpress accompanying the engraving of this work 'the rabbits mark the quiet of the scene, and express a wildness scarcely anything else could so well represent'.

10 BODIHAM CASTLE, SUSSEX

38.1 × 55.9cm (15 × 22in) *c.1816*

Bodiam Castle is situated about six miles from Rosehill and dates from 1385. Jack Fuller was to buy the property in 1828 to prevent its demolition and it was finally restored in 1919.

Turner here views the building from across the river Rother. On the left is the Red Lion inn (now The Castle) which dates from the fifteenth century. Some women are drying the washing in the sun. Note how Turner makes the gate-post to the right of the bridge repeat the curved line of the timber bridge-supports. The drawing has a wonderful richness of tone and colour and the distant castle seems dream-like in the early morning haze.

11 THE VALE OF ASHBURNHAM

37.9 × 56.3cm (14⁹⁄₁₀ × 22⅕in) 1816
Signed and dated

This drawing epitomises Turner's genius for organising a picture around his knowledge of the history and social background of a locale. In the far distance are the Martello towers running around Pevensey Bay to Beachy Head. In front of them is Ashburnham Place, the ancestral home of the Ashburnham family. They were extensively engaged in the manufacture of iron. In the absence of coal, iron-smelting required a great deal of charcoal to fuel the furnaces and like other important ironmasters (including the Fullers) the Ashburnhams had been responsible for the destruction of vast expanses of East Sussex woodland, especially during the Napoleonic wars when there was a high demand for the metal.

Turner frames Ashburnham Place with the industry that helped create the family's wealth. Just behind the trees on the right was Ashburnham Forge, the actual site of the iron-smelting works. A strong compositional line runs from the ash trees through the felled timber in the centre to the men loading the wood onto a cart at the left. It continues in the pall of smoke that may issue from a charcoal-burners' fire in the forest beyond them and arrives at the great house itself.

12 WINCHELSEA, SUSSEX, AND THE MILITARY CANAL

12.7 × 20.3cm (5 × 8in) *c.1817*

Unlike *Hurstmonceux Castle* (6) and *Bodiham Castle* (10) which were also intended for the sequel to the 'Views in Sussex', this watercolour was not owned by Jack Fuller and its dimensions greatly differ from those of his other drawings. The size and subject suggest that it was originally made for the 'Southern Coast' series and diverted to this project by W. B. Cooke who was responsible for engraving it. The engraving was never completed.

The picture looks along the Royal Military Road that links Rye to Winchelsea. This road was built between 1804-9 as part of a twenty-eight mile long, military defence system running around Romney Marsh. A larger part of the fortification is a canal constructed at the same time as the road. Along this stretch, however, the Brede river was used as a barrier in place of the canal. The river can be seen on the left. The canal on the right is completely fictitious and the work's title is therefore topographically erroneous.[10] In the far distance on the left are several Martello towers and rain passes away on the right.

Turner visited the area during the Napoleonic wars (between 1805-7) and he probably saw the road under construction. He certainly witnessed large numbers of soldiers there, for the association of the army with Winchelsea remained in his memory. Soldiers appear in two *Liber Studiorum* views of the town, and the baggage train and marching column again reappear in the later 'England and Wales' view[11] of the road leading up to the Strand gate from exactly the same position. That drawing is more elemental, Turner using a stormy sky to evoke the mood of war. Here, however, the approach is freshly naturalistic and Turner captures the early morning light to perfection.

13 HASTINGS FROM THE SEA

39.8 × 59.1cm (15 × 23¼in) 1818
Signed and dated

This picture was completed[12] around July-August 1818. In recent years it has been known as *Hastings: deep-sea fishing*,[13] a spurious title that ignores Turner's own name for the work which is given above. The correct title was appended to the drawing when it was exhibited[14] at W. B. Cooke's Gallery in 1822. On that occasion Cooke announced his intention to engrave the picture in the sequel to the 'Views in Sussex' ('Views at Hastings and its vicinity') and he re-stated that aim in his 1824 exhibition catalogue. However, he never published the engraving. This failure may have been due to the subsequent financial failure of the Sussex project, the fact that he was already over-burdened with work or simply because he delayed engraving it for far too long and was unable to do so after he and Turner broke off relations in 1827. In any event the drawing subsequently passed to Gambart who had it engraved[15] by Robert Wallis in 1851. Turner approved that engraving but he died before he was

able to 'touch' the proofs.

The inclusion of 'deep-sea fishing' in the title is also factually inaccurate. The work clearly depicts inshore fishing and in any case the waters around Hastings are technically considered shallow. At no point are they more than twenty fathoms deep. Moreover, none of the fishing boats depicted are large enough to carry deep-sea tackle.

The work is an intricately structured and well-observed study of Hastings, containing a wealth of foreground incident. Over a figure-of-eight pattern Turner counterpoints a series of shallow V-lines. The tip of the predominant line meets at the helmsman of the boat in the foreground and beyond him these lines are repeated by those of the hills which seem to recede infinitely into the distance.

From left to right we see a pall of smoke which indicates the strong westerly wind; a cutter with his sails 'goose-winged', sailing straight down the wind; a fishing smack at work; and in the centre a yawl[16] which has just arrived on the scene. The crew have dropped its head and boom-masts, the top and bottom masts of the mainsail. The falling sail can be seen at the base of the mast. The fishermen are about to tie up at a buoy in order to begin fishing and at the prow a man prepares to grab the buoy with a grappling hook. A rope is ready (in the water) to make fast with to the buoy. The helmsman is bringing the boat round into the wind and when she is secured to the buoy another man in the bow will drop the anchor.

Beyond the yawl a hoy is fast approaching, tacking into the wind. Its shape acts as the keystone of the picture's architecture. To the right of the yawl is another smack, with lowered masts, in which men are busy fishing. Beyond it a brig is exchanging cargo with smaller boats as it is unable to berth closer inshore. Finally, immediately below the brig, a seagull is poised above a piece of jetsam. Their juxtaposition exactly balances the grappling hook poised to catch the buoy on the left.

The distant landscape is ethereal and brilliant. As usual Turner gives his cliffs a sense of alpine scale. Turner made two colour studies for this

work (see Concordance) and in 1835 he exhibited a similar oil-painting entitled *Line-fishing, off Hastings* at the Royal Academy.

14 ERIDGE CASTLE, EAST SUSSEX

36.9 × 54.3cm (14½ × 21⅓in) *c.*1815-20

Although this drawing was not bought by Jack Fuller it may have been intended for him. Its size is the same as the other east Sussex drawings he commissioned and its dating strengthens this assumption. Moreover, Jack Fuller was a friend of the owner of Eridge Castle, the Earl of Abergavenny. Like Fuller he was one of the principal landowners in the county.

Eridge Castle was, in reality, a house which dated from before Elizabethan times. By the end of the eighteenth century it had fallen into considerable disrepair and was eventually used as a farmhouse. When Abergavenny took it over in 1787 he spent a fortune rebuilding the property in the fashionable Gothic style. It was reputed to embody the worst possible taste and was demolished in 1939.

In the foreground a shepherdess picks herself up from the ground. This may be an allusion to the restoration of Eridge Castle, a fact surely known to Turner. The light is hot and brilliant and the sense of distance particularly well suggested.

15 PEVENSEY CASTLE, SUSSEX

37.5 × 55.9cm (14¾ × 22in) *c.*1820-3

Pevensey Castle was built by the Normans inside the walls of a Roman fortress dating from the third century A.D.

Turner commands a range and control of tone that is extraordinary. The immense delicacy towards the distance gives the castle a visionary appearance that is reminiscent of the 1832-3 drawing of *Kidwelly Castle* in the 'England and Wales' series.[17] The building to the left of the castle subtly modulates the otherwise enveloping light

tone of the distance. The sense of ethereal radiance is heightened by the extreme contrast provided by the blackness of the cow on the right.

In the front of the picture some men are dipping sheep and Turner captures the exact stance of the animals as they shake themselves dry. The fine focus of the foreground detail again adds to the great depth of the work. The qualities of form and colour suggest that the picture dates from later than any of Fuller's other Turner drawings.

The watercolour was exhibited in the 1823 Cooke Gallery exhibition. The catalogue (No. 15) tells us that the work was 'Now being engraved for the Views in [sic] Hastings and its vicinity' but there is no indication that Cooke ever actually began engraving the work.

'The Rivers of Devon'

W. B. Cooke advertised this work in 1818 but it never appeared. Turner made four watercolours for the series (16, 17 and 98, 99) and another Devon river scene may be connected with the scheme (18). Only three engravings of these works were published in Turner's lifetime.

16 IVY BRIDGE, DEVONSHIRE

28 × 40.9cm (11¼ × 16 1/10 in) *c.*1813
 TBCCVIII-X

In 1811 Turner visited Ivybridge, a small town about nine miles east of Plymouth. He subsequently exhibited a view of Ivybridge Mill at the Royal Academy in 1812. He went there again in 1813 and this watercolour grew out of sketches made on that second visit (see Concordance).

The drawing exemplifies Turner's ability to differentiate large masses of foliage with complete clarity. The river Erme flows gently over the rocks beyond the bridge and then eddies slowly to the foreground. Only the figure running across Ivy bridge to catch the waiting Plymouth coach imparts a touch of urgency to the otherwise peaceful afternoon scene.

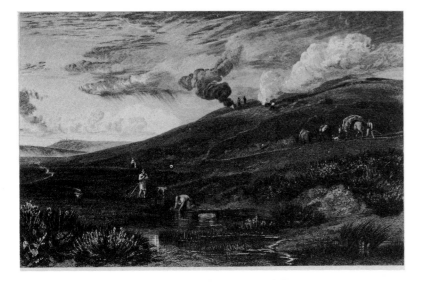

4 Source of the Tamar and Torridge (engraving). The drawing was engraved by W. B. Cooke after 1816, but it remained unpublished until 1850.

17 SOURCE OF THE TAMAR AND TORRIDGE

20 × 31.9cm (7½ × 12⁹⁄₁₆in) *c.1811-3*

The area about four miles south of the Hartland peninsula in north-west Devon forms an important watershed. Three rivers rise from it: the Marsland which runs west; the Tamar which flows south through Devon down to Plymouth; and the Torridge which progresses east and then turns north to enter the sea at Bideford.

Here Turner depicts the source of the latter two rivers. This is at a point about a mile east of the Woolley Barrows, some neolithic grave-mounds which can be seen in the distance on the left (they are emphasized in the engraving, Ill.4). Turner clearly indicates the precise source of the two rivers by depicting a kneeling figure looking into the water. This passage was also strengthened in

the engraving which Turner worked on around 1816, although it was not published until 1850.[18] In it he added another figure standing next to the dog. This man adds to the line that runs through the.rock, the kneeling figure and the woman (and child), leading the eye into the distance. On the hillside two bonfires give off clouds of smoke. Their opposed black and white tones and the different directions taken by these two columns are clearly intended to denote the rising and divergence of the two rivers. The Tamar winds away to the left repeating the course taken by the left-hand pall of smoke. The Torridge passes out of the front of the picture in the direction indicated by the white smoke.

Turner must have visited the spot in 1811. No sketches of it exist but judging from its style the drawing may date from earlier than 1813 which has recently been suggested as a date for the work.[19] This picture especially indicates how freely Turner could use green when necessary. The handling is extremely spontaneous with much evidence of scumbling and extensive scratching and scraping out of the highlights.

18 RIVER TAVEY, DEVONSHIRE

21.7 × 36.7cm (8½ × 14⅖in) *c.1813*

Although there is no known documentary link between this work and 'The Rivers of Devon' series, its size, subject and probable date suggest a relationship.

The title and topographical location of the picture present considerable problems. Ruskin owned the drawing and his first title for it was *Pigs in Sunshine. Scene on the Tavey, Devonshire.* Later he inexplicably altered the name to *Sunshine on the Tamar.* The work has been identified as a scene on that river ever since (both waterways converge above Plymouth). Before Ruskin owned the picture it belonged to the dealer Gambart who had it reproduced as a chromo-lithograph in 1855 and published it as *The banks of the Tavey*

(R.851). That title, and Ruskin's first identification, supports the view that this is the work that was exhibited (under the title given here) in the 1829 Egyptian Hall, Piccadilly exhibition.[20] No other known work by Turner offers itself as a candidate for consideration as that picture.

Turner sketched the scene during his 1813 stay in Plymouth (see Concordance). Attempts to identify the location of the view have not been successful. On the left is a limekiln and, in front of it, some pigs. Ruskin wrote of these animals that Turner '. . . could draw *pigs* better than any other animal . . . Sunshine, and rivers, and sweet hills; yes, and who is there to see or care for them? — only the pigs!'[21] In fact, the pigs seem to take little interest in their lovely surroundings.

'Picturesque Views on the Southern Coast of England' 1811-25

Turner made thirty-nine watercolours for this series between 1811 and 1825. Another drawing (105) made for the *Liber Studiorum* was also engraved for it. The scheme was launched by the brothers William Bernard and George Cooke who originally intended to engrave the entire work themselves but were eventually forced to call in the assistance of other engravers in order to complete it.

19 POOLE, AND DISTANT VIEW OF CORFE CASTLE, DORSETSHIRE

13.9 × 21.9cm (5½ × 8⅗in) *c.1811*

Westward the sands by storms and drift have
 gained
A barrier, and that barrier maintained,
Backed by a sandy heath, whose deep-worn
 road
Deny'd the groaning wagon's ponderous load.
This branches southwards at the point of Thule,
Forms the harbour of the town of Poole.

A little headland on a marshy lake,
Which probably contemptuously was given
That deeps and shallows might for once be
even.
The floating sea-weed to the eye appears,
And, by the waving medium seamen steers.
One straggling street here constitutes a town;
Across the gutter here ship-owners frown,
Jingling their money,—passengers deride,
The consequence of misconceived pride

Turner's letterpress for the
'Southern Coast' engraving[22]

The view is from Canford Heath, above Fleets corner, towards Poole in the distance. The empty bay stretching around to Poole was in fact mostly filled with Pergins Island and Parkstone promontory but Turner worked this picture up from a very meagre sketch (see Concordance) and he greatly altered and simplified the actual topography. The curvature of the bay is exactly repeated by the curve of the road leading down the hill in the foreground. To accentuate the repetition Turner places a distant figure on the bend. Corfe Castle can be seen across Poole harbour with Brownsea Island at the extreme left.

In the foreground the 'groaning wagon' carries its 'ponderous load'. Turner makes the load of timber look extremely like a field-gun. When this work was created the Peninsula War was at its height and such cannons featured prominently in the campaign. In the distance, immediately above the protruding barrel-like trunk is a pall of smoke which augments the association. Turner was fond of using this type of vertical alignment to extend meaning as numerous pictures in this book demonstrate (see 17, 26 or 42 for example). In the foreground on the right a sleeping figure may be intended to suggest the fact that mainland Britain was physically untouched by the war. The figure also stresses the languid afternoon heat. The sky, with its descending beams of light, is extremely similarly rendered in other drawings made of Dorset subjects (*Weymouth*, 20, or *Bow and Arrow Castle*, 29).

20 WEYMOUTH, DORSETSHIRE

14 × 21.3cm (5½ × 8⅖ in) *c.*1811
Signed

By 1811 Weymouth was well-established as a fashionable holiday resort; its long bathing-beaches were considered among the finest in Britain.

In the foreground bathers are being dried with towels while local washerwomen look on. By them are lobster pots which they are using as weights to hold down their washing. The picture sparkles with tiny scratched highlights and the rays of afternoon sunlight are particularly felicitous. The topsail of the cutter passing in front of the Portland peninsula was evidently added as an afterthought. Note how Turner creates a further vertical accent by placing a figure immediately beneath the cutter. They both move in the same direction.

21 LULWORTH COVE, DORSETSHIRE

14.7 × 20.3cm (5¾ × 8in) *c.*1811

This drawing was sold at Christie's on 14 December, 1928. It was bought by Agnew and is now untraced. Fortunately it was reproduced in colour in *The Water-colours of J. M. W. Turner* by W. G. Rawlinson and A. J. Finberg in 1909. That colour reproduction represents the work here.

Lulworth Cove is a natural harbour on the south Dorset coast. Turner noted in a sketchbook[23] that it contained 'water for 80 ton burthen'. It was the property of Thomas Weld who was known to Turner (see *Lulworth Castle*, 33). The view shows St. Albans head in the distance. On the left is a public house and some cottages. Turner was obviously impressed by the silent grandeur of the scene and he emphasizes its lonely, vast scale by only populating it with a few sheep, a couple of seagulls and some tiny fishing boats. The strata of shelly limestone (with their labyrinthine seams of chert) in the foreground afford him the opportunity to create superb complex rhythms. The

most prominent of the seams is vertically aligned both with an outcrop of the Purbeck hills in the distance and with a fissure in the rock beneath it.

22 LYME REGIS, DORSETSHIRE: A SQUALL

15.3 × 21.7cm (6 × 8½ in) *c.*1811

This vigorous drawing perfectly captures the fresh morning light and sudden fierce onset of the squall indicated in the title. The strength of this wind is clearly demonstrated by the angle of the lugger's masts and by the slight sense of alarm manifested by the bathers in front of it.

The view is from Charmouth looking towards Lyme Regis in the distance. To the left of it is the Cobb, a large breakwater that had only been completed in 1795.

The drawing was engraved by W. B. Cooke. He later recorded an extremely illuminating anecdote of Turner's working methods on the engraving (see Ill.5 overleaf).

23 TEIGNMOUTH, DEVONSHIRE

15.1 × 22.2cm (5⁵⁄₁₆ × 8¾ in) *c.*1811
Signed

Turner visited Teignmouth on his 1811 West Country tour and made several sketches of this scene (see Concordance). From them he developed an oil-painting (now at Petworth) as well as this very similar watercolour. Both pictures depict virtually the same effect of dawn sunlight, with boats being dismantled for their timber on the right. In the oil Turner idealized the scene a little and placed a girl herding some cows on the left where we see the fishermen unloading their catch.

Judging from the sketches Turner depicts the scene much as he had originally seen it and the Teign estuary mudflats at low tide are deftly rendered. Two far-off figures act as tiny accents that heighten the effect of distance and their dark

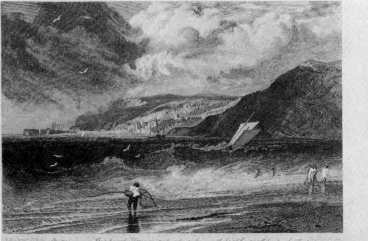

tones also increase the brilliance of the light by contrast. When the work was engraved Turner deprecated George Cooke's rendition of these figures as 'One . . . too much a Falstaff, the other Master Slender'.[24] They were adjusted accordingly.

24 THE MEW STONE AT THE ENTRANCE OF PLYMOUTH SOUND

15.6 × 23.7cm (6⅛ × 9½in) *c.1814*

In the . . . 'Mewstone' there were some strange, weird clouds introduced, which had a demoniacal air about them; insomuch that Mr. Stokes [the owner of the drawing] was struck by them, and asked Turner if he did not mean them for the demons and angels of the storm. Turner confessed the intention.

 W. Thornbury, *Life of Turner* 1877 ed.,p.541

The Great Mew Stone (named after the seagulls

5 *Touched proof of the engraving by W. B. Cooke of* **Lyme Regis, Dorsetshire.** *In the margin Cooke has written 'On receiving this proof Turner expressed himself highly gratified—he took a piece of <u>white</u> chalk and a piece of <u>black</u> giving me the option as to which he should touch it with. I chose the white,—he then threw the black chalk to some distance from him. When done, I requested he would touch another proof in <u>black</u>.— 'No', said he, 'you have had your choice and must abide by it'—how much the comparison would have gratified the admirers of the genius of this <u>great and extraordinary Artist.</u> W.B.C. Touched by Turner 1814 WBC.*

which inhabit it) stands at the eastern entrance to Plymouth Sound. Turner would have sailed directly past it on his 1813 trip to Burgh Island (see p.7). Although distant sketches of it do exist, Turner more probably elaborated the watercolour from his memory of it on that outing.

The drawing has a magnificent tonal range. Immediately above the rock are the wisps of cloud that so reminded Stokes of 'angels'. Turner completely captures the racing movement of both the clouds and the tide. The small merchantman is in no danger though. He has reefed his topsails in order to lower his centre of gravity in the strong wind, and is sailing into the calmer waters of the Sound.

25 FALMOUTH HARBOUR, CORNWALL

15.2 × 22.9cm (6 × 9in) *c.1812-3*

Falmouth harbour is filled with both civilian and military shipping, a reminder of the war still in progress when this work was made. In the centre, across Carrick Roads, is Pendennis Castle with St. Mawes in the distance on the left. In the foreground sailors and their women celebrate a rare spell of shore leave by holding a drunken debauch. The music is provided by a peg-legged fiddler. On the right a smoking chimney repeats and amplifies the shape of various bottles, a shape that has sexual connotations of which Turner seems totally aware.

26 PLYMOUTH DOCK, FROM NEAR MOUNT EDGECUMBE

15.6 × 24.1cm (6⅛ × 9½in) *c.1813*
Signed

Plymouth Dock was the largest town in Devon at the time of this drawing. In 1823 the inhabitants petitioned George IV for the town to be separately established from adjacent Plymouth. It was renamed Devonport in 1824.

We look north-eastwards from the entrance of Mount Edgcumbe Park on the right. Mount Wise and Plymouth Dock can be seen across the intervening channel. In the dockyard are numerous ships, hulls under construction and sheer-hulks. A mass of shipping is lying in the major fleet anchorage of the Hamoaze. On the left is the village of Torpoint and beyond it Saltash in the distance. Almost imperceptible in the plate is Bren Tor, on Dartmoor, some nineteen miles away (but see Ill.6). Turner vertically aligns the Tor with the tower of the parish church of Stoke Damerel, a

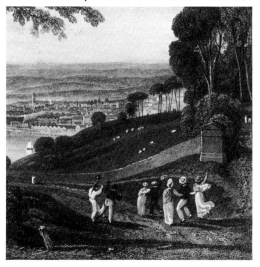

6 *Engraving by W. B. Cooke of* **Plymouth Dock** *(detail). The vertical alignment with Bren Tor is visible.*

small boat's sails, a figure on the road and a stake in the foreground.

Cyrus Redding recorded that Turner told him that

he had never seen so many natural beauties in so limited an extent of country as he saw in the vicinity of Plymouth. Some of the scenes hardly appeared to belong to this island. Mount Edgecumbe particularly delighted him; and he visited it three or four times.[25]

Redding also tells of a picnic in Mount Edgcumbe Park to which Turner treated his friends in 1813:

There were eight or nine of the party, including some ladies. We repaired to the heights of Mount Edgcumbe at the appointed hour. Turner, with an ample supply of cold meats, shell-fish, and wines, was there before us. In that delightful spot we spent the best part of a beautiful summer's day. Never was there more social pleasure partaken by any party in that English Eden. Turner was exceedingly agreeable . . . The wine circulated freely, and the remembrance was not obliterated from Turner's mind long years afterwards.[26]

Here Turner has replaced his friends with some sailors and their women. They are accompanied by a fiddler with a peg-leg and are waving to a couple making their way up the drive on the right. The carousing men and women seem well-matched by the equally rhythmic and lively beech trees. In the engraving Turner made some adjustments to the image, giving a somewhat bawdier clarity to the waving gestures of the figures (see Ill.6).

27 PLYMOUTH, WITH MOUNT BATTEN

14.6 × 23.5cm (5¾ × 9¼ in) c.1814

This peaceful harbour scene depicts the view across Cattewater from Turnchapel. In the distance is the huge citadel, to the right Plymouth itself and on the left the small fort on Mount Batten point.

In the foreground Turner exemplifies both the peaceful and military associations of the town. Some women seem to be discussing the quality of the corn while a marine and a sailor recline nearby in the hot afternoon sunshine. The standing woman reinforces the pictorial emphasis of the fort above her. For an extremely dissimilar rendering of the same view see *Plymouth* (78).

28 PENDENNIS CASTLE, CORNWALL; SCENE AFTER A WRECK

15.5 × 23.5cm (6⅛ × 9¼ in) c.1816

The view is from Pennance Point looking across Falmouth Bay towards Pendennis Castle. This was erected by Henry VIII as part of a chain of fortifications to deter French invasion. It dominates the Fal estuary and appears elsewhere in this book (25, 39 and 80).

The drawing is an immensely rich and vigorous morning scene. The reds, pinks and golds of the foreground effectively throw back the cooler tones of the distance. Turner admirably suggests the fresh wind blowing off the sea.

29 BOW AND ARROW CASTLE, ISLAND OF PORTLAND

15.2 × 23cm (6 × 9in) c.1815

Beyond the twelfth-century Rufus Castle the cliffs stretch southwards towards Portland Bill. The castle received its nickname from its windows designed for archers. Most of the castle has now fallen into the sea and this process of erosion is clearly visible in Turner's picture.

The foreground is filled with quarrymen at work. Portland is famous for its excellent white limestone and the small peninsula is covered with such quarries. The hot morning sunlight filters down through the clouds in a way reminiscent of Turner's earlier drawing of nearby Weymouth (20).

30 EAST AND WEST LOOE, CORNWALL

15.9 × 24.1cm (6¼ × 9½ in) c.1815

Unfortunately this watercolour is badly faded owing to prolonged exposure to light. The areas where Turner used indigo to supply his dark tones, as in the rain-cloud at the top right-hand corner, now appear almost completely white. Turner only realised the dangers of using indigo relatively late in his career, but provided the drawings are sheltered from strong light fading can be avoided.

The view is from the hillside above East Looe. On the right is the narrow thirteen-arched bridge which linked the two halves of the town. The bridge was built in 1418 and demolished in 1853. In the distance the coast stretches around to Hannafore Point.

The tone of the picture suggests the dazzling light of Turner's later works, though of course this effect was unintentional.

31 TINTAGEL CASTLE, CORNWALL

15.6 × 23.7cm (6⅐ × 9⅓ in) c.1815

The site of Tintagel Castle was inhabited by monks before A.D.500 and the castle dates from the twelfth century. Turner's watercolour takes a relatively subdued approach to the subject (the 1818 engraving[27] is an altogether more spectacular affair with a heightened rhythmic pulse and greater tonal variety used to enhance the sense of drama).

A fine flowing line defines the edges of the cliffs. Turner contrasts their monumental scale with his foreground figuration. Slate is being stacked in preparation for shipping. On the projecting wooden stage a boat is about to be lowered by a pulley controlled by the capstan on the left.[28] Turner vertically aligns this capstan with the lowest point of the edge of the rock-face beyond.

32 BRIDPORT, DORSETSHIRE

15.2 × 23.5cm (6 × 9¼in) *c.*1813-7

In Turner's time Bridport was famous for rope. It virtually monopolised the supply of cordage to the navy and parts of the town were even laid out to facilitate rope-making. Turner was undoubtedly aware of this and shows the rope being used by men warping a brig into the harbour. In the poetic letterpress which he originally wrote to accompany the engraving, he wrote:

> . . . the low-sunk town
> Whose trade has flourished from early time
> Remarkable for thread called Bridport twine.[29]

When the work was engraved Turner added a figure running along the beach at the extreme left. Although this drawing has recently[30] been dated *circa* 1820 it was with W. B. Cooke in July 1817 and its inclusion in Turner's letterpress (written to accompany the first parts of the 'Southern Coast' to appear in 1814) suggests that it may date from even earlier. Unfortunately, large areas of the sea and sky in this picture have faded owing to exposure to strong light and this may have been exaggerated by the use of indigo which is notorious for swift fading. A measure of how much has been lost can be seen in the strips on the edges where the drawing was covered by the frame.

33 LULWORTH CASTLE, DORSETSHIRE

15.5 × 23.5cm (6¹⁄₁₀ × 9¼in) *c.*1820

Turner visited Lulworth Castle and cove (see *Lulworth Cove,* 21) in 1811. They were owned by a prominent Roman Catholic, Thomas Weld, to whom Turner had dedicated an engraving[31] of Stonyhurst College, Lancashire in 1801 (Weld had recently given Stonyhurst to the Jesuits to found a seminary). Nine years after making this drawing Turner was to depict the college in an elaborate allegory of Roman Catholic emancipation in the 'England and Wales' series.[32]

In the foreground a shoeless itinerant ostensibly[33] asks the way of a fishing yokel. In the distance is the castle which was built in 1608 and destroyed in 1929. To the left is the village of East Lulworth and beyond it the Purbeck hills. Golden morning light fills the work with a wealth of brilliant colours. Turner's mixing of gum with his pigment is evident in the water-lilies on the stream and scraping-out is apparent throughout the foliage.

34 TORBAY, SEEN FROM BRIXHAM, DEVONSHIRE

15.8 × 24cm (6³⁄₁₆ × 9⁵⁄₁₆in) *c.*1816-7

Throughout the nineteenth-century Brixham was considered the mother port of channel-trawling. A typical Brixham Mumble-Bee (a ketch-rigged trawler) can be seen docked at the quayside immediately above the two women in the centre.

In this brilliant dawn scene we look north-west towards Paignton and Torquay across Torbay. The sun is therefore rising in the north. Turner had to compress a wide vista into a narrow space, and to do so was obliged to distort the topography of the scene, which included moving the sun to the left. The work is based on a sketch on page 48 of the 1811 'Corfe to Dartmouth' Sketchbook (TBcxxiv). This sketch contains much of the detail shown here, excluding the figures, but it contains no indications of lighting.

In the foreground a seated man waves at some nearby women folding washing. The phallic shape formed by the man's arm and hat recurs in other works[34] by Turner in a more bawdy context (see *Plymouth Dock,*26).

35 MINEHEAD, SOMERSETSHIRE

15.2 × 22.2cm (6 × 8¾in) *c.*1818

This view of Blue Anchor Bay takes in Dunster Castle in the centre and Minehead on the right. Above Minehead looms the vast bulk of Porlock hill.

In the foreground is the Blue Anchor Inn, a farmhouse inn which had stood on this spot for more than 200 years (its successor is still in existence today.) Immediately in front of the inn sign rest some travellers. The late afternoon sun casts long shadows and the whole work is filled with a spirit of repose.

The engraving of this watercolour was published under the title *Minehead and Dunster Castle, Somersetshire* in January 1821. The original drawing has recently[35] been dated *circa* 1820 but it was with W. B. Cooke in July 1818 and a note on page 35a of the 'Hints River' Sketchbook of 1818 (TB cxli) also suggests it was made in that year.

36 MARGATE, KENT

15.5 × 23.6cm (6¹⁄₁₀ × 9³⁄₁₀in) *c.*1822

Turner may have known Margate since childhood as he probably went to school there: his first drawings of it date from his tenth year. Throughout his life he demonstrated his fondness for the place by returning there and he painted it numerous times.

We see the town across a foreshore dramatically filled with figures salvaging wreckage and in the shallows a beached merchant-brig is exchanging cargo. The calm sea and soft evening light form a complete contrast beyond. Several bathing machines can be seen in the harbour.

The hillside is dominated by a curious structure. This was Hooper's Mill, a windmill that was built under Royal patent. Its horizontal sweeps were controlled by a system of vertical shutters. It was recorded as being in operation in 1825 but soon afterwards it was badly damaged in a severe gale and subsequently demolished. It may appear in another watercolour of Margate (75) dating from 1826-7. Recognition of this building clearly supports the suggestion put forward by Andrew Wilton[36] that a painting now in the Tate Gallery (at

present entitled *Harbour Scene, possibly Margate)* is indeed a view of Margate. Hooper's Mill is clearly identifiable in the picture, silhouetted by the setting sun. It can also be seen in an 1808 painting of Margate whose identification has been equally problematic.[37]

37 RYE, SUSSEX

14.5 × 22.7cm (5⁷⁄₁₀ × 8⁹⁄₁₀in) *c.*1823

In this magnificent drawing Turner depicts the Royal Military Road that connects Winchelsea with Rye across the salt-marshes. Turner probably witnessed the road being made sometime between 1805-7 (see *Winchelsea,* 12). He again sketched Rye around 1815 but from much closer than it appears here. From those sketches he made an elaborate watercolour now in a private collection in Canada.[38]

This work is an entirely imaginative construction of the scene. Turner has moved Camber Castle (seen to the right of the town in the distance) about three miles from its correct location. He has also taken topographical liberties with the river Brede. In reality it runs parallel with the road. Here it has disappeared and been replaced by a flood-tide surging under a bridge that does not exist. Turner probably created this dramatic event to stress his awareness of the historic vulnerability of Rye to such flooding. A sense of panic fills the foreground and is heightened by the linear convolutions of the inrushing sea.

38 CLOVELLY BAY, DEVONSHIRE

14.7 × 22.6cm (5³⁄₄ × 8⁹⁄₁₀in) *c.*1823

The view is from the village of Buck's Mills looking towards Clovelly and Hartland Point across the bay. Lundy Island can be seen in the far distance on the right.

In the foreground herring fishing-boats are drawn up on the semi-circular Gore, a spit of rock running out from Quay point. Near them is a pool that may have been artificially constructed for salting the fish. Also to be seen are limekilns which processed limestone brought from Pembrokeshire (the lime was employed to neutralise acids in the local soil). Making their way up the steep hillside are donkeys whose panniers would probably have been filled with seaweed. This was also widely used as compost in the area.

The gold to deep-blue colour range conveys the oppressive afternoon heat well. The packed forms of the rocky cliff are matched by masses of gathering storm-clouds.

39 ST. MAWES, CORNWALL

14.1 × 21.7cm (5⁹⁄₁₆ × 8⁹⁄₁₆in) *c.*1822
Signed

Turner was very attracted to this view: in addition to making it the subject of a painting exhibited at the Royal Academy in 1812 he later[39] drew it in watercolour for the 'England and Wales' series sometime between 1825 and 1829.

In the distance, across Carrick Roads, is Pendennis Castle which appears several times in this book (25, 28 and 80). On this side of the Fal estuary is St. Mawes Castle, built by Henry VIII in 1543. The foreground is filled with figures pulling their nets ashore, buying fish or shovelling pilchards landed from the smack on the left. A number of red shirts set off the blues, whites and ochres distributed across the picture. Turner's depiction of early morning sunlight accurately captures the moist haze and rising temperature.

40 HYTHE, KENT

14 × 22.9cm (5½ × 9in) *c.*1823

Hythe is seen here from the Ashford road with St. Leonard's church in the distance. In front of the

town is the Royal Staff Corps barracks, built between 1808-10 (note the soldiers on parade). This was the main depot of the Royal Waggon Train, a corps that serviced the Royal Military Canal, seen under the oak tree in the centre. The canal was an extensive fortification built during the Napoleonic wars to defend Romney Marsh against French invasion. Turner suitably juxtaposes a cannon with the canal and a sentry points along more coastline that the army is marching off to defend. The oak tree also extends the protection of its shade.

The military usefulness of the canal was debatable. William Cobbett visited it at about the time this drawing was made and remarked:

as if those armies who had often crossed the Rhine, and the Danube, were to be kept back by a canal, made by Pitt, thirty feet wide at the most![40]

41 COMB MARTIN

14.6 × 23.3cm (5³⁄₄ × 9⅛in) *c.*1824

Turner here depicts the view along Combe Martin Bay towards the Burrow Nose in the distance. The time is early morning. In the foreground women lay out washing to dry on a limekiln while a man pitchforks laver (an edible marine algae eaten locally) into panniers on the donkeys.

Turner subtly creates a series of circles running right across the picture, from the wagon-wheel on the left, to the linen-basket on the right. These rounded lines are often repeated or reversed in vertical alignments. When the drawing was engraved[41] Turner added a small fishing smack to the distance and some masts on the right. Unfortunately, judging from the engraving, important features of the work are masked by the picture mount (which it was impossible to remove for photography): a man standing at the extreme left edge, and a washerwoman on the extreme right, have almost completely disappeared.

Although Turner has written the name of the

place in the picture, the work was not exhibited during his lifetime and the only authentic spelling of the title must therefore be taken from the engraving. In fact Turner has written *Coobe Martin* on the stern of the boat.

42 PORTSMOUTH, HAMPSHIRE

15.2 × 21.8cm (6 × 9in) *c.*1824

Turner also depicted this exact view in 'The Ports of England' (74) and 'England and Wales' series.[42] In all of these treatments of the subject he emphasizes the windy character of the place.

On the left two frigates are anchored off Gosport blockhouse. The harbour beyond is filled with ships; a 'first-rate' man-of-war is prominent among them. On the right is Portsmouth itself with a Royal Navy longboat passing in front of the towers of Burridge's Folly and the Admiralty semaphore. Turner's watercolour also includes the cathedral (behind the longboat) but this is now completely obscured by the picture's frame and is not apparent in the reproduction.

In the sky is a massive cumulus cloud. Its circular forms are repeated by the round buoy immediately below it. Another vertical alignment is effected in the centre. In the far distance is the tower of the Dockyard semaphore. This controlled the entrance of ships to the harbour by means of signals. Underneath it Turner puts a naval officer waving his orders to the men lowering the sail of his gig and exactly below him is the rudder of the gig in the foreground. In this way the theme of naval control is repeated three times in one concise line.

43 BOSCASTLE, CORNWALL

14.2 × 23.1cm (5⅗ × 9 1/10 in) *c.*1824

In Turner's time Boscastle was a small but important trading port. Owing to a strong tidal flow, passage into its harbour was extremely dangerous in stormy weather and all large ships entering had to have their impetus controlled by restraining hawsers. Here we see these lines attached to a partially dismasted brig as it passes through the inlet under Willapark point (up on the left). Turner emphazises the check on its motion by placing a small boat immediately under its bow. On the right a mother and child play with a hoop whose circular shape repeats that of the mooring-ring on the pier immediately beneath it. Turner often used such hoops (and mothers and children playing) to symbolize happy states of mind. Here they are obviously included to pinpoint the sense of security afforded by the harbour and the mooring to the damaged ship.

Ruskin thought this[43] one of the finest water-colours in the 'Southern Coast' series. The strong afternoon light creates a superb richness of colour. In the harbour the tide whips up the waves and the whole drawing is charged with energy. Turner repeats the curves of the boats and the quay on the left in the lines that lead the eye up to the climactic heights of Botreaux castle on the right.

44 FOLKESTONE, KENT

15 × 24.2cm (5 9/10 × 9½in) *c.*1822

In the early nineteenth century Folkestone was notorious for smuggling and areas of the town were honeycombed with secret passages to facilitate the activity. Turner visited the place in 1821 and may then have even gone out with the smugglers at night. He eventually made four drawings that portray various stages of smuggling operations and they all show a surprisingly intimate knowledge of the techniques employed. Two more of these drawings are reproduced in this book (66 and 116) and the other was made for the later 'England and Wales' series.[44]

In the foreground the smugglers have run in and hauled their kegs of spirits up the cliffs. They are burying them for dispersal later. One of the smugglers covers his face with his arm, a gesture that suggests both his understandable desire for anonymity and also his tiredness from having hauled the kegs up the cliffs after being up all night.

Along the Lees in the distance is the church of St. Mary and St. Eanswythe, called 'Hurricane House' locally owing to its exposed position; below it is the Stade or harbour. The cliffs recede along the coast to Dover. The morning light is soft but warm and the regular motion of the waves creates a strong series of rhythmic repetitions.

45 DEAL, KENT

13.5 × 24.1cm (6 × 9½in) *c.*1825

Here Turner depicts Deal beach with the Royal Hotel to the left of centre. In the far distance is Sandown Castle, now destroyed by the erosion of the sea. Along the beach are the signals-flags that appear in the later drawing of Deal (76) in the 'Ports' series. In the centre some men prepare to fire the minute-gun into the strong north-easterly wind.

Deal is situated near the Goodwin Sands, an area of the English channel that is especially hazardous to shipping. This danger presented the local inhabitants with a flourishing source of income. The town was particularly renowned for its hovellers, Deal lugger crews of up to ten men whose livelihood depended on salvage on a 'no wreck-no pay' basis. They even had their own dress-uniform of tall hats and pumps. On the left hovellers run out their hovelling luggers. In the centre Turner places the fragment of mast that appears in a number of his other drawings of this period. On the right is the wreck that the hovellers intend to hovel.

46 DOVER FROM SHAKESPEARE'S CLIFF

15.9 × 24.1cm (6¼ × 9½in) *c.*1825
Signed with initials

The view across Dover is from the Western

Heights, a vast complex of underground fortifications originally built between 1793 and 1814 under the threat of French invasion. They were modelled upon the principles of Vauban, the seventeenth-century military engineer and they included a number of deep, brick-faced 'lines'. These were dry moats whose approaches were covered by gun-emplacements.

Such a defile fills the foreground. At its head on the extreme left are the gun-embrasures. Near them some workmen on a temporary scaffold are busy pointing the brick wall of the moat. To the left is a heavily laden haycart (the land above the redoubt was cultivated) which is preparing to cross the moat over the bridge. The vertiginous passage is emphasized by the figure pointing into the depths below, though in reality the fosse is about thirty feet deep. A dog that has crossed safely seems transfixed by the sight that has presented itself through the gateway: on the cliffs firing-practice is taking place (with the guns aimed towards France). The military associations of the scene are further indicated by the smoke billowing out over Shakespeare beach on the right and by the ship testing its guns in the distance. Above the dog are the numerous masts of ships lying in the inner harbour. The entrance to the harbour can be seen at the tip on the extreme right.

In the distance the cliffs recede along the coast to the South Foreland. The castle appears hazy in the damp, late afternoon air and the reflection of brilliant sunlight from the hillside on which it stands creates an aureole of light around it. The cliffs in shadow appear both firmer and cooler in tone. The drawing has suffered a great deal of foxing but its rich colours remain undimmed. Note the surreptitious appearance of Turner's initials in the bottom left-hand corner.

47 WHITSTABLE, KENT

16.1 × 24.3cm (6⅜ × 9⅝in) *c.1825*
Signed

Whitstable oysters have been famous since Roman times. Henry VIII instituted the Company of Dredgers to control the fisheries and here we see the dredgers at work in the distance. A horse-drawn cart brings the harvest ashore and the effort of crossing the mud-flats is demonstrated by men either pulling the horse or pushing a wheel of the cart. A line of figures lead the eye to the distance and these accents are repeated and amplified by the stakes in the foreground. The slow movement of the horse and cart is matched by the suggested motion of the clouds. A storm passes over Long Rock point and crosses Swalecliff beyond Whitstable, while the town gleams in the afternoon light. In the bottom right-hand corner an overturned basket and a cloth perhaps resemble oyster-shells, a visual pun of the type that Turner often enjoyed making. The picture particularly demonstrates Turner's matchless ability to convey the moisture of sea air.

48 WHITBY

15.9 × 24.8cm (6¼ × 9¾in) *c.1825*

This watercolour presents something of an enigma. Like *Folkestone* (83) and *Tynemouth* (111) it was engraved in 1844 for 'Dr Broadley's Poems', a privately-published work. Its appearance, though, suggests that it was made much earlier than that date suggests. Indeed, given its size and subject one might think it was originally intended for 'The Ports of England' series. However, it is more delicately drawn than other similar subjects in the 'Ports' series. Furthermore, the fine quality of the detail suggests it was made with line-engraving rather than mezzotint in mind. A possible explanation is that it was made for the projected next section of the 'Coast' scheme up the east coast of England, well before Turner's break with Cooke in 1827. It shows a great stylistic similarity to *Dover from Shakespeare's Cliff* (46) in the 'Southern Coast' series. That drawing dates from *circa* 1825 and is almost exactly the same size as this work (the heights of both works are identical). When Turner did finally embark on the

'East Coast' series around 1827 he had clearly changed his mind by then about the type of paper to be used for the series and the drawing was left out for that reason. This hypothesis would explain why the work has such affinities with the late 'Southern Coast' drawings and also why its detailing would have been suitable for line-engraving.

The view looks southward from Upgang and the cool, misty late-afternoon sunlight is rendered with absolute precision. Turner's incomparable ability to render the dampness of wet sand can be seen across the beach. He achieves the suggestion of grainy texture not through rubbing the paper but by laying down washes of colour and by stippling over them when they are dry.

'The Rivers of England' 1822-6
This series of mezzotint engravings was produced by W. B. Cooke. Turner made at least seventeen drawings for the scheme and another, much earlier work was also included, *Warkworth Castle* (1). Two of the engravings were left uncompleted due to the severance of relations between Cooke and Turner in 1827, and another was abandoned due to the failure of the plate.

49 SHIELDS, ON THE RIVER TYNE

15.4 × 21.6cm (6 × 8½in) 1823
Signed and dated TB CCVIII-V

This memorable image probably inspired the commissioning of a later oil-painting of the same scene entitled *Keelmen heaving in Coals by Night*[45] which was exhibited at the Royal Academy in 1835. The two works are very similar although the watercolour is less spacious in scale and less silvery in colour. Turner here uses a range of blues and blacks to evoke romantic moonlight. However, the coal-heaving keelmen (who would literally shovel or 'heave' the coal from barges into collier-brigs) obviously have little time or inclination to contemplate the picturesque qualities of the scene.

The coal was carried down the Tyne by flat-bottomed barges (keels) from the coalfields above Newcastle but after 1823 there was an increasing dependence upon railways to undertake this transport. Indeed, up on the right we can see a coal-wagon discharging coal directly into the hold of a collier-brig.

50 NEWCASTLE-ON-TYNE

15.2 × 21.5cm (6 × 8½in) c.1823
Signed with initials TB CCVIII-K

Turner based this work on a sketch made in Newcastle in 1818 when he visited the town on his way to Scotland (see Concordance). The view is of the Tyne with Gateshead on the left and Newcastle on the right. From left to right are the tower of St. Mary's, Gateshead (destroyed by fire in 1979); the bridge of 1772 (demolished in 1876); above it the Elswick shot-tower; to its right the Norman castle; then the lofty spire of All Saints; and finally the medieval steeple of the church (later cathedral) of St. Nicholas. Before them are the crowded staithes and steep hillsides of the river, with men hauling timber on the right. The marine, sailor and woman waving to the keelmen below add to the drawing's sense of bustle and further represent a cross-section of the town's working population. Note the surreptitious appearance of Turner's initials at the bottom right forming the shadow cast by the woman.

51 MORE PARK, NEAR WATFORD, ON THE RIVER COLNE

15.7 × 22.1cm (6⅕ × 8⁷⁄₁₀in) 1822
 TB CCVIII-H

Moor Park was enclosed by sanction of Henry VI in 1426. The house itself was built during the reign of Edward IV by George Nevil and was at one time owned by Cardinal Wolsey. The 500-acre estate was later landscaped by James Thornhill and Capability Brown and it was very famous in Turner's day. The Grand Union canal occupies the foreground with Lot Mead lock in the centre. The river Colne can be seen beyond it, below to the left.

This is one of Turner's most lyrical watercolours. The artist might make the low Hertfordshire hills look more like the Yorkshire moors, but in every other respect he portrays the scene with an intense regard for accuracy. Rain clouds pass away to the west and the depiction of wet foliage is particularly truthful, especially on the right. As a result of the reflections the whole picture has a sparkling and verdant freshness.

The shallow V line of the lock-gates is reiterated by similar lines above and they lead the eye to the house in the distance. The inactivity of all the figures helps to establish further the picture's overall mood of complete repose.

The drawing was hired[46] from Turner by W. B. Cooke in 1822. It has recently been thought that it was made at a later date although this is obviously mistaken (this comment also applies to the following three drawings and 56).

52 ROCHESTER, ON THE RIVER MEDWAY

15.2 × 21.9cm (6 × 8⅗in) 1822
 TBCCVIII-W

Rochester was the subject of one of Turner's very first oil-paintings (now untraced) and he depicted it several times. Here he virtually obscures the town with a great deal of river shipping. This includes a hay-carrying Thames barge and a prison hulk. Visible on the hulk is a washing-line and a canvas ventilating shaft which had an open mouth and was designed to allow fresh air into the lower decks.

Turner repeats the shape of the Cathedral's spire with a series of triangles formed by the rigging of the hulk and the sail peaks of the barge and ketch beyond it. The twelfth-century castle looks even more square by comparison. The morning light is hazy but warm. The depiction of reflections upon the Medway is especially brilliant and Turner accurately plays a myriad of colours and shapes across its surface.

53 NORHAM CASTLE, ON THE RIVER TWEED

15.6 × 21.6cm (6⅛ × 8½in) 1822
 TB CCVIII-O

Norham Castle was one of Turner's favourite subjects. He depicted it in seven major watercolours and a dazzling late oil-painting that dates from sometime between 1835 and 1851.

The drawing is superbly rich in colour. Turner enhances the impact of the brilliant dawn light by bringing into play a vast range of textures and stipplings. The rubbed areas of the wake of the boat and the mist on the right add to this richness.

This stretch of the Tweed marks the boundary between Scotland, on the left, and England, on the right. Turner therefore introduces a kilted Scot on the left. The remains of the building above him were still evident when the author visited the site recently. Turner makes it look more Italian than Borders. He has also considerably enlarged the castle and raised it higher in the process. Note also how he repeats the shape of the castle's keep in the square sail of the boat below it.

54 DARTMOUTH CASTLE, ON THE RIVER DART

15.9 × 22.4cm (6¼ × 8⁷⁄₈in) 1822
 TB CCVIII-D

Dartmouth Castle stands a mile south of Dartmouth itself and it appears distantly in other Turner views of the town (see 56 and 104). It was completed in 1494. Above it, to the right, is the tower of the church of St. Petroch.

As in the other view over the Dart in this series (56) Turner depicts the sun just risen and he correspondingly includes a rich interplay of warm

light and deep shadow. Waving figures also appear in another Turner watercolour of Dartmouth belonging to the 'England and Wales' series.[47a] Here, however, they lack the later work's bawdy implications. Note the discarded swords and bottle in the right foreground and the way that Turner brackets the castle with two masts. He obviously remembered having done this once before (see *Dartmouth, Devonshire,* 104). Two chimneys on the castle's turret repeat these twin verticals and in the distance these uprights are repeated again on Kingswear Castle.

55 OKEHAMPTON CASTLE, ON THE RIVER OKEMENT

16.3 × 23cm (6⅖ × 9in) *c.*1824
TB CCVIII-E

Okehampton Castle was one of the largest castles in Devon until it was destroyed by Henry VIII. Turner makes the ruin seem even higher than it is by taking an extremely low viewpoint, an emphasis he reinforces by placing a section of tree-trunk immediately beneath it. This form reverses and extends the shape of the conical hill above. Other typical Turnerian 'echoes' occur at the tops of the two nearest trees. The further one repeats the shape of the gap in the castle's wall while the nearer tree exemplifies the mood of ruin with the bare and tormented shapes of its lightning-struck branches. The rushing lines of the river are extended by the wavy rhythms of the timbers and shadows in the foreground. Amid all this dense, natural profusion and chaotic movement the woodcutter finds peace with his wife and child.

56 DARTMOUTH, ON THE RIVER DART

15.7 × 22.7cm (6³⁄₁₆ × 8⅞in) 1822
TB CCVIII-C

Although this has recently[48] been described as a

sunset it is in fact a dawn scene for the view looks east towards the sunrise above Kingswear. On the right a milkman makes his early rounds. Below him a milkmaid steps out of the path of a train of pack-mules progressing down the steep lane on their way to the 'pannier-market', a regular market held in Dartmouth for the sale of produce from outlying farms.

Beneath are the shipyards which were very busy during this period: in 1826 no less than nineteen vessels were built in them. The central group of trees also appears, more dominantly, in the other view of Dartmouth Castle (54) in this series. The atmosphere of well-being is expressed by the golden warmth of the light. Turner also alludes to this mood by his depiction of a hoop in the right foreground. He frequently used such hoops to symbolize harmonious states of mind.

57 BROUGHAM CASTLE, NEAR THE JUNCTION OF THE RIVERS EAMONT AND LOWTHER

16.1 × 22.8cm (6⅓ × 9in) *c.*1824
TB CCVIII-N

Brougham Castle, near Penrith, Cumberland, formed part of a defensive system of Norman castles built to prevent Scots invasion and cattle-stealing in the Borders. The keep dates from the time of Henry II and the castle was destroyed during the Civil War.

Turner visited the site in the summer of 1809 during an extensive tour of the north-west of England. This was in connection with commissions to paint views of Cockermouth and Lowther castles. He then made two detailed pencil studies of the castle (see Concordance) and later synthesized them to form the basis of the present work. Across the Eamont the Norman keep is lit by late-afternoon sunlight. The sparse figuration and the stormy sky help to create a mood of foreboding which complements the castle's forlorn appearance.

58 KIRKSTALL ABBEY, ON THE RIVER AIRE

16 × 22.5cm (6⁵⁄₁₆ × 8⅞in) Nov. 1824-Dec. 1825
TB CCVIII-M

Turner first visited Kirkstall Abbey in 1797. From the sketches made on that tour he worked up three impressive watercolours, one of which was exhibited at the Royal Academy in 1798. Thereafter he visited the site a number of times, usually while staying nearby at Farnley Hall, the home of his great patron, Walter Fawkes. Indeed, the basis of this watercolour is a pencil-study made while he was at Farnley. It includes Kirkstall weir but omits the bay-willow trees completely. This sketch dates from November-December 1824 (see Concordance). Here, however, Turner depicts the abbey in summer, as the foliage testifies.

The drawing is remarkable for its wistful mood, as the tower of the ruined Cistercian foundation catches the last rays of evening sunlight. Note the typical way that Turner makes a sapling return the girl's waving gesture.

59 MOUTH OF THE RIVER HUMBER

16.5 × 24.3cm (6½ × 9½in) *c.*1824-5
TB CCVIII-R

The view encompasses Spurn Head at the right and Grimsby in the distance on the left. Despite this wide arena Turner prefers to jumble his shipping together, revelling in the variety of form that such a juxtaposition creates. A Billy-Boy (a river barge and coasting vessel that was used extensively off the east coast) is running before the wind with its leeboard up. Beyond it a man-of-war is anchored into the wind while a brig passes between them. The picture is filled with energy. Turner unifies it with an arabesque that runs around the emerging line of light in the distance, along the Billy-Boy's gunwale and up through the sails into the sky beyond.

60 ARUNDEL CASTLE, ON THE RIVER ARUN

15.9 × 22.8cm (6¼ × 9in) *c.*1824
 TB CCVIII-G

This is one of Turner's loveliest panoramas. We see Littlehampton in the distance on the extreme left, the Martello towers along the coast and the final wanderings of the Arun to the sea in the centre. The park of Arundel Castle occupies the foreground with the distant castle subtly acting as the work's primary focal point. Turner creates a marvellous range of textures in his rendering of the variegated foliage in the park. Especially adroit is his depiction of the rain-shower and its shadow passing over the hill on the right. The left side of the landscape, now bathed in sunshine, demonstrates the particular clarity that light possesses after rain.

61 KIRKSTALL LOCK, ON THE RIVER AIRE

16 × 23.5cm (6⁵⁄₁₆ × 9¼in) Nov. 1824-Jan. 1825
 TB CCVIII-L

Despite Turner's title[49] this drawing primarily depicts the Leeds and Liverpool canal which runs parallel but south of the river Aire at this point. Kirkstall lock may be observed in the central distance, the Bradford-Leeds road on the left and Kirkstall Abbey far over on the right. The Aire itself can just be seen passing in front of the abbey out of the picture to the right, thereafter it would flow over the weir depicted in *Kirkstall Abbey* (58), swing around towards us and pass by just off the picture. That Turner knew he was portraying a canal in the 'Rivers' series is attested to by one of the sketches used as the basis for this work. On page 60a of the 'Brighton and Arundel' Sketch-book (TB CCX) he wrote the words 'canal road'.

Turner made these sketches while staying nearby at Farnley in the winter of 1824. As with the other Kirkstall drawing he translates the scene into a summer landscape. The late-afternoon light radiates intense colours and shadows. Rich textures and multitudinous highlights impart a brilliant vibrancy to the scene.

Leeds was rapidly expanding at the time and the picture clearly contrasts the peaceful countryside with the busy activities of the town. In the foreground building-work takes place on the Kirkstall brewery.[50] On the right the approaching Bradford coach adds an extra dash of movement; below it Turner characteristically names a barge, 'Leeds', after its normal place of residence.

62 STANGATE CREEK, ON THE RIVER MEDWAY

16.1 × 24cm (6⅓ × 9⅖in) *c.*1824
 TB CCVIII-A

Stangate Creek forms part of the Medway estuary. The first two hulks to be stationed there were originally 44-gun ships which were converted for use as quarantine vessels. Plans to build a nearby land-based lazaret or quarantine house came to nothing and by 1820 there were eight such vessels moored in the creek. They quarantined goods and people to check the importation of plagues from ships returning from overseas.

These hulks can be seen in the distance on the left. On the right are decommissioned navy ships anchored near the top of the creek. In the foreground is a barrel-laden topsail barge, a Thames barge adapted for sea rather than river use. Passing behind it is a Bermuda sloop.

The work is remarkable for its limpid calm and delicate colour. When it was engraved the image became much darker in tone and Turner had a huge buoy placed in front of the floating logs to add to the work's interest. The time of day depicted in this picture has been described[51] as a sunset but it is in reality a dawn scene. The hulks were stationed by Chetney Hill at the south-east end of Stangate Creek, which runs from north to south, and we are therefore looking in the direction of the rising sun.

63 TOTNES, ON THE RIVER DART

16.2 × 23cm (6⅖ × 9in) *c.*1824
 TB CCVIII-B

Turner here evokes the perfect stillness that follows a storm. The heavy clouds pass away, leaving the castle, town and river basking in gentle late-afternoon sunshine. In the foreground Turner places some resting sea-birds and a small hoy whose slack sail pinpoints the dead calm; together they heighten the effect of ineffable tranquillity beyond. The confident depiction of trees and foliage, the inexhaustible variety of the reflections on the river, the intricate counterpoint of the lines of the hills and the wealth of colour-contrasts and stippled textures all combine to form one of Turner's most idyllic creations.

64 ARUNDEL CASTLE, WITH RAINBOW

15.9 × 23cm (6¼ × 9in) *c.*1824
 TB CCVIII-F

Turner obviously witnessed a downpour at Arundel once, for it is evident in another drawing of the castle in this series (60). The after-effects appear in a later 'England and Wales' series watercolour of the town.[52]

Rainbows are an occasional feature of Turner's work in the 1820s (see 65 and 78). The rainbow in this work is truly spectacular. The damp sunlight carries complete conviction and the air positively exudes moisture. Note the 'A' on the barge at the right. This signifies 'Arundel'. Turner frequently painted similar identifications on the sides of his barges (see *Kirkstall Lock,* 61).

65 THE MEDWAY

15.6 × 21.8cm (6⅐ × 8⅗in) *c.*1824
 TB CCVIII-P

This work was almost certainly made for the

'Rivers of England' series even though it was not engraved. A modified version of the design was mezzotinted in the 'Little Liber' series (R. 809a). The hulks are probably ships laid up 'in ordinary' (i.e. they had had their sails, rigging, guns and re-usable parts removed). Before them are a yawl and a bumboat carrying a marine officer, sailors, women, children—and necessary umbrellas. There is a very palpable sense of the warm, moist atmosphere after a storm.

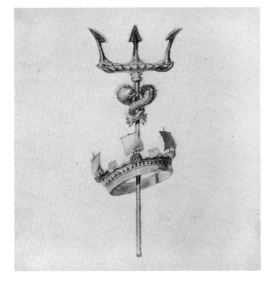

7 Neptune's Trident. Original design in watercolour for the wrapper vignette for the 'Marine Views'. The drawing remained in the Turner Bequest (CLXVIII-C). It was probably engraved by W. B. Cooke.

'Marine Views' c.1822-4

W. B. Cooke commissioned this unfinished series of mezzotint-engravings. Turner almost certainly made six drawings for it (66-68, and 114-116) and the wrapper vignette (see above, Ill.7). Also included in the scheme was a picture of the Eddystone lighthouse (113) that had been with Cooke since 1817. In the event Lupton only completed two of the mezzotints and left a third unfinished. The series was finally abandoned after the vignette and the two engravings were published in 1824 and 1825.

66 FOLKESTONE FROM THE SEA

48.9 × 69.1cm (18¾ × 27in) c.1822-4

TB CCVIII-Y

Smuggling took place on a vast scale in the 1820s. It was opposed by the Coast Blockade, formed in 1816. This had some success and smugglers were forced to resort to more surreptitious methods. The technique portrayed here, and in other Folkestone drawings, was known as 'sinking and creeping'. Kegs of tea, tobacco or spirits were fastened in pairs to a heavily-weighted 'sinking-rope' and dropped into the sea on a set bearing from two landmarks (in this case perhaps the tower of St. Mary's church in the distance is one of them). Later, under the guise of 'fishing', the smugglers would 'creep' these kegs by dragging the sea-bottom with grapnel-hooks.

Here we see the sinking of the kegs. A Blockade-boat is fast approaching from the right and, warned by a smuggler standing by its foremast, the French lugger (note its tricolour) is raising sail and quickly jettisoning the cargo. A man at the stern can be observed just about to drop two kegs into the water. Meanwhile, the men in the Folkestone cocktail (a six-oared rowing boat) are positioning the 'sinking-rope'.

Turner repeats the circle of the moon with the rounded lines of the foresail. The drawing exhibits a beautiful polarity between cool moonlight and the first warm colours of daybreak as the dawn light is reflected by clouds above Folkestone. The marked swell of the sea is depicted with an exact understanding of its underlying motion.

This work was almost certainly intended for the 'Marine Views' but it was never engraved (see page 10). Turner made an elaborate colour-study for it (TB CCLXIII-357), in which a figure warning of the Blockade boat's approach is prominent.

67 DOVER CASTLE

43.2 × 62.9cm (17 × 24¾in) Dec. 1822
Signed and dated

The coming of the age of steam is celebrated in a drawing of outstanding splendour. At the left and centre are the south and north pier-heads that stand at the entrance to Dover harbour. Owing to a strong westerly wind, the lugger in the foreground and various fishing smacks are finding it difficult to enter port and are reducing sail to avoid being blown out to sea. Those on the right will either have to wait for the tide or row into harbour as there is not sufficient room to tack. A paddle steamer, however, cuts through the prevailing wind and races towards harbour. It is welcomed on the pier by waving men, a startled dog and some running figures who both extend the impetus of the steamer and exemplify the excitement that was initially felt upon seeing this revolutionary form of transport.

The first steamer to cross the English channel was the *Majestic* in 1816. However, this was only an individual run. In 1821 the *Rob Roy* initiated a regular service and within a short time there were a great number of privately owned steam-ships crossing to the Continent. Turner here depicts a boat that has been converted from sail for she has a sailing hull and a beak head at the prow. Immediately beyond her is a wrecked brig and the juxtaposition of these two vessels is a pictorial comment upon the supplanting of wind-power by steam. Indeed, the brig even looks as though it has been pushed aside by the steamer. Sixteen years before painting *The Fighting Temeraire* Turner took an optimistic view of progress, but even so he indicated the cost of this change.

Aboard the lugger[53] on the left members of the crew are shouting at the helmsman or peering around from midships to see what is happening. At the stern is a large arched gallows designed to support the foremast, which was lowered when the boat was drift-fishing and lying to the nets. To minimise excessive rocking, a riding sail would then have been raised on the mainmast. This sail

has been in use but on being struck it has been left unfurled and can be seen billowing over the stern. Fishing completed, the foremast and foresail have again been set to give forward motion. As the boat approaches the harbour it is again necessary to strike the mainsail to reduce speed. It is being abruptly lowered but, because the riding sail is still unfurled, the whole deck will be covered in canvas in a few seconds—not a healthy state to be in at a harbour mouth with so much shipping in the vicinity. Indeed, it seems very likely that the lugger will collide with another boat in front of it. The lugger's helmsman is therefore desperately trying to pull the tiller hard over to starboard to turn the vessel into the harbour, but he is wedged between the gallows and the unfurled canvas and has no room to move the tiller any further. Despite all the shouting there is little that he can do.

In the distance the castle and East cliffs are ethereal in the damp, late-afternoon sunlight. Turner aligns the towers of the Roman Pharos (or lighthouse) and the church of St. Mary in Castro with the foremast and funnel of the steamer. This pairing is repeated by the masts of the wrecked brig and the two sails of the lugger in front of the steamer. The movement of the sea, the tossing, wind-whipped flow of water and the interplay of brilliant reflections and deep shadows are expressed with unrivalled mastery.

68 A STORM (SHIPWRECK)

43.4 × 63.2cm (17 × 25in) 1823
Signed and dated

This watercolour was also probably made for the 'Marine Views' series but it was never engraved. It was introduced by W. B. Cooke into his 1823 exhibition under the title of *A Storm*. Thereafter it appears in his account books as *Shipwreck*. This title was also used for the work by *The Literary Gazette* in a review on 24 May.

The picture is one of Turner's most ferocious seascapes. He brings to it every aspect of his immense experience in depicting such scenes; he

had, after all, been painting them since the early years of the century. The violent blues and blacks in the sky, the opposing golden yellows and pinks of the rocks, the streaks of lightning, the white boiling foam and the rhythmic convulsions of the waves animate the picture with a truly terrifying energy.

'The Ports of England' 1825-8

Twenty-five drawings were commissioned for this series by Thomas Lupton who proposed to mezzotint and publish the works himself. Eventually he and Turner quarrelled and relations were broken off in 1828. By that time seven engravings had been completed, including a wrapper design by Turner (see below), and another six were left unfinished. Lupton kept all of the plates and re-issued them as 'The Harbours of England' in 1856 in collaboration with Ruskin. Up to four other drawings (82-84 and 111) may have been intended for this series.

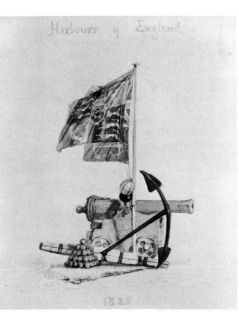

69 SCARBOROUGH

15.7 × 22.5cm (6 3/16 × 8 7/8 in) *c.*1825
 TB CCVIII-I

Turner made several magnificent watercolours of Scarborough. Two of them date from 1809 and 1811 and both show boys crab-fishing. The later drawing also contains shrimpers, beached boats, bathing-machines and washerwomen. In 1816 the artist made a more distant view of the town. This 'Ports of England' version, dating from the mid-1820s, represents his final comment on the subject.

The castle and town appear ethereal in the dawn light. In the foreground is a cutter with a brig drawn up behind it. They are beached because Scarborough harbour is extremely shallow and only accessible at high tide. The dark tones of these ships make the distance seem even more delicate by contrast.

Ruskin noted a characteristic feature of the work. This was Turner's:

> *doubling* of every object by a visible echo or shadow throughout . . . The grandest feature of it is the steep distant cliff; and therefore the dualism is more marked here than elsewhere; the two promontories or cliffs, and two piers below them, being arranged so that the one looks like the shadow of the other, cast irregularly on mist. In all probability, the more

8 Vignette for the design on the wrapper of 'The Ports of England', indian ink and grey wash on paper, 30 × 21.1cm (11 7/8 × 8 1/4 in), Fitzwilliam Museum, Cambridge. As can be seen, Turner's original title for this series was 'Harbours' rather than 'Ports of England'. However, when the vignette was engraved in 1826 it did not include a title and when the series was published it was known as 'The Ports of England'. When the series reappeared in 1856 the publisher reverted to the use of 'Harbours' in the title. The engraver of this design is unknown but a proof in the British Museum includes pencil instructions by Turner, so it may well have been Thomas Lupton who was responsible for engraving the rest of the series.

distant pier would in reality, unless it is very greatly higher than the near one, have been lowered by perspective so as not to continue in the same longitudinal line at the top;—but Turner will not have it so; he reduces them to exactly the same level, so that the one looks like the phantom of the other; and so of the cliffs above.

Then observe, each pier has, just below the head of it, in a vertical line, another important object, one a buoy, and the other a stooping figure. These carry on the double group in the calmest way, obeying the general law of vertical reflection, and throw down two long shadows on the near beach. The intenseness of the parallelism would catch the eye in a moment, but for the lighthouse, which breaks the group and prevents the artifice from being too open. Next come the two heads of boats, with their two bowsprits, and the two masts of the one farthest off, all monotonously double, but for the diagonal mast of the nearer one, which again hides the artifice. Next, put your finger over the white central figure, and follow the minor incidents round the beach; first, under the lighthouse, a stick with its echo below a little to the right; above, a black stone, and its echo to the left; then a starfish [Ruskin notes here that Turner puts this starfish in all his depictions of Scarborough— obviously he once saw one there and thereafter always associated it with the town] . . . a white spot its echo to the left; then a dog and a basket to double its light; above, a fisherman, and his wife for an echo; above them two lines of curved shingle; above them two small black figures; above them two unfinished ships, and two forked masts; above the forked masts, a house with two gables, and its echo exactly over it in two gables more; next to the right, two fishing boats with sails down; farther on, two fishing boats with sails up, each with its little white reflection below; then two larger ships, which, lest his trick be found out, Turner puts a dim third between; then below, two fat colliers, leaning away from each other, and two thinner colliers leaning towards each

other; and now at last, having doubled everything all round the beach, he gives one strong single stroke to gather all together, places his solitary central white figure, and the Calm is complete.[54]

70 WHITBY

15.8 × 22.5cm (6¼ × 8⅞in) *c.*1825
TB CCVIII-J

Turner may have witnessed a dawn scene such as this on one of his many journeys along the east coast. The abbey and cliffs catch the first rays of sunlight and the shadow of a cloud still partially covers the lower part of the rock-face. Turner unifies the whole work with a subtle curve that amplifies both the circular shape of the shadow and that of the cliff-edge beyond it. An intermittent line runs up the gunwale to the prow of the coble in the foreground and it is picked up and extended by the course mainsail of the brig, continuing across the tops of the large cloud formations. The golden colour of the lugsail of the coble on the left adds to the sense of growing warmth and its curve repeats the greater line running around the drawing. The linear 'Y' shape formed by the boat's lug and mast directs our eye to the abbey beyond it. Turner denotes the fresh morning breeze with exactitude and the alternation of soft warm and cool colours throughout the picture helps fix the precise degree of temperature.

71 DOVER

16.1 × 24.5cm (6⅓ × 9⅗in) *c.*1825
TB CCVIII-U

This work takes a viewpoint similar to that of the larger and more dramatic drawing of Dover dating from 1822 (67). Here Turner surveys the variety of shipping characteristic of the port. From the left we see a gig with its lugsail being set and its crew hauling on the oars; a lobster boat with a fisher-

man with folded arms; in the distance the beached rotting timbers of a wrecked brig (perhaps the same wrecked brig that appeared in the 1822 drawing); a small, heavily laden hoy; the cross-channel packet with steam issuing from its funnel in an adroitly simple squiggle; a lugger; and finally the ubiquitous Turnerian brig.

Ruskin, noting the characteristic exaggerations in the picture, wrote that Turner has considerably heightened the cliffs throughout and given the barracks, seen up on the left, '. . . more the air of a hospice on the top of an alpine precipice, than of an establishment which, out of Snargate street, can be reached, without drawing breath, by a winding stair of some 170 steps; making the slope beside them more like the side of Skiddaw than what it really is, the earthwork of an unimportant battery . . .' He also observed that:

The left-hand side is most interesting, and characteristic of Turner: no other artist would have put the round pier so exactly under the round cliff . . . Turner knew exactly the value of echo, as well as of contrast, of repetition, as well as of opposition. The round pier repeats the line of the main cliff, and then the sail repeats the diagonal shadow which crosses it, and emerges above it just as the embankment does above the cliff brow. Lower, come the opposing curves in the two boats, the whole forming one group of sequent lines up the whole side of the picture . . . Note how dexterously the two front sails of the brig are brought on the top of the white sail of the fishing-boat [the lugger] to help to detach it from the white cliffs.[55]

72 RAMSGATE

16.1 × 23.2cm (6⅓ × 9⅙in) *c.*1825
TB CCVIII-Q

This drawing should be compared with the 'Southern Coast' view of the town (108). The same weather, sea and shipping appear in both pictures, but the other work depicts the scene as it would

have appeared just a few moments later. Turner must have approached the harbour-mouth by ship from the north on some occasion and drawn upon his memories of the scene for both works. Ruskin noticed this link and marvelled at Turner's ability to reconstruct the same events at different viewpoints from memory.[56]

The drawing is artfully composed. Turner contrasts the dark mass of the sea and brig on the right with the light sky beyond. On the left he reverses this effect; the dark sky throwing forward the lighter sea and lighthouse.

On the quay some men are struggling to control windswept sails and rigging. The drawing is filled with a tempestuous energy. As Ruskin commented: 'The lifting of the brig on the wave is very daring; just one of the things which is seen in every gale, but which no other painter than Turner ever represented; and the lurid transparency of the dark sky, and wild expression of wind in the fluttering of the falling sails of the vessel running into the harbour, are as fine as anything of the kind he has done.'[57]

73 SHEERNESS

16 × 23.8cm (6¼ × 9⁷⁄₁₆in) *c.*1825
TB CCVIII-T

The Nore, off Sheerness, is situated at the confluence of the rivers Thames and Medway, and it was the busiest naval and merchant-shipping anchorage in Britain. Tens of thousands of vessels passed through it every year and it was therefore a natural choice of subject for this series. Turner had already painted it many times and here he portrays a number of the types of ship that might have been seen there. From left to right are a sheer-hulk, used for masting shipping; a collier-brig of the type Turner himself used frequently to travel to the north of England or Scotland; a Navy longboat (note its white ensign); a cutter passing behind it; beyond that a lugger; and finally a man-of-war. Sheerness can be seen in the far distance on the left. The time is late afternoon.

Ruskin noted the repetition of the shape of the cutter's hull by that of the buoy in front of it. He also called this drawing 'one of the noblest sea-pieces which Turner ever produced . . . the objects in it are few and noble, and the space infinite. The sky is quite one of his best; not violently black, but full of gloom and power . . . the dim light entering along the horizon, full of rain, behind the ship of war, is true and grand in the highest degree.'[58]

74 PORTSMOUTH

16 × 24cm (6⅓ × 9⅖in) *c.*1825
TB CCVIII-S

This is perhaps the most optimistic and heroic version of Turner's three treatments of this view (see also *Portsmouth, Hampshire,* 42). The morning light is charged with moisture and Turner clearly establishes the strong, cold breeze blowing across the harbour. The rushing motion of the water is accentuated by the roundness of the buoy on the left and the curved, wind-filled sails of the cutter on the right. The space before the vast 'first-rate' preparing to make sail in the distance is only populated with relatively small boats. They emphasize its impressive scale by contrast. The 'first-rate' towers over the adjacent longboat, harbour and town as the very embodiment of naval grandeur.

Above the cutter is the Admiralty semaphore. By a system of relays across southern England this device could communicate with the Admiralty in London in less than three minutes. It had amply demonstrated its military usefulness during the Spithead mutiny of 1797 and the long wars of 1793-1815. To emphasize its importance Turner places a signalling figure immediately beneath it. His straw-hat points directly at it. Their connection is reinforced by a series of diagonals that further structure the work. These are apparent in the cutter's main-yard and the lines of shadow in the sky.

The waving sailor makes an important contri-

bution to the drawing's sense of urgency. He also seems to be a clear, if unconscious, reminiscence of a similar figure in Gericault's *Raft of the Medusa* which Turner is sure to have seen when it was displayed[59] to great acclaim in London in 1820.

Ruskin drew attention to Turner's incorrect depiction of the setting of the battleship's sails, noting[60] that the jib (the sail seen edge-on at the bow of the ship) would not be wanted with the wind blowing from behind. Furthermore, a man-of-war would never have her foretop-gallant sail set and her main and mizzen top-gallants furled— 'all the men would be on the yards at once.' However, this is an over-literal response to the work. Turner elaborates the sails to emphasize their billowing surges of energy. He had earlier done this in his 1824 painting of *The Battle of Trafalgar.* Note how the curve of the cutter's mainsail exactly repeats the curvature of the sailor's waving arm. The shadow cast by the breaking wave in the lower left-hand corner is also particularly subtle.

75 MARGATE

15.4 × 25.5cm (6 × 10in) *c.*1825

In the centre a dismasted collier-brig has run aground and is having her cargo removed from the hold by a pulley-system erected on deck. The coal is presumably being transferred to the waiting boats. In the harbour is a paddle-steamer of the type that Turner used frequently between Margate and London. Bathing machines line the shore.

This drawing takes exactly the same view of the town as the 'Southern Coast' version of the subject (36). The horizontal mill that appears in that work is less clearly defined here (it was demolished in 1826) and by the time this drawing was made the large church of Holy Trinity was being erected very near to it. Both buildings seem to appear in silhouette in Lupton's unfinished mezzotint which is much darker, stormier and dramatic in mood, almost turning late afternoon into night.

76 DEAL

16.2 × 23.7cm (6⅓ × 9⅓ in)　　　　*c.*1826

The Downs, off Deal, formed an important anchorage for ships either sheltering in the lee of Deal from south-westerly gales, or else waiting for favourable winds to carry them around the South Foreland into the English Channel. Often many hundreds of ships would be anchored there, some for long periods in the absence of favourable conditions. Shore communication with these ships would be effected through signals-flags, a great number of which can be seen hoisted on masts ranged along the beach. These masts were owned by shipping companies or even foreign countries who kept consulates in the town expressly for the purpose.

Also servicing these ships were a fleet of Deal luggers. They ferried supplies and passengers, and stood by in case of need due to storms and other hazards (see 45). In the foreground one such lugger beats around into the wind and trims its sails accordingly. It is doubtless coming about to go to the aid of some of the ships massed beyond in a typical Turnerian jumble. These ships are beginning to suffer the first effects of the oncoming storm.

77 SIDMOUTH

18.4 × 26.3cm (7¼ × 10⅓ in)　　　　*c.*1823-5

This picture contains the most sexually explicit image in all of Turner's public output. Such a bawdy statement was the natural expression of his desire to encompass all aspects of human experience in his art.

Turner visited Sidmouth in 1811 and made two sketches of the town and beach on pages 203a and 205 of the 'Devonshire Coast No. 1' Sketchbook (TB CXXIII). These two sketches (Ills. 9 and 10) were synthesized to form the present work. As the second of these sketches demonstrates, Turner has not depicted the sandstone rock he actually saw at Sidmouth, instead he has elevated it into a massive phallus. Its sweeping shape also summarises the movement Ruskin described as 'the noble gathering together of the great wave on the left; — the back of a breaker, just heaving itself up, and provoking itself into passion, before its leap and roar against the beach.'[61]

Turner may have located this image in Sidmouth for a specific reason. In his day, of course, Sidmouth was not only a place; it was also a man. Lord Sidmouth (Henry Addington, 1st Viscount Sidmouth, 1757-1844) had been Home Secretary between 1812 and 1822. He was responsible for a great deal of repressive legislation including the

9 and 10　Pages 203a and 205 of the 1811 **Devonshire Coast No. 1 Sketchbook** *(TBCXXIII) which were synthesized to form the watercolour of* **Sidmouth** *(77). The rock that forms such a prominent feature of the work can be seen on the left in Ill. 10.*

suspension of *Habeas Corpus* in 1817 and the draconian Six Acts of 1819. Furthermore, Sidmouth was held to be largely to blame for the infamous Peterloo massacre. As such he was despised throughout British society, not least of all by the radical Whigs, one of whom was Walter Fawkes, a man who contributed much towards forming Turner's own political views.

In 1823 Sidmouth had been the subject of great popular ridicule, a lot of it with bawdy overtones, when at the age of sixty-five he had taken a much younger woman as his second wife. The awareness of this may have determined Turner's imagery in the picture. The drawing is slightly larger than the other 'Ports' series watercolours so it could have been made before the inception of the scheme, perhaps at the time of Sidmouth's marriage.

The town and cliffs bask in the morning sunshine. Turner reiterates the curve of the rock by the lines of the cliffs and the sails. The sky is especially fine. Characteristically, Ruskin missed the point of the rock, commenting that 'The detached fragment of sandstone . . . has long ago fallen, and even while it stood could hardly have been worth the honour of so careful illustration.' He was also excusably mystified by the inclusion of Sidmouth as one of the 'Ports' of England.

78 PLYMOUTH

16 × 24.5cm (6³⁄₁₀ × 9⅗ in)　　　　*c.*1825

This drawing takes an identical, if slightly closer and lower, view across Cattewater as *Plymouth, with Mount Batten* (27). A comparison of the two works shows how far Turner had evolved in less than ten years. Whereas in the earlier drawing he constructed a happy evocation of warm afternoon light and the bustle characteristic of the harbour, here his greatly developed visionary imagination has transformed the view. The brilliant light after rain and the higher pitch of colour and wider tonal range signify how little Turner was interested in naturalism by now. The rainbow may seem rather crude but it is undeniably dramatic, in fact

startlingly so. Ruskin wrote of it:

> It is like one of Turner's pieces of caprice to introduce a rainbow at all as a principal feature in such a scene; for it is not through the colours of the iris that we generally expect to be shown eighteen-pounder batteries and ninety-gun ships.[62]

At the end of the rainbow and on the right (above the men carrying spars) are Plymouth long-boomers, local sea-going cutters. Note how Turner echoes the rotundity of the small tower on Mount Batten point by the placing of some barrels in the foreground.

79 CATWATER, PLYMOUTH

15.9 × 22.9cm (6¼ × 9in) *c.1826*

The drawing has an enormous tonal range and an exhilarating rhythmic flow. Very evident is the stippling that is such a feature of the 'Ports' series. Turner employs this with great subtlety across the heights of Mount Gould, beyond Sutton Pool, and in the shadows cast by strong early morning sunlight falling on the tower on Mount Batten point. The tower is silhouetted by white clouds although it is easy to 'read' the sharp line of the edge of these clouds in reverse: the blue sky above them is difficult to distinguish from the blue-grey rain-clouds passing in front, and so it too appears as cloud seen against lighter clouds beyond.

Turner here takes his viewpoint from the position of the small lugger apparent in the engraving of *Plymouth Citadel* (98) made for 'The Rivers of Devon' series. The cliffs below the citadel can be seen on the left. Beyond them a number of ships are anchored in Sutton Pool. Two merchantmen are making their way up the

*11 Page 145a of the 1811 **Devonshire Coast No. 1 Sketchbook** (TBCXXIII) upon which the watercolour of **Falmouth** (80) was based.*

Cattewater towards the harbour. In the centre is a small boat with a winch attached to its stern.

80 FALMOUTH

14.5 × 22cm (5⁷⁄₁₀ × 8⁶⁄₁₀in) *c.1825*

This watercolour was based upon two detailed line-drawings in pencil on page 145a of the 'Devonshire Coast No. 1' Sketchbook of 1811 (TB CXXIII—see Ill. 11). Turner has drawn St. Mawes Castle in the foreground and Pendennis Castle across Carrick roads in the bottom sketch; above it he continued the view across the estuary of the river Fal to include Falmouth in the distance. The upper sketch is therefore the extension of the lower one to the right.

In the final work he amalgamates the two sketches so that one is looking simultaneously at St. Mawes Castle from the north, and Pendennis Castle and Falmouth from the south. In order to accommodate them he considerably heightens the hill on which Pendennis Castle stands.

From this viewpoint, therefore, the various castle batteries and the man-of-war are firing their salvoes *inland*. As this depicts no recorded act of war it is clear that Turner intended the salvoes to represent a salute. What they might be celebrating is suggested by a close examination of the details. On the right some storm clouds are passing away

(observe the strong wind denoted by the flags and the man-of-war's pennant). Obviously the sun has only recently come out, thus allowing a washerwoman to lay out her washing in the now warmer clime. A sword and some drums have been abandoned next to her. The radical change in the weather and the discarded military objects clearly allude to the coming of peace after war and the firing guns are therefore celebrating the cessation of hostilities. Although Turner had not witnessed such an event in Falmouth he certainly remembered the place from his 1811 visit during the Napoleonic war and it must have seemed an apt setting for commemorating the end of that struggle. This interpretation is supported by a later watercolour of *Yarmouth, Norfolk* (in the 'England and Wales' series[63]) where Turner similarly used a washerwoman to help suggest a state of peace.

The castle at St. Mawes was built by Henry VIII between 1540 and 1543. Turner draws the circular keep and bastions supremely well and creates a wonderfully expressive play of light across its surfaces. Ruskin found this work 'disagreeably noisy . . . to have great guns going off in every direction . . . is to my mind eminently troublesome.' He did, however, concede that the drawing of the smoke and flash of fire on the right was 'very wonderful and peculiarly Turneresque'.[64]

81 RAMSGATE

16.1 × 23.8cm (6³⁄₈ × 9³⁄₈in) *c.1825*

This drawing forms one of a group of works (82-86 and 111) whose size and probable date suggest that they were made for possible inclusion in either the 'Southern Coast' or 'Ports of England' series. The work has not been included in Andrew Wilton's recent listing of all of Turner's known watercolours although its provenance is partially given there in connection with the 'Southern Coast' view of Ramsgate.[65]

Despite the title the drawing does not depict Ramsgate but rather the view from the sea off

Ramsgate looking south-west. Deal is shown in the distance. Clearly evident is the long beach there as well as a building that resembles Sandown Castle (the coastline at Ramsgate is much higher than that depicted here; the town is situated amid a chain of cliffs that run along the coast from Pegwell Bay, around North Foreland, to Margate). The rather vague topographical location of this work may explain why it was not engraved.

In the centre a fisherman pulls his net aboard a rowing-boat with the aid of a grappling hook. He is being assisted by a man wearing a jersey whose stripes are re-iterated by the adjacent reflections on the hull of a Le Havre Trawler. Turner obtains a huge variety of tone and colour from an extremely limited palette in this drawing and the choppy sea is delineated with superb finesse.

82 SHIPWRECK OFF HASTINGS

19 × 28.5cm (7½ × 11⅕in) *c.*1825

The size, subject and widespread use of stippling apparent in this drawing all suggest that it was made for engraving in the 'Ports of England' series. The stippling particularly indicates this, for it is a prominent feature of the 'Ports' drawings. The work has in recent years been thought[66] to be the *Hastings from the sea* made in 1818 but this identification is refuted in note 14, p.158.

As in a great many of Turner's pictures, the topographical subject of the work is depicted in the distance. In front of Hastings Turner places a capsizing boat which is throwing its crew into the sea. A number of people stand watching helplessly on the cliffs.

Although this is an undeniably pessimistic subject the drawing lacks the sense of hopeless tragedy that Turner was to impart to his shipwreck scenes over the next few years. The lighter emotional tone is the result of the picture's rich colour, the work being divided into contrasting areas of gold, blue and green-grey. Particularly finely observed is the spume blowing across the brow of the cliffs.

83 FOLKESTONE

18 × 26cm (7 × 10¼in) *c.*1828
Signed

The sun sets beyond the Stade and it silhouettes the church of St. Mary and St. Eanswythe on the Lees at the right. Drawn up on the beach is a lugger with a cod bow net hanging up to dry from the mainmast.[67] Fish are being sorted on the beach.

Like *Whitby* (48) and *Tynemouth* (111), this drawing was engraved[68] (under the title given above) in 1844 for 'Dr Broadley's Poems'. Yet it seems to date from much earlier and was probably originally made for engraving in the 'Ports' series. Although it is slightly larger than most of the 'Ports' drawings it is virtually identical in size with *Sidmouth* (77) which was engraved for the scheme. The stippling apparent on the rocks at the right helps support this supposition, for it is a notable feature of the 'Ports' watercolours.

The watercolour is unusual in that Turner here chose to ignore his usual association of Folkestone with smuggling (see 44 and 66). Interestingly, though, exactly the same rhythm is imparted to the sea on the left in the distance as it is in the *Folkestone* (44) in the 'Southern Coast' series. The numerous brilliant highlights and rich colours and textures make this one of Turner's loveliest sunset scenes.

84 OFF DOVER

16.5 × 26.7cm (6½ × 10½in) *c.*1825

This unfinished work is extremely similar in size, subject and probable date to the other drawings made for the 'Ports' series. However, the free handling suggests that it was made by Turner as a preparatory study for a 'Ports' drawing that was never realized. Turner often made colour studies for his works and occasionally he must have developed these beginnings to an advanced stage. This seems to be such a work.

The topography only vaguely resembles Dover. Turner seems to have moved the castle across the valley in which Dover is situated. However, he was to do this again in his later 'England and Wales' treatment of the town[69] so this cavalier approach to topography is not unique. The drawing is unexpectedly rich in colour for a storm scene although it lacks dramatic focus, which may be why Turner never went on to make a final version.

85 SHOREHAM

21 × 31.2cm (8¼ × 12¼in) *c.*1824

Although this drawing is not related in size to any of Turner's other groups of watercolours made for engraving, the subject, style and execution suggest that it may have been made for the 'Ports' scheme. Although the work has been variously dated between 1825 and 1830, a note of its name on page 88a of the 1824 'Brighton and Arundel' Sketchbook (TB CCX) hints that the work was made in 1824.

The view looks from Portslade across Shoreham harbour at sunset. In Turner's day Shoreham was a busy shipbuilding centre and trading port although the harbour was only accessible at high tide because of shifting sands. The gentle surge of the tide can be seen at the extreme left.

Turner breaks the otherwise featureless horizon line with the tower of the church of St. Mary de Havra in the distance and a lime-kiln on the right. The foreground figures unloading timber and the onlookers animate the picture.

86 TINTAGEL CASTLE

17.7 × 24.4cm (7 × 10in) *c.*1825

The subject and style of this drawing suggest that it dates from the mid-1820s. The extreme freedom of execution is similarly encountered in *Off Dover* (84) and, as in that work, Turner may have been

simply trying out an idea for the 'Ports' series.

The picture is not included in Andrew Wilton's recent list of Turner's watercolours, but it is undoubtedly by Turner. The title too seems appropriate though features of the landscape have clearly been distorted. The castle looks very different in the 'Southern Coast' *Tintagel* (31) and the slate quarry that appears on the left in that picture has now disappeared. Moreover, the buildings up on the right seem much more extensive here than they do in the other view of Tintagel Castle. However, given Turner's usual topographical licence it may be idle to seek for truthfulness to the 'real' Tintagel in the work.

The watercolour displays the combination of high colour, furious energy and dramatic content that so characterizes the artist's work during this period. Rarely is Turner's religious pessimism so clear: on the crest of the hill stands a Cross, while in the sea a figure clings to a mast-top and on the right another drowns; wreckers line the cliffs and beach.

'Picturesque Views on the East Coast of England' c.1827

The Cooke brothers had originally envisaged that the 'Southern Coast' series would be followed by similar works that would eventually depict scenes around the entire coastline of mainland Britain. Such a continuation was proposed to Turner in about 1824 as the 'Southern Coast' series drew near to completion. However, plans to carry out this work in collaboration with W. B. Cooke came to nothing because of the split between Cooke and Turner in 1827. Turner then seems to have attempted to produce the work himself in collaboration with the line-engraver J. C. Allen.[70] For the scheme he made four vignettes and six drawings, all in body-colour on blue paper which he had begun using around 1825 for drawings of French rivers. Three vignettes and three larger drawings were engraved but two more plates were left unfinished. Eventually Turner abandoned the idea and none of the engravings were published.

87 LOWESTOFFE LIGHTHOUSE

Vignette 12.5 × 9.5cm ($4\frac{9}{10}$ × $3\frac{1}{4}$in) *c.*1827
Watercolour and body-colour on blue paper

The original lighthouse at the north end of Lowestoft High Street was built in 1609 and was the oldest existing lighthouse in England in Turner's day. It was replaced in 1854. The drawing shows an abundant use of French ultramarine blue which only became available in the mid-1820s. When the work was engraved Turner introduced a ship[71] on the sea, directly under the moon.

88 HASBORO SANDS

Vignette, 16.5 × 12.7cm ($6\frac{1}{2}$ × 5in) *c.*1827
Watercolour and body-colour on blue paper

Happisburgh, the place depicted, is a small fishing village on the Norfolk coast about twenty miles north of Yarmouth. The name Happisburgh is pronounced 'Hāsborough' which explains Turner's title, written very faintly in his hand across the bottom of the sheet. The shoals of Happisburgh Sands have always presented a danger to shipping and the lighthouse was built there in 1791 as a consequence of this.

Turner makes the building the vignette's central focus. Its pointed form is repeated by the fisherman's dark cap beneath. On the beach fishwives gut and clean the fish. Although the picture represents a dawn scene, in reality the sun would have to rise in the north to be located in the position it occupies here.

89 ORFORD HAVEN

Vignette, 19 × 12cm ($7\frac{1}{2}$ × $4\frac{3}{4}$in) *c.*1827
Watercolour and body-colour on blue paper

This lovely study of evening light is of a stretch of the river Ore with the twelfth-century Orford Castle on the left. In the distance is the west tower

of St. Bartholomew's church, the top of which collapsed in 1830. Boat-building is in progress on the right. Note how the sunlight appears through the window of the castle tower, and that Turner draws our attention to it by placing a mast immediately beneath it.

90 GREAT YARMOUTH FISHING BOATS

Vignette, 23.5 × 17.8cm ($9\frac{1}{4}$ × 7in) *c.*1827
Watercolour and body-colour on blue paper

This vignette is not recorded in Andrew Wilton's recent list of all of Turner's known watercolours, though it has been sold twice recently on the art market. The circular shape, subject and paper all clearly indicate that it was made for the 'East Coast' series.

The title of the vignette is written in Turner's hand separately from the drawing and so has been omitted from the reproduction. As it specifies the subject is the local shipping: from front to back are a lobster-boat, a Yarmouth beach yawl and at least three Yarmouth shrimp-boats, one with raised sails. The colour range is limited to the three primaries and white. Turner uses them to describe the calm, early morning light with complete assurance.

91 ALDBOROUGH

17.2 × 25.4cm ($6\frac{3}{4}$ × 10in) *c.*1827
Watercolour and body-colour on blue paper

Here a dismasted brig similar to that in *Orfordness* (93) and *Lowestoffe* (94) has finally been beached and its cargo is being removed. On the left is the Martello tower at Slaughden and beyond it Aldeburgh with the church of St. Peter and St. Paul above. Turner exacts the maximum tonal contrast from the two halves of the picture. The glistening reflections on the sand give the town a floating, disembodied appearance. Note the dab of Schweinfurt or emerald green on the right which Turner began to use in the mid-1820s.

92 DUNWICH

17.4 × 25.7cm (6⅚ × 10¹⁄₁₀in) *c.1827*
Watercolour and body-colour on blue paper

In the Middle Ages Dunwich was one of the most prosperous ports in England. Constant erosion by the sea led to its decline and by Turner's time it was only an impoverished fishing village.

On the hill stand the ruins of All Saints church, which have been turned through one hundred and eighty degrees to put the tower nearest the sea. The tower itself finally disappeared in 1919.

The watercolour is drawn very freely. When the work was engraved Turner included a bolt of lightning (see Ill.12) which adds to the work's expressiveness. The generally darker tone of the engraving also increases the picture's sense of mystery.

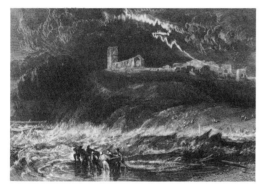

*12 Engraving of **Dunwich** by J. C. Allen.*

93 ORFORDNESS

16.5 × 25.4cm (6½ × 10in) *c.1827*
Watercolour and body-colour on blue paper

Orford Ness stands on a twelve mile-long spit of land that joins the mainland at Slaughden, just below Aldeburgh. Beyond the spit is the river Ore. Orford Castle and church can be seen in the

distance. In Turner's time the spot was uninhabited except for the two lighthouses, the low light (on the right) and the high light, built in 1792. The point itself is very dangerous: no less than a dozen ships were wrecked there in a single night in 1627.

One of Turner's most frequently stated pessimistic themes from the latter half of the 1820s onwards was that such beacons are futile. This was in keeping with his belief that all hope is fallacious. Between two such aids against shipwreck we see, therefore, a dismasted brig which has been jury-rigged and is now abandoned. In the sea various small boats have attached lines to her bow in an attempt to salvage her. Spectators line the beach.

The variety of tone is quite remarkable as is the range of different blues. They include French ultramarine blue which could only have just become available by 1827. The blues are offset by the gentle ochres of the beach and lighthouse, which in reality was painted red.

94 LOWESTOFFE

17.4 × 25.2cm (6⅘ × 9⁹⁄₁₀in) *c.1827*
Watercolour and body-colour on blue paper

Here Turner again depicts a lighthouse which has failed in its purpose. On the right is the upper lighthouse at Lowestoft, also seen in 87. Immediately before it is some wreckage. On the left is a Yarmouth beach-yawl and beyond it a Lowestoft Drifter, both of which are making their way towards a distant, dismasted brig. This is very probably the same brig that appears in *Aldborough* (91). Turner was again to depict Lowestoft from a similar vantage point in the 'England and Wales' series[72] and there too the lighthouse is juxtaposed with wreckage.

In the sky immediately above the bow of the Lowestoft Drifter, Turner has made the edge of a cloud distinctly resemble a wing. To the right of it, above the lightning, he appears to have elaborated this into the shape of a winged figure, perhaps an angel, in silhouette. This is not as far-fetched as it

may seem. In about 1832, Turner was to make a watercolour vignette called *The Evil Spirit* (TBcccLxxx-202) as an illustration to Canto XII of Samuel Rogers's 'Voyage of Columbus'. In that work, the winged figure hovers directly above the *Santa Maria* and indisputably forms the subject of the picture. The image occurs again, this time in celestial rather than diabolical form, in an oil-painting called *The Angel standing in the Sun* which was exhibited at the Royal Academy in 1846. Furthermore, an anecdote connected with *The Mew Stone* (see 24), which was drawn in about 1814, shows that that picture too has been associated with winged figures. The anecdote also provides documentary evidence that Turner was not averse to personifying the spirit of the storm in this manner. Here, of course, the conjunction of such an image with a ship in distress would be entirely appropriate.

95 YARMOUTH SANDS

18.5 × 24.5cm (7¼ × 9⅝in) *c.1827*
Watercolour and body-colour on blue paper

This ingenious drawing demonstrates Turner's ability to imbue landscape with a larger significance.

On the right is Nelson's Column, Yarmouth, which was built in 1817 to commemorate both Nelson and his victory at Trafalgar in 1805. It is 144 feet high and is surmounted by a statue of Britannia.

In front of it a group of figures enact a naval engagement with the aid of ship's models. These are laid out in parallel rows according to the old-established order-of-battle at sea: two lines of warships would sail in opposite directions, raking each other with their guns as they passed.

Nelson's great tactical coup at Trafalgar, however, had been to sail the English fleet in two parallel columns *at right angles* to the French and Spanish fleets, thereby driving a wedge into their line (Ill. 13). This tactic is clearly suggested by the group at the centre-right. The seated women's

42

skirts exactly resemble arrow-heads in shape and detail and they initiate a massive wedge-shape that incorporates the whole group of figures and anchors. A sense of forward motion is imparted to this triangular form by the sailor's pointing arm and the straight shanks of the anchors behind him. On the right, below the column, a lone Jack Tar balances and opposes the (French?) sailor standing on the left. In front of the Tar are a bottle and a glass. Perhaps Turner intends a toast to Nelson's memory with them.

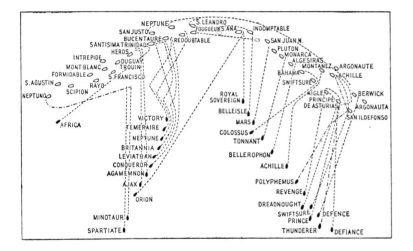

13 Plan of the battle of Trafalgar, October 21, 1805. By sailing his fleet in parallel columns at right angles to the French and Spanish, Nelson broke their line (observe the 'Téméraire' following the 'Victory', Nelson's flagship).

'Views in Sussex'

96 BATTLE ABBEY, THE SPOT WHERE HAROLD FELL
Present whereabouts unknown c.1815

Original drawing size: 37.5 × 55.2cm (14¾ × 21¾ in)
Engraving size: 15.2 × 24.1cm (6 × 9½ in)
Engraved (published date): 1819 by W. B. Cooke
Rawlinson No. 129

The original drawing for this engraving was sold at the Acland-Hood sale on 4 April, 1908 where it was bought by 'Levin'. Its present whereabouts are unknown.

Battle Abbey was built by William the Conqueror as the result of a vow he had made shortly after the battle of Hastings to construct the building. The altar of its church supposedly stood on the spot where Harold was killed. The abbey was one of the many destroyed in the Reformation.

The original letterpress for the 'Views in Sussex' by R. R. Reinagle gives an insight into Turner's underlying meaning:

> . . . a violent storm is just passing away . . . The decay of a few straggling yet standing firs give a powerful impression of melancholy and sadness to the scene . . . To add to all this admirable feeling and exquisite sensibility of combination, both in form and effect, Mr. Turner has given us an episode, a hare just on the point of being run down by a greyhound which fills the mind of the observer with only one sentiment, that of death . . .

Reinagle's interpretation of the hare and greyhound as symbols is supported by an anecdote. Some years after making this work Turner visited Edinburgh[73] where 'Cockneyism' was 'the prevailing subject of . . . ridicule'. Turner's London accent was therefore the object of much amusement. The story gives us both a record of his speech-patterns and also a valuable insight into his habit of associating places with a knowledge of their history:

Thomson[74] was examining this drawing with admiration when Turner called out, "Ah! I see you want to know why I have introodooced that 'are. It is a bit of sentiment, sir! for that's the spot where 'Arold 'arefoot fell, and you see I have made an 'ound a-chasing an 'are![75]

Another symbolic feature present in the work was noted by Ruskin: 'the blasted trunk on the left, takes, where its boughs first separate, the shape of the head of an arrow'.[76] A similar symbolic use of a tree is also present in an earlier drawing of the same subject, *Battle Abbey* (5). A colour-study for this work is in the Turner Bequest (CXCVI-D).

97 THE OBSERVATORY AT ROSEHILL, SUSSEX, THE SEAT OF JOHN FULLER, ESQ.
Present whereabouts unknown c.1815

Original drawing size: 31.8 × 55.9cm (12½ × 22in)
Engraving size: 17.8 × 29.2cm (7 × 11½in)
Engraved: 1816 by W. B. Cooke
Rawlinson No. 130

The drawing for this engraving was sold at Christie's in the Acland-Hood sale on the 4 April, 1908. It was bought by Agnew and its present whereabouts are unknown.

The observatory in Rosehill Park was designed for Jack Fuller by Sir Robert Smirke. It stands 646 ft. above sea-level at one of the highest points of the eastern Weald and was fitted with a telescope. Turner adroitly makes it the picture's focal centre by framing it with clouds and the smoke given off by burning scrub. To add to this emphasis, he places a sharp vertical in the form of a girl reading a ballad immediately beneath it. She is being reminded that it is time to milk the cows; note the full udders and arrow-like dash of white on the flank of the leading cow.

98 PLYMOUTH CITADEL

Colour photograph unobtainable *c.*1813

Original drawing size: 17.8 × 29.2cm (7 × 11½in)
Engraving size: 17.8 × 28.5cm (7 × 11¼in)
Engraved: 1815 by W. B. Cooke
Rawlinson No. 137

This work is in a private collection in Canada but it was not possible to obtain a colour transparency of it for reproduction. A poor black and white photograph of the watercolour is reproduced below and the excellent engraving by W. B. Cooke represents the work more fully in monochrome as Plate 98.

The picture was clearly created as a pendant to *Plymouth Sound* which follows. Indeed, when the engravings of the two works were exhibited in 1821 their titles included the complementary descriptions *a gale* (for this work) and *a light breeze.* Moreover, this picture is the extension to the left of the view in *Plymouth Sound.*

Plymouth Citadel dates from the late seventeenth century and it dominates the approach to the harbour. Turner visited it in 1813. While he was sketching in the vicinity an incident occurred

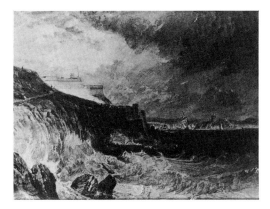

14 *Plymouth Citadel,* watercolour

which was recorded by Cyrus Redding. It affords startling proof of Turner's power of concentration:

> We were standing outside the works on the lines at Plymouth, close under a battery of twenty-four pounders, which opened only three or four feet above our heads. I was startled by the shock, but Turner was unmoved. We were neither prepared for the concussion, but he showed none of the surprise I betrayed, being as unmoved at the sudden noise and involvement in the smoke as if nothing had happened.[77]

99 PLYMOUTH SOUND

Present whereabouts unknown *c.*1813

Original drawing size: 17.8 × 28cm (7 × 11in)
Engraving size: 18.5 × 28.5cm (7¼ × 11¼in)
Engraved: 1815 by W. B. Cooke
Rawlinson No. 138

Nothing is known of the provenance or whereabouts of the drawing from which this engraving was made except that it was offered for sale at Christie's sometime at the end of the nineteenth century. W. G. Rawlinson describes having seen it there[78] but says it was 'very faded'.

The picture forms a companion to *Plymouth Citadel* (98). The view is from Devil's Point with Drake's Island on the far left and on the right Mount Edgcumbe seen across Barn Pool. In the far distance in the centre is the Mew Stone, itself the subject of a drawing in the 'Southern Coast' series (24).

Turner based this work on a study on page 10 of the 1813 'Plymouth, Hamoaze' Sketchbook, TB CXXXI (Drake's Island is carried over from page 9). The whole right side of the engraving is contained in that study, including the large ship on the right. In the sketch, however, this appeared as a two-masted brig. Here Turner has elaborated it into a frigate. The work is suffused with gentle early-afternoon sunlight and one can palpably sense the 'light breeze' that originally formed part of the engraving's title.

100 ST. MICHAEL'S MOUNT, CORNWALL

Colour photograph unobtainable *c.*1811

Original drawing size: 14.6 × 22.2cm (5¾ × 8¾in)
Engraving size: 14.6 × 22.2cm (5¾ × 8¾in)
Engraved: 1814 by W. B. Cooke
Rawlinson No. 88

This drawing is now in a private collection in the U.S.A. and it has only been possible to obtain a black and white photograph of it. The watercolour was recently offered on the London market in a severely faded condition. For this reason the work is now better represented, especially in monochrome, by its engraving. The watercolour is reproduced below.

St. Michael's Mount was originally the site of a monastery dating from the twelfth century. At the Reformation it became royal property, and later passed into private hands. The rock is surmounted

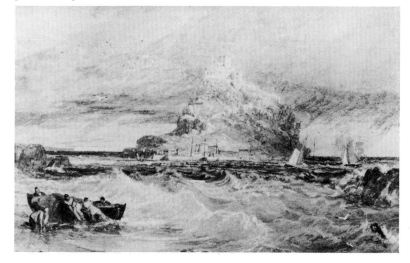

15 *St. Michael's Mount, Cornwall,* watercolour

by a chapel and tower that mainly date from the fourteenth and fifteenth centuries. Turner quite naturally makes the tower the picture's focal point although this effect is now clearer in the engraving where the building is thrown into greater relief by the much darker sky beyond.

On the right are Mount's Bay drifters trawling for mackerel. On the left a pilchard boat is being hauled ashore, its pilchard seine-nets clearly visible.

101 LAND'S END, CORNWALL
Present whereabouts unknown *c.*1811

Original drawing size unknown
Engraving size: 14 × 22cm ($5\frac{5}{8}$ × $8\frac{5}{8}$in)
Engraved: 1814 by George Cooke
Rawlinson No. 90

The drawing for this watercolour was bought and sold by Agnew in 1893; it is now untraced. In the 1822 W. B. Cooke Gallery exhibition catalogue it was titled *The Land's-End, Cornwall. Approaching Thunderstorm* (Cat. No. 31). The work was described by W. G. Rawlinson in 1908 as 'somewhat faded'.[79]

The picture shows the view across Whitesand Bay looking north-east to Cape Cornwall with the Brisons to its left. When the watercolour was exhibited in 1822 it was mentioned in a review by Robert Hunt, the editor of *The Examiner* (4 February, p.75):

Never have we seen so much done, such gigantic talent, in so little space—a few square inches. It is so truly Miltonic, that the mere space is annihilated, and we would rather possess it—as an imaginative stimulant, than half the esteemed English landscapes ever painted.

The engraving is also a superb work with a wide tonal range and strong rhythmic flow. As in the treatment of Land's End in the later 'England and Wales'[80] series Turner depicts the scene without any human figuration, thereby increasing the

sense of utter desolation. The brooding calm seems very threatening.

102 CORFE CASTLE, DORSETSHIRE
Present whereabouts unknown *c.*1811

Original drawing size: 13.8 × 22.3cm ($5\frac{2}{3}$ × $8\frac{7}{10}$in)
Engraving size: 14.6 × 21.6cm ($5\frac{3}{4}$ × $8\frac{1}{2}$in)
Engraved: 1814 by George Cooke
Rawlinson No. 93.

The drawing from which this engraving was made is listed by Andrew Wilton[80a] as belonging to someone named 'Thomson'; the work is now untraced.

Corfe Castle was a Norman building which became a Royalist stronghold during the Civil War. After a long siege it fell to Parliamentary forces and was destroyed in 1646.

Turner visited it in 1811 and sketched it exactly as it appears here (see Concordance). Only the women enliven the scene as they lay out washing to dry in the warm afternoon sun. The contrasted tones of the washing lead the eye to the castle gateway. Turner's original draft letterpress for the engraving[81] specifies his feelings about the ruin:

The arched causeway . . . towering keep
And yet deep fosse, scarce feed the straggling
 sheep,
While overhanging walls, and gateway's nod,
Proclaim the power of force and Time's keen
 rod

103 ILFRACOMBE, NORTH DEVON
Colour photograph unobtainable *c.*1813-7

Original drawing size: 14.4 × 23cm ($5\frac{2}{3}$ × 9in)
Engraving size: 15.9 × 24.1cm ($6\frac{1}{4}$ × $9\frac{1}{2}$in)
Engraved: 1818 by W. B. Cooke
Rawlinson No. 105

The watercolour for this engraving is in a private collection in Switzerland. It was not possible to

get the work photographed in colour. However, the author was able to obtain a black and white photograph (see below) but this is of such poor quality that the picture is more fairly represented by its engraving. W. G. Rawlinson described this print as one of the '. . . finest renderings of a stormy sea in the [Southern Coast] series'. He doubted it has 'ever been surpassed in sea engraving.'[82]

The boiling sea and violent tonal contrasts impart a furious energy to the work. In the centre is a sinking brig, figures clinging to its bowsprit rigging. The ship is highlighted by the brilliant white spume and above it loom the precipitous Hillsborough cliffs which are too sheer and dangerous to make any rescue possible. Onlookers stand around helplessly watching the ship and crew go down.

Ilfracombe can be seen in the distance. At the entrance to the harbour is Lantern Hill, surmounted by a lighthouse converted from the old chapel of St. Nicholas. In the foreground a spar of wreckage points directly to the lighthouse and underlines its inability to keep the ship off the rocks. Turner was to use lighthouses as symbols of failed human endeavour in a number of later works, for example *Orfordness* (93) and *Lowestoffe* (94).

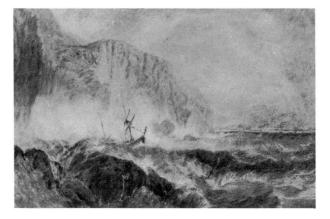

*16 **Ilfracombe, North Devon**, watercolour*

104 DARTMOUTH, DEVON
Present whereabouts unknown

14 × 21.6cm (5½ × 8½in) *c.*1811

This drawing was sold at Christie's in April 1926 when it was bought by Princess Obolensky (*neé* Astor). Although it was exhibited at the Fine Art Society in 1946 it is now untraced.

This is the first and most simple of Turner's several treatments of Dartmouth. He builds the work around his observation of the town's principal industry. In the foreground a fishing-lugger is pulling away from a small hoy which is bringing ashore barrels of Newfoundland cod presumably off loaded from the brigs in the harbour. The Newfoundland fisheries were Dartmouth's main source of income in the early nineteenth century and, despite inroads caused by the great wars of 1793-1815, they still employed a majority of the town's population.

In the distance are Dartmouth Castle and St. Petroch's church. Turner neatly frames them with two masts. He repeats this device in the later drawing of the castle (54) for 'The Rivers of England' series.

105 MARTELLO TOWERS NEAR BEXHILL, SUSSEX

18.4 × 27.3cm (7¼ × 10¾in) *c.*1806-10
Sepia TB CXVII-K

Although it has recently[83] been thought that the basis for the 'Southern Coast' vignette of this subject was a missing watercolour, examination of the lettering of the engraving reveals that the work was 'engraved by W. B. Cooke, by permission of J. M. W. Turner R.A. from his work of Liber Studiorum'. The original sepia drawing which formed the basis of both works is accordingly reproduced here in black and white. The *Liber Studiorum* mezzotint by W. Say was published in June 1811 as Plate 34 of that work (under the title given above). The 'Southern Coast' vignette was published in May 1817. Why Turner should have used an image originally made for the *Liber* as a 'Southern Coast' subject is open to conjecture but perhaps he wanted to see how it would 'translate' into line-engraving.

On the right is Galley Hill, Bexhill. Nine Martello towers can be seen along the coast. Their military purpose is underlined by the addition of some hussars riding up while a suitably aggressive mood is evoked by a man beating a pannier-laden ass. The vigorous handling demonstrates Turner's ability to render the fresh early-morning light and damp atmosphere even in monochrome.

106 WATCHET, SOMERSETSHIRE
Present whereabouts unknown *c.*1818

Drawing size unknown
Engraving size: 15.5 × 24cm (6⅛ × 9⅜in)
Engraved: 1820 by George Cooke
Rawlinson No. 107

This drawing was sold at Christie's on 22 May, 1880 where it was bought by 'Philpott'. It is now untraced. The view is of Blue Anchor bay with Cleeve hill on the left and Minehead in the distance.

When Turner visited Watchet in 1811 he sketched it in rough outline only (see Concordance). In the sketch he indicated a square-shaped rock in the foreground. In the final work this was sharpened to echo the shape of Cleeve hill beyond it. Its more pointed form tautens the composition and increases the embracing movement and sense of enclosure afforded by the harbour. The pointed shape is repeated by the woman's cap in the foreground.

The work is skilfully structured. The nets laid out for mending on the left are the culmination of a series of lazy circular rhythms running across the picture from the right. The engraving conveys the warm afternoon sunlight well. A woman carries up washing in the foreground while others lay it out to dry on the extreme left. Their activity underlines the sense of heat. The idle sailors with their discarded bottle also extend the picture's torpid mood.

107 ENTRANCE OF FOWEY HARBOUR, CORNWALL
Present whereabouts unknown *c.*1816-7

Original drawing size: 15.2 × 22.9cm (6 × 9in)
Engraving size: 15.5 × 23.4cm (6⅛ × 9¼in)
Engraved: 1820 by W. B. Cooke
Rawlinson No. 109

The watercolour upon which this engraving was based was last known to belong to A. C. Pilkington; it was sold in 1966 and is now untraced. It was exhibited in 1824 under the title of *Fowey Harbour, Cornwall.*

The work takes an identical viewpoint to the picture of the same subject in the later 'England and Wales' series.[84] Both show St. Catherine's fort on the right and in the distance the forts built by Edward IV. The two pictures were based upon the same sketch (see Concordance). The later work depicts drowning and shipwrecked figures with flare-carrying rescuers on the rocks at the right. Here, in a somewhat calmer mood, Turner depicts a brig entering harbour and a pilchard boat raising her lugsail.

108 RAMSGATE, KENT

Present whereabouts unknown *c.*1823
Original drawing size: 16.5 × 24.1cm (6½ × 9½in)
Engraving size: 15.2 × 24.1cm (6 × 9½in)
Engraved: 1824 by Robert Wallis
Rawlinson No. 117

The drawing for this engraving was last seen at the Levy sale at Christie's in 1875; it is now untraced.

On the left two fishing smacks have sailed upwind and are lowering their sails so as not to make too much way on entering harbour. Beyond

them is the 1802 lighthouse and on the far right the brig seen in *Ramsgate* (72) is here putting out to sea in a far less dramatic manner. A diagonal line under it leads the eye to a buoy and to what seems to be a whirlpool whose circular motion balances the upward line of the wave on the left. This curved shape can also be observed in the line of light in the sky and in the rounded end of the east pier beneath it. Note the man on a horse in front of the lighthouse.

109 MOUNT EDGECOMB, DEVONSHIRE

Present whereabouts unknown *c.*1818

Original drawing size unknown
Engraving size: 16.2 × 24.1cm (6⅜ × 9½in)
Engraved: 1826 by Edward Goodall
Rawlinson No. 125

Nothing is known about the early history or whereabouts of the original drawing for this engraving.

Mount Edgcumbe, to the west of Plymouth, was the site of a great country-house built between 1547-54 and virtually destroyed in the Second World War. The surrounding park was always very famous and it was a 'must' for any tourist visiting Plymouth.

We see Mount Edgcumbe from Mount Batten point across Plymouth Sound. On the right a man-of-war is beating up for anchor. She has backed her foresails and topsails and is sheeting in her top gallants. Along the deck the men are manning the anchor-capstan and getting ready to go aloft. In the foreground are a lobster-boat and a lugger. A hoy comes up on the left. Despite the unpromising nature of the view Turner creates a picture that is charged with energy, the sky and sea creating rich and complex rhythms. The engraving is particularly fine. The watercolour was paid for by W. B. Cooke in July 1818 and Turner noted it as a work in hand on page 35a of the 'Hints River' Sketchbook (TB CLXI) of 1815-8.

110 BRIGHTHELMSTON, SUSSEX

Present whereabouts unknown 1824

15.2 × 22.9cm (6 × 9in)

This drawing was last known to belong to a 'Mrs. Robinson of Sheffield' who bought it at around the turn of the century. It is now untraced.

The work was very topical when it was created: the chain-pier had only been completed in November 1823. It was a 378-yard long suspension bridge supported on four columns and was destroyed by a storm in December 1896. Turner painted several pictures of it.

On the hill in the distance is the parish church of St. Nicholas. The Marine (or Royal) Pavilion stands in the centre. This was also only finished in 1823. Beyond the pier is Marine Parade which was still under construction. On the pier itself is a signal mast. In the foreground two luggers are passing one another, the nearest reducing sail as it runs before the wind, the other tacking up.

Immediately beneath the principal dome of the Royal Pavilion Turner places a large winch (on a ramp) which was for dragging large boats on to the shingle. Under the winch he draws a buoy, thus creating a series of circular repetitions. He was very fond of vertical reiterations of this sort (see *Portsmouth, Hampshire,* 42). Running through the work, moreover, is a series of major circular movements. These can be observed most clearly in the wave to the left of the nearest boat, the shape of the boat's hull itself and the counter-rhythms of the chain-pier's suspension system.

111 TYNEMOUTH PRIORY

Present whereabouts unknown

15.9 × 24.1cm (6¼ × 9½in) *c.*1825

This drawing may be in a British private collection but although it was photographed very recently there is now no record of its whereabouts. The picture was engraved (under the title given above) by William Miller in the early 1840s for 'Dr

Broadley's Poems', a private publication.[85] The drawing has been dated[86] *circa* 1818, but it was without doubt made later. It was not engraved for either the 'Rivers' or the 'Ports' series but it was probably made for one of them. It is the same general size as those drawings and comparison with *Whitby* (70) in 'The Ports of England' reveals a startling resemblance between the two works, both in the configuration of the land and shipping and also in the handling and quality of execution. Perhaps it was this similarity that led Turner to divert the drawing elsewhere. Moreover, Tynemouth is not a port but a small town at the entrance to one of England's great rivers and the work could well have been intended for the 'Rivers' (rather than the 'Ports') series. The 'Rivers' project already contained two Tyne subjects, *Shields, on the River Tyne* (49) and *Newcastle-on-Tyne* (50), so this may also account for the work's separation.

On the left is a cutter-rigged fishing smack. In the centre a coble, a hoy and a brig are all in danger of colliding. A man climbs the shrouds on the brig to secure the main top-gallant sail. Beyond the brig is another (wrecked) brig also appears at the same spot in a later view of Tynemouth in the 'England and Wales'[87] series. On top of the steep cliffs is Tynemouth Priory with the lighthouse to the right.

'East Coast'

112 WHITBY

Original watercolour probably destroyed *c.*1827

Original watercolour size: 16.5 × 25.4cm (6½ × 10in)
Engraving size: 19 × 25.4cm (7½ × 10in)
Engraved: (open etching only) by J. C. Allen c.1828
Rawlinson No. 312

The watercolour for this uncompleted engraving

is untraced. However, there is a very great probability[88] that it was destroyed by fire at Brocklesby Hall, Lincolnshire on 27 March, 1898.

An open etching is the preliminary state of an engraving. The work reproduced here had only reached this stage when it was abandoned. It is probably our only evidence of the appearance of the original work.

'Marine Views'

113 THE EDDYSTONE LIGHTHOUSE

Present whereabouts unknown *c.*1817

Original drawing size: 43 × 65cm (16$\frac{9}{10}$ × 25$\frac{1}{2}$in)
Engraving size: 21.6 × 31.1cm (8$\frac{1}{2}$ × 12$\frac{1}{4}$in)
Engraved: 1824 by T. Lupton
Rawlinson No. 771

The drawing for this engraving was sold at Christie's on 17 April, 1869 and it has not been seen in public since.

The third Eddystone lighthouse was built by James Smeaton between 1757 and 1759. It was re-erected on the Hoe in Plymouth in 1882. Turner probably visited the lighthouse in 1813 (see Concordance). The watercolour on which this mezzotint was based has recently[89] been dated *circa* 1822 but it was hired from Turner by W. B. Cooke in 1817 (see Appendix B).

Mezzotint is a process which entails working from dark to light (the plate is initially black all over and the lighter areas of tone are achieved by burnishing). Because of this it is an ideal medium for expressing night-effects and Turner was to experiment with it precisely for this reason in a group of mezzotints known as the 'Little Liber' series.

He depicts the lighthouse in the midst of a storm. In front of it is a wrecked mast and mizzen-top. In the distance is the ship to which they belong. Note the trail of smoke issuing from the light.

114 SUN-RISE. WHITING FISHING AT MARGATE

Yale Center for British Art, 1822
Paul Mellon Collection, U.S.A.

Original drawing size: 42.6 × 64.8cm (16$\frac{3}{4}$ × 25$\frac{1}{2}$in)
Engraving size: 21.4 × 31.2cm (12$\frac{5}{16}$ × 8$\frac{5}{16}$in)
Engraved: 1825 by T. Lupton
Rawlinson No. 772
Signed and dated

The drawing for this mezzotint was untraced until it was recently acquired by the Yale Center for British Art. Unfortunately it was only learnt that the picture had reappeared after the illustrations for this book had gone to press, and so the work is represented by its engraving.

Amid the perfect calm of sea and sky Turner creates a veritable hubbub as fishermen work, compare and barter their catches. Margate pier with its lighthouse and the town can be seen on the right. At the deep entrance to the harbour Turner improbably places a bathing-machine! In the distance on the extreme left a frigate fires the morning gun, adding to the impression of noise.

115 FISH-MARKET, HASTINGS

Present whereabouts unknown

44.4 × 66.3cm (17$\frac{1}{2}$ × 26$\frac{1}{8}$in) 1824
Signed and dated

This drawing was sold by the Hammer Galleries, New York, in the mid-1960s but it is now untraced. The Hammer Galleries offered it for sale under the title of *Arabs trading on the beach*. Their uncertainty as to the precise location of the subject may have been caused by the fact that it contains figures not normally associated with a Hastings fish-market.

In the centre some middle-class ladies (accompanied by a schoolboy with a hoop) are discussing the fish on offer with fishermen and fishwives. This group of figures is framed by two people in Greek costume.[90] Kneeling on the right is a man whose bandaged arm is supported by a sling. He is dressed in Attic costume. The woman on the left is dressed in the chieftain's attire typical of Roumeli and the Morea. She has her hand on a fisherman's shoulder in an attempt to attract his attention. A spear-like grappling-hook has been planted in the sand in front of her.

The drawing was made for the 'Marine Views' series between January and April 1824 and it was displayed in the W. B. Cooke Gallery exhibition which opened on 8 April. At the time the Greek War of Independence was at its height (Byron died at Missalonghi on 19 April) and there was widespread activity taking place in Britain to raise money for the Greeks. Turner had shown[91] a particular interest in the cause of Greek Independence since 1816.

Between 1823 and 1824 Turner made seven illustrations for an edition of 'Lord Byron's Works' that appeared in 1825. One of them depicts the Acropolis with Greeks fighting Turks in the foreground.[92] In addition, an 1822 watercolour entitled *The Acropolis, Athens*[93] takes its theme from Byron's *Giaour* and shows the citadel in the distance with Greece symbolized as a beautiful chained nude reclining in the foreground beneath a watchful Turkish guard. Underneath is written the quotation 'T'is living Greece no more'. It seems natural, therefore, that two years later Turner should have introduced a *clothed* symbol of nascent Greece into one of his pictures. Here the Greek figures are positioned at the edge of the crowd and are perhaps attempting to draw the attention of the English to their cause. The attention-seeking gesture was to be repeated by Turner in an 1830-1 watercolour of *Northampton* (in the 'England and Wales' series)[94] where a French 'Marianne' reminds an elderly Tory of the 1830 revolution in France. Interestingly, there is also a reference to Greek Independence in the 'England and Wales' series. In *Nottingham*,[95] a work that celebrates the passing of the 1832 Reform Bill, the flag of the new State of Greece (1831) flies from the mast of a canal boat.

In the early morning haze Turner exaggerates the height of the cliffs. On the right is a winch for

hauling boats ashore and beyond it a hut made from an upturned boat. This was obviously a forerunner of the 'net-shops' (sheds for hanging nets in) which exist on the same spot today.

116 TWILIGHT–SMUGGLERS OFF FOLKESTONE FISHING UP SMUGGLED GIN

43.2 × 64.8 cm (17 × 25½ in) 1824
Signed and dated

This work has recently been listed[96] as untraced but it is in fact in a private collection in the U.K. Unfortunately it was not possible to obtain a colour transparency of it.

The picture is a logical development of *Folkestone from the sea* (66) which shows the gin being 'sunk' at dawn. Here it is being 'crept' after sunset. Aboard a small rowing-boat the smugglers peer around warily as they go about their clandestine activities. The boat tilts precariously as the heavy kegs are taken aboard.

The drawing was extremely well-received when it was exhibited in 1824. Robert Hunt in *The Examiner* (19 April) wrote '. . . water was never more illusively lucid . . . though MR. TURNER draws figures badly, he manages, in spite of this drawback, to give them very expressive action'. *The Literary Gazette* (10 April) called it 'among the most spirited effusions of [Turner's] pencil'. Ackermann's *Repository of the Arts* (May), characterised it as '. . . a fine marine production. There is a richness, a force of expression and a bold tone of nature in every part.' More recently A. J. Finberg wrote memorably that '. . . the hurried movements of the three picturesque ruffians in the nearer boat, their anxiety to avoid observation either from the sea or the cliffs, the tumult of the scurrying storm-clouds, the majestic roll of the incoming waves fretted with wreaths of foam and angry little jets of spray by those recoiling from the land—all this seen in the gathering twilight, makes up a moving drama comparable in imaginative power to many of his earlier sea-pieces.'[97]

GLOSSARY OF SHIPS PAINTED BY TURNER

It should be remembered that much variety is encountered in the rigging of each type of ship and that Turner occasionally simplifies or alters their characteristics. Some masting terms are given at the end.

Brig: a large two-masted, square-rigged ship (see *Dover*, 71 or *Ramsgate*, 72).

Coble: flat-bottomed fishing-boat common to the north-east coast of England (see *Whitby*, 70).

Cutter: a fast, single masted vessel rigged much like a sloop (q.v.), with a long bowsprit, a topsail and a gaff mainsail (see *Portsmouth*, 74).

First-rate Warship: after 1810 this was any ship of the line (q.v) that carried more than 110 guns (see *Portsmouth*, 74).

Frigate: a class of three-masted warship with one gun-deck (see *Plymouth Sound*, 99).

Hoy: a small, single-masted coasting and river vessel with a variety of rigs (see *Hastings*, 13 or *Mount Edgecomb*, 109).

Longboat: the largest of the ship's-boats carried on a warship. It was also the principal lifeboat (see *Portsmouth*, 74).

Lugger: a sailing vessel, usually two-masted, rigged with lugsails (see *Dover*, 71 or *Deal*, 76).

Ships of the line: warships were divided into six rates. The first three rates were ships considered powerful enough to sail in the line of battle during engagements and were therefore known as ships of the line.

Sloop: the class of vessel immediately below Frigate (q.v.). Turner depicts a Bermuda sloop in *Stangate Creek* (62).

Yawl: a two-masted sailing boat with a mainmast and a small mizzenmast stepped aft the steering gear (see *Hastings*, 13).

MASTS

Foremast: the first mast of a three-masted ship. In two-masted ships where the second mast is smaller than the first, the leading mast is known as the mainmast.

Mainmast: the largest mast on a ship.

Mizzenmast: the aftermost mast of a three-masted square-rigged ship. Also the name of the small aftermast of a ketch or yawl.

EXHIBITIONS

Listed below are the drawings in this book exhibited in Turner's lifetime with their original catalogue numbers.

All the drawings were owned by W. B. Cooke unless otherwise stated.

1822 W. B. Cooke Gallery, 9 Soho Square
1 *Ilfracombe, North Devon—Storm and Shipwreck*
2 *Tintagel Castle, Cornwall*
3 *Lyme Regis, Dorsetshire: a squall*
9 *Hastings from the sea*
15 *Torbay, seen from Brixham, Devonshire*
26 *Dartmouth, Devon* [lent by Charles Stokes]
31 *The Lands-End, Cornwall. Approaching Thunderstorm*
91 *Winchelsea, Sussex, and the Military Canal*
92 *Poole, and distant View of Corfe Castle, Dorsetshire* [lent by Charles Stokes]
94 *Minehead, Somersetshire*
103 *Lulworth Castle, Dorsetshire*
104 *Pendennis Castle, Cornwall; scene after a Wreck* [lent by G. Cooke]
111 *Weymouth, Dorsetshire*
112 *Teignmouth, Devonshire*
113 *Plymouth Dock, from near Mount Edgecumbe*
117 *St. Michael's Mount, Cornwall* [lent by Sir John St. Aubyn]
244 *East and west Looe, Cornwall*
279 *Bow and Arrow Castle, Island of Portland* [lent by J. C. Allen]
294 *Watchett, Somersetshire* [G. Cooke]
1823 W. B. Cooke Gallery, 9 Soho Square
15 *Pevensey Castle, Sussex* [lent by J. Fuller]
26 *Dover Castle. Drawn in December 1822*
99 *Hurstmonceux Castle, Sussex* [lent by J. Fuller]
 uncatalogued: *A Sun-rise* and *A Storm*
1824 W. B. Cooke Gallery, 9 Soho Square
21 *Fish-market, Hastings*
32 *The Mew Stone at the entrance of Plymouth Sound* [lent by Charles Stokes]
41 *Twilight-smugglers off Folkestone fishing up smuggled gin*
86 *The Observatory in Rose-hill Park, the seat of John Fuller, esq.*
93 *Margate* ['Southern Coast'—lent by George Cooke]
94 *Bridport, Dorsetshire* [lent by Charles Stokes]
99 *Fowey Harbour, Cornwall* [lent by Charles Stokes]
104 *Warkworth Castle. In the possession of Messrs. Hurst, Robinson & Co. (for sale)*
1829 Egyptian Hall Piccadilly (organised by Charles Heath)
21 *River Tavey Devonshire* [lent by Charles Heath?]

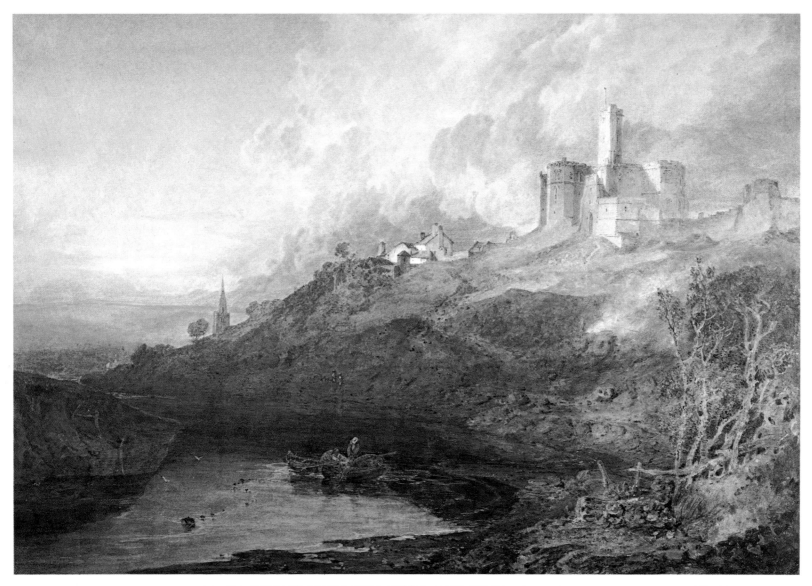

1 WARKWORTH CASTLE, NORTHUMBERLAND — THUNDER STORM APPROACHING AT SUN-SET Victoria and Albert Museum, London 'The Rivers of England'

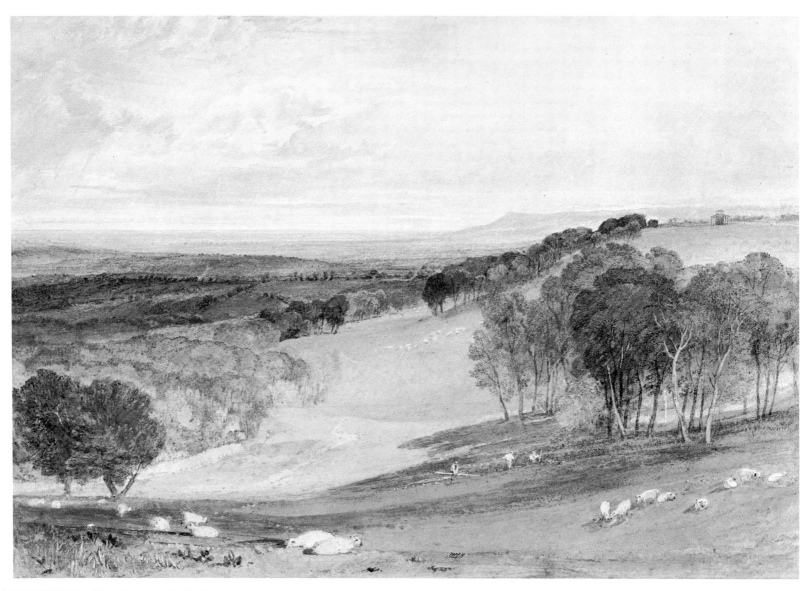

2 ROSEHILL Fitzwilliam Museum, Cambridge

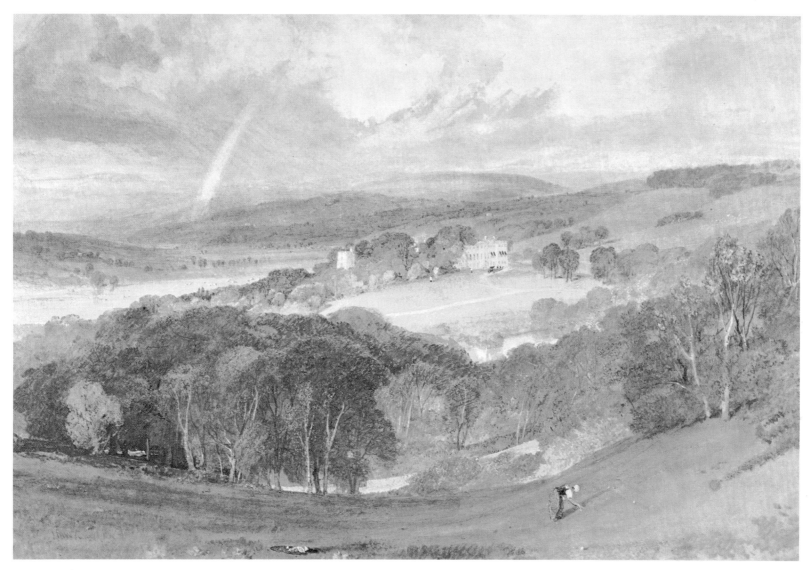

3 ASHBURNHAM University of Liverpool, U.K.

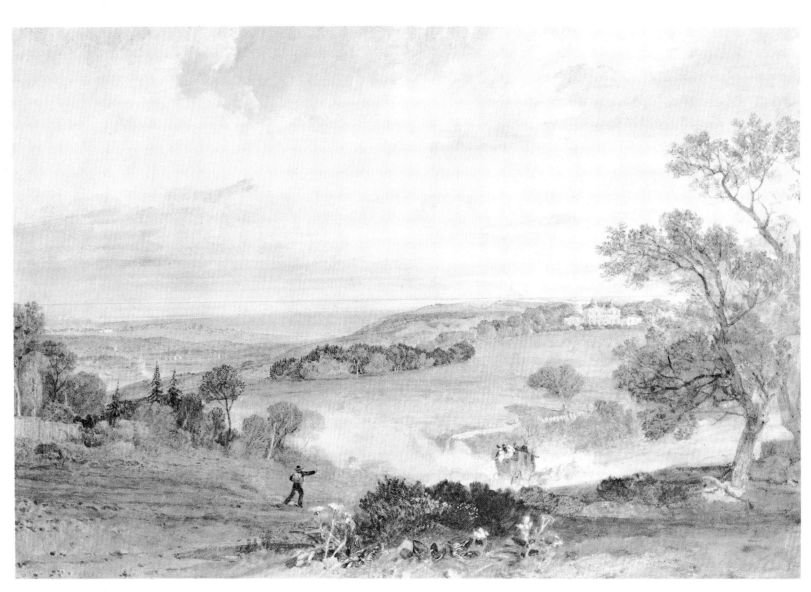

4 BEAUPORT Fogg Art Museum, Harvard University, U.S.A.

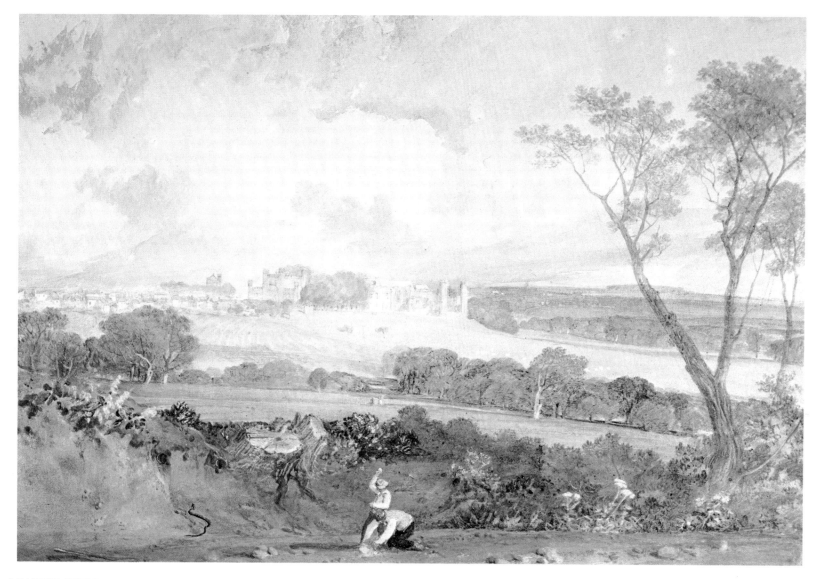

5 BATTLE ABBEY Private Collection, U.K.

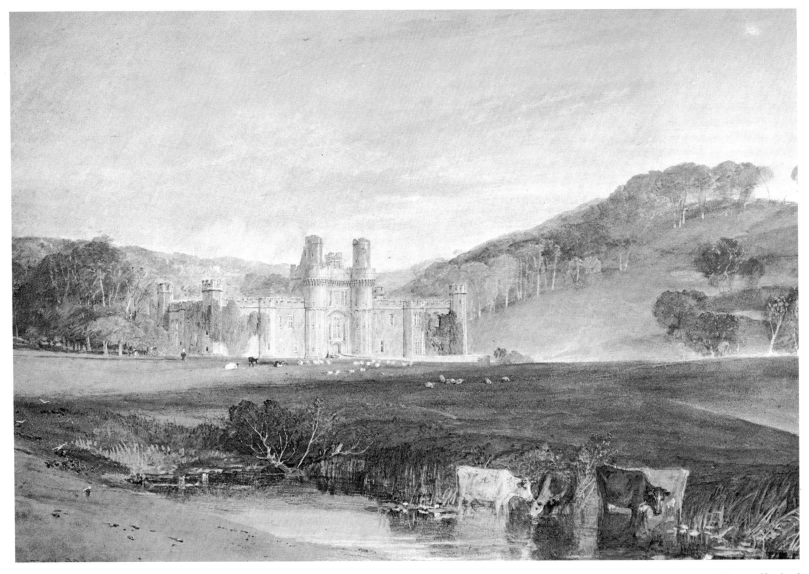

6 HURSTMONCEUX CASTLE, SUSSEX Private Collection, U.K.

'Views at Hastings'

7 PEVENSEY BAY, FROM CROWHURST PARK Private Collection, U.K.

'Views in Sussex'

8 ROSEHILL, SUSSEX British Museum, London

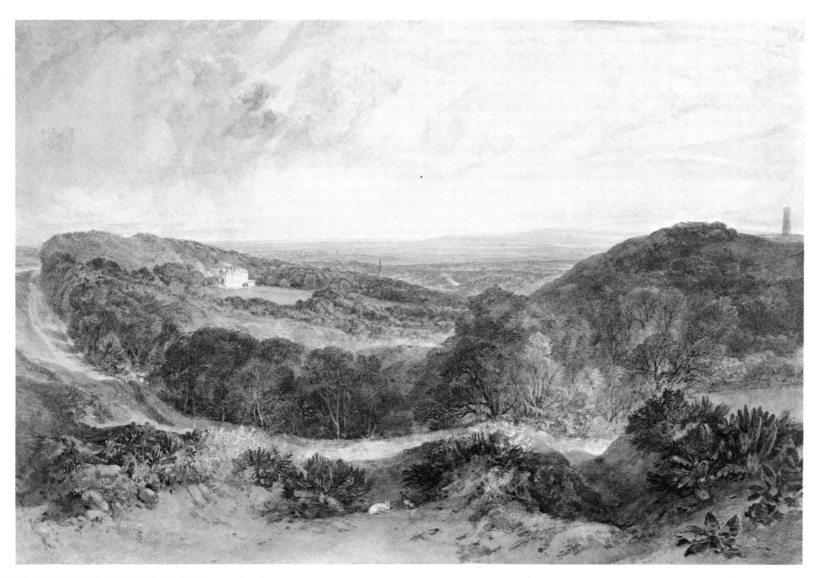

9 THE VALE OF HEATHFIELD British Museum, London

'Views in Sussex'

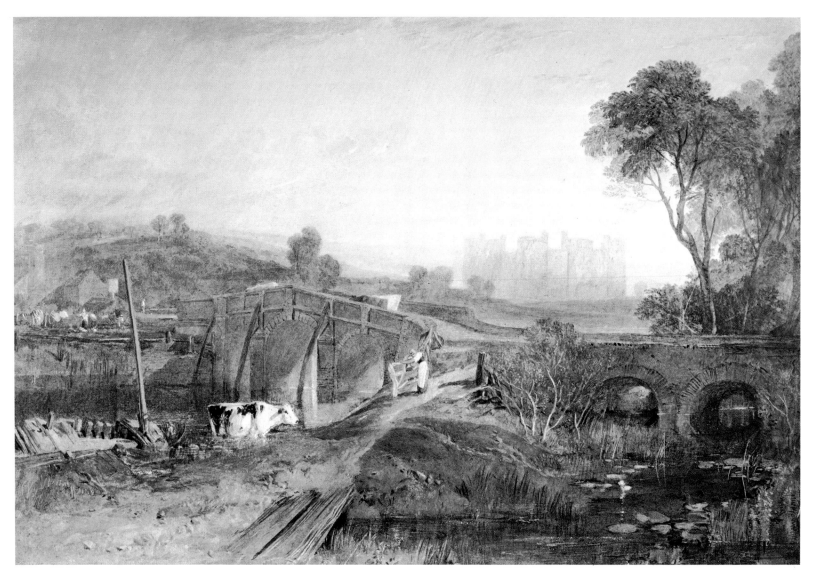

10 BODIHAM CASTLE, SUSSEX Private Collection, U.K.

'Views at Hastings'

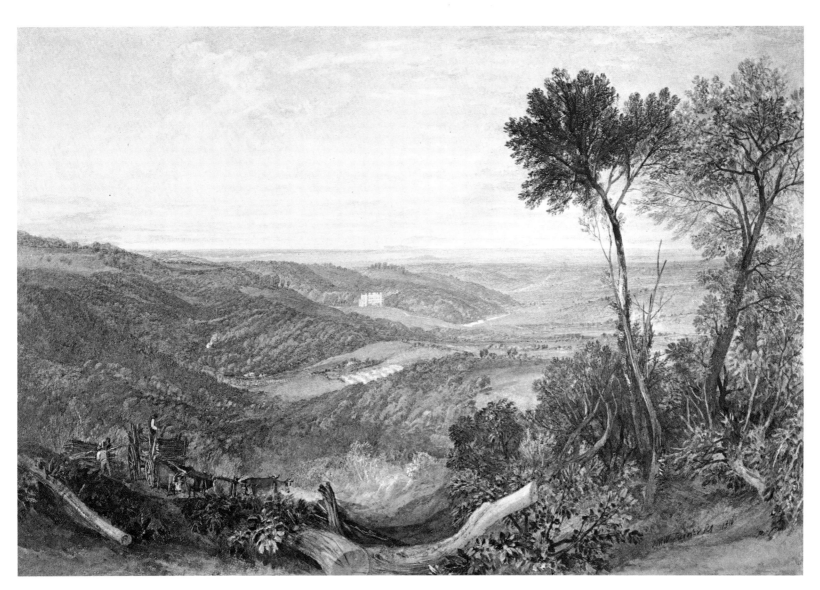

11 THE VALE OF ASHBURNHAM British Museum, London

'Views in Sussex'

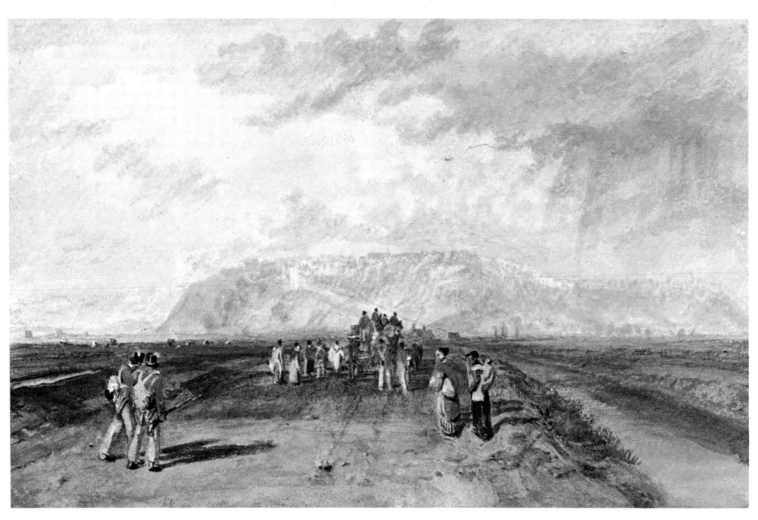

12 WINCHELSEA, SUSSEX, AND THE MILITARY CANAL Private Collection, U.K.

'Views at Hastings'

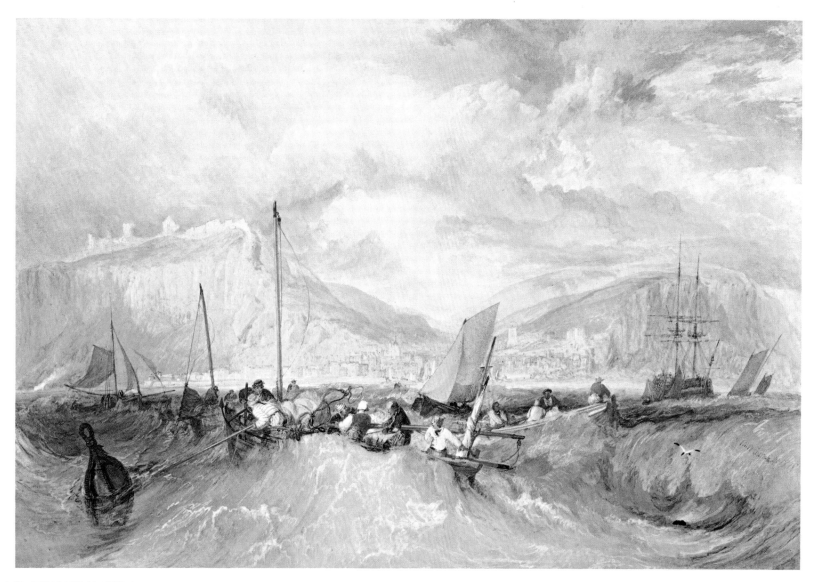

13 HASTINGS FROM THE SEA British Museum, London

'Views at Hastings'

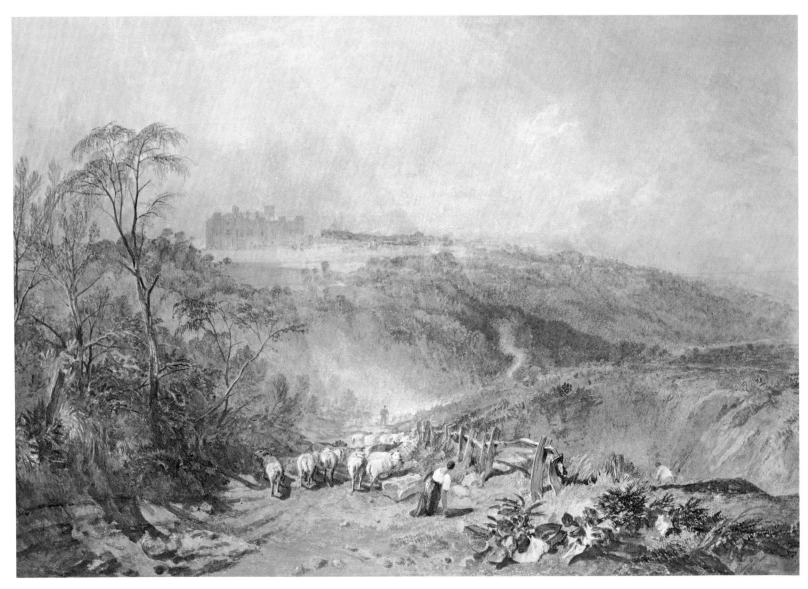

14 ERIDGE CASTLE, EAST SUSSEX Whitworth Art Gallery, Manchester, U.K.

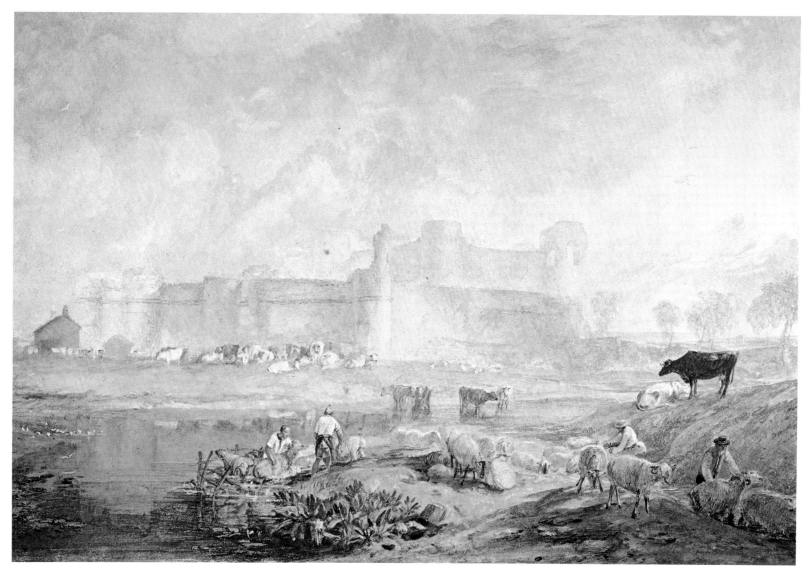

15 PEVENSEY CASTLE, SUSSEX Private Collection, U.K.

16 IVY BRIDGE, DEVONSHIRE British Museum, London (Turner Bequest)

'The Rivers of Devon'

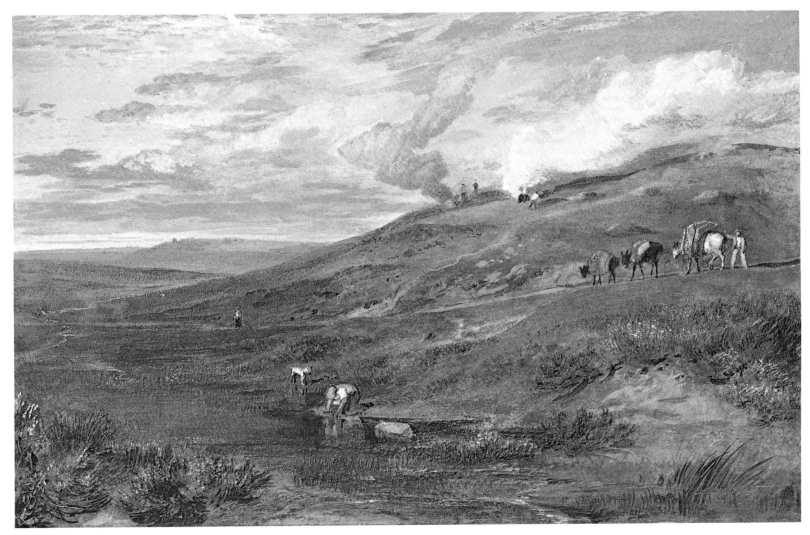

17 SOURCE OF THE TAMAR AND TORRIDGE Yale Center for British Art, Paul Mellon Collection, U.S.A.

'The Rivers of Devon'

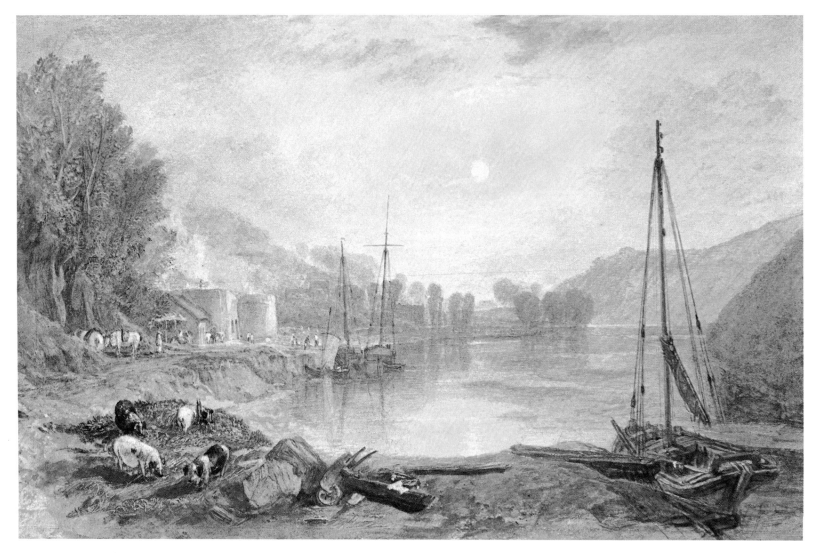

18 RIVER TAVEY, DEVONSHIRE Ashmolean Museum, Oxford

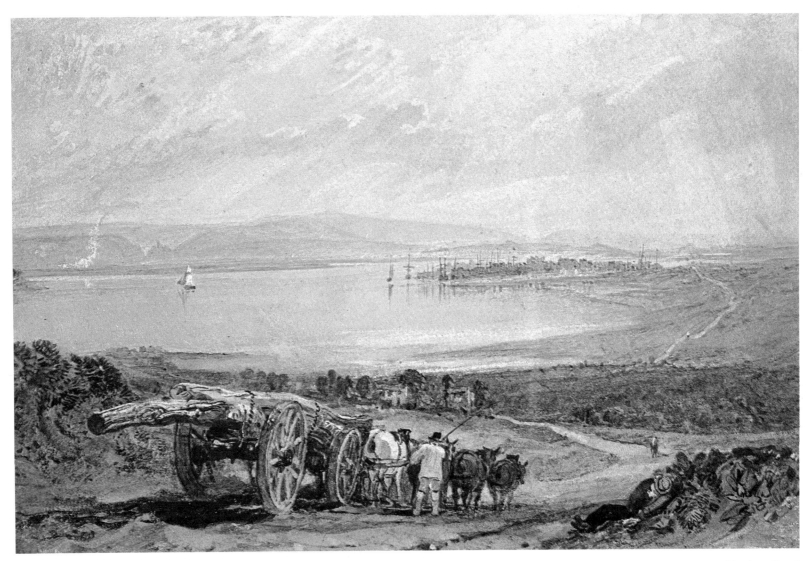

19 POOLE, AND DISTANT VIEW OF CORFE CASTLE, DORSETSHIRE Private Collection, U.K.

'Southern Coast'

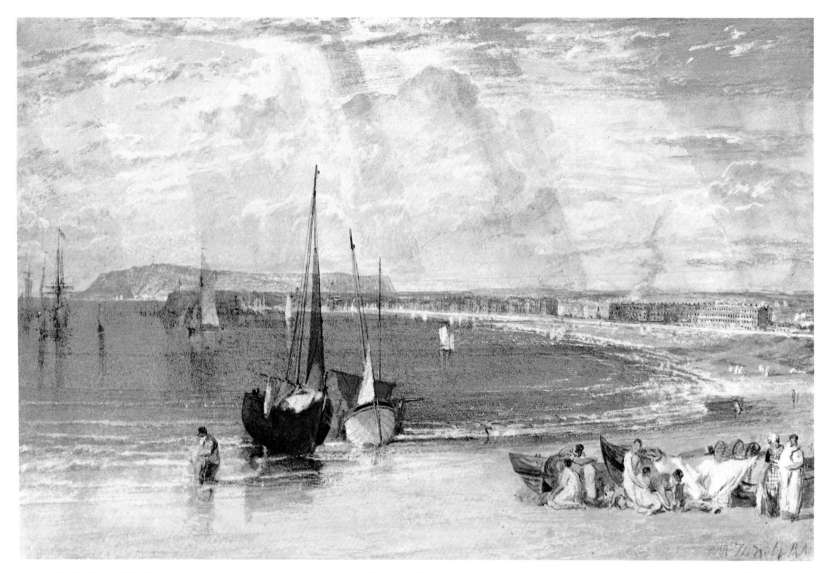

20 WEYMOUTH, DORSETSHIRE Yale Center for British Art, Paul Mellon Collection, U.S.A.

'Southern Coast'

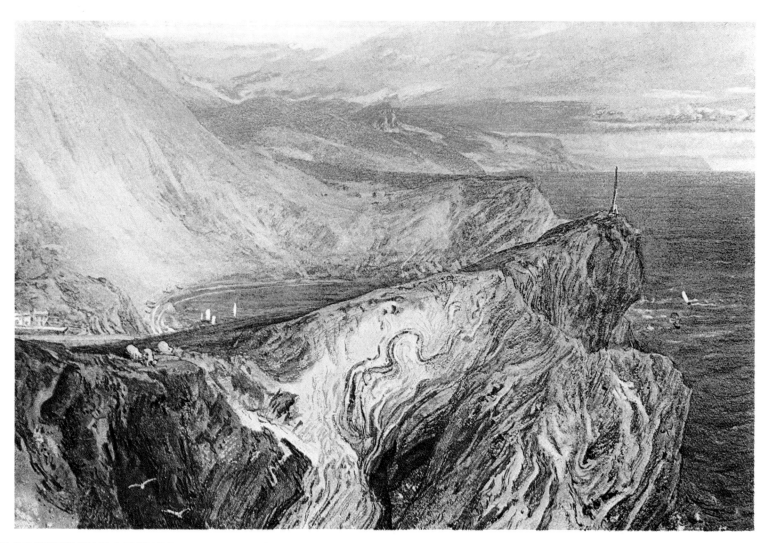

21 LULWORTH COVE, DORSETSHIRE Present whereabouts unknown

'Southern Coast'

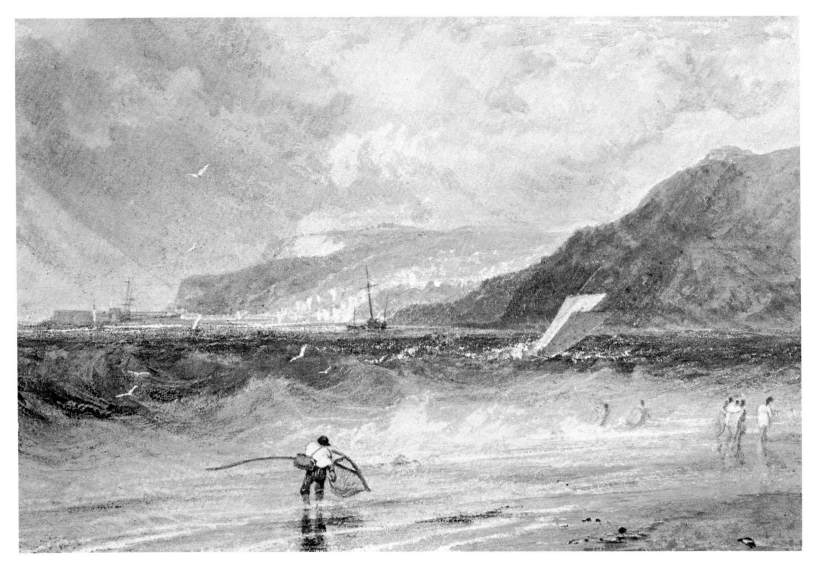

22 LYME REGIS, DORSETSHIRE: A SQUALL Art Gallery and Museum, Glasgow, U.K.

'Southern Coast'

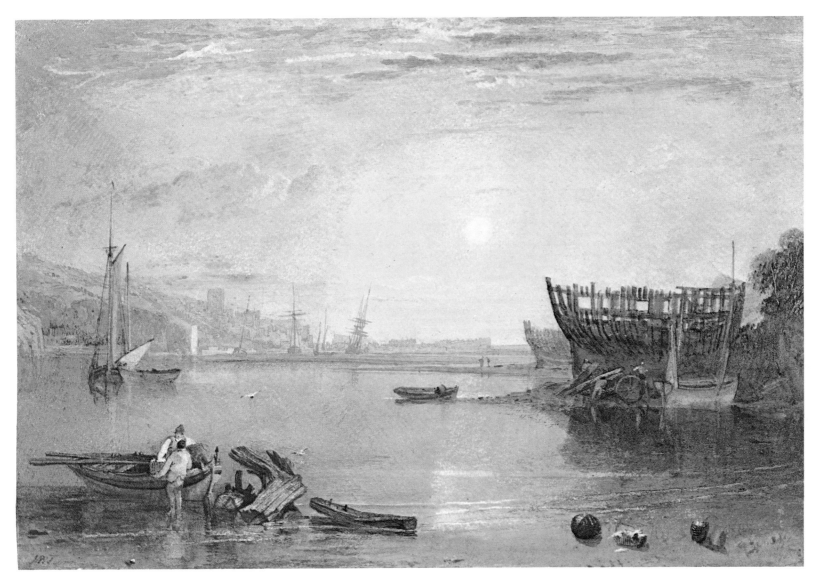

23 TEIGNMOUTH, DEVONSHIRE Yale Center for British Art, Paul Mellon Collection, U.S.A.

'Southern Coast'

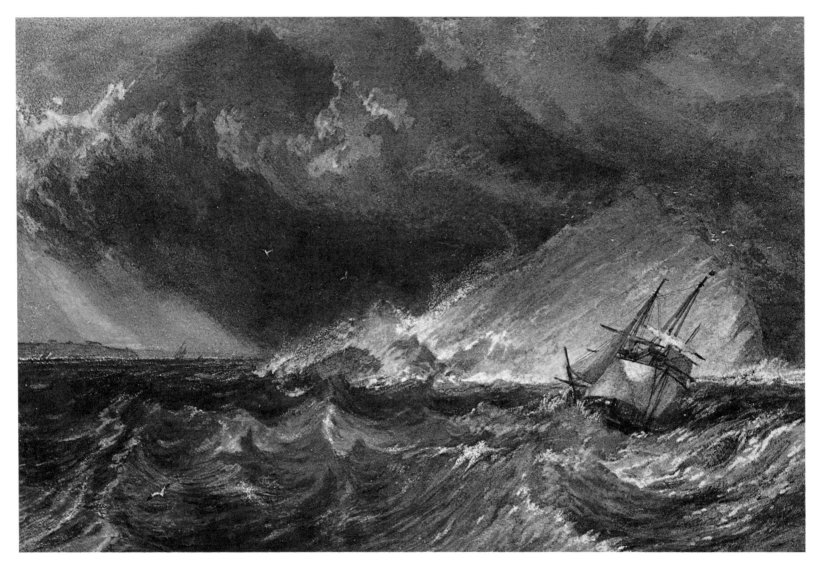

24 THE MEW STONE AT THE ENTRANCE OF PLYMOUTH SOUND National Gallery of Ireland, Dublin

'Southern Coast'

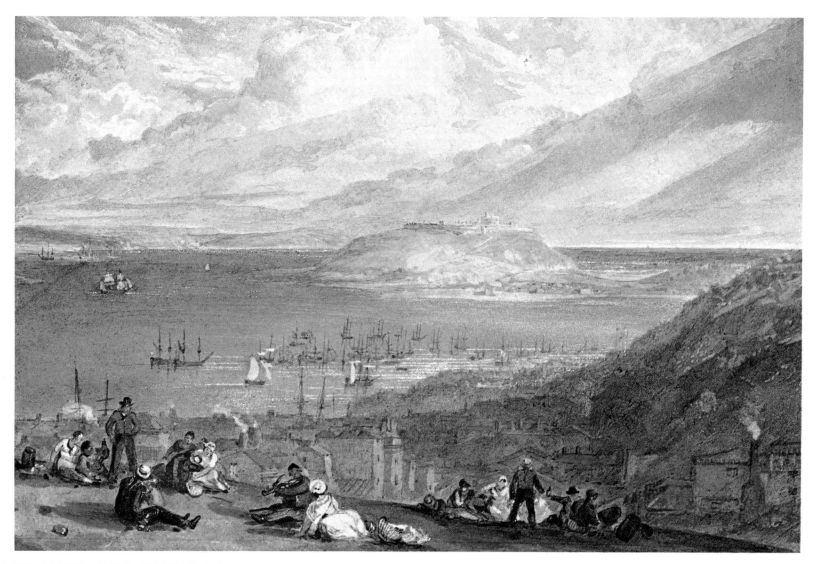

25 FALMOUTH HARBOUR, CORNWALL Lady Lever Art Gallery, Port Sunlight, U.K.

'Southern Coast'

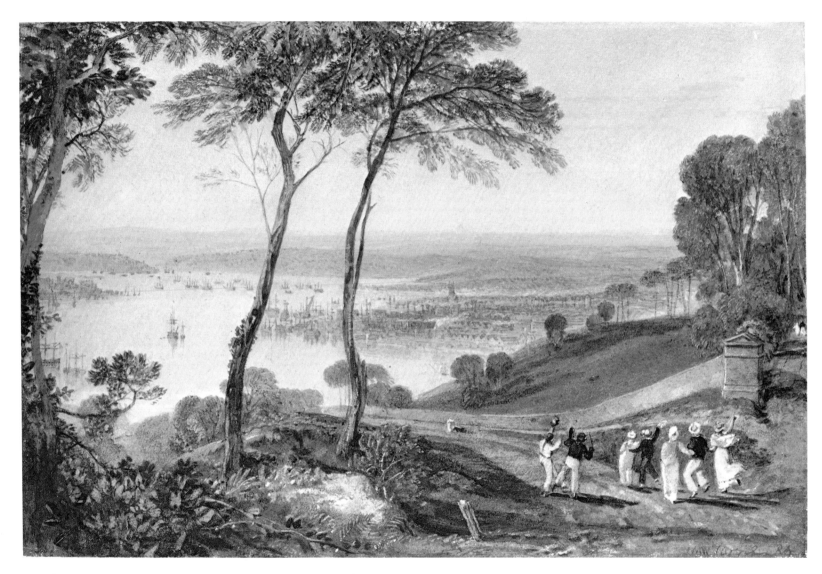

26 PLYMOUTH DOCK, FROM NEAR MOUNT EDGECUMBE Private Collection, U.K.

'Southern Coast'

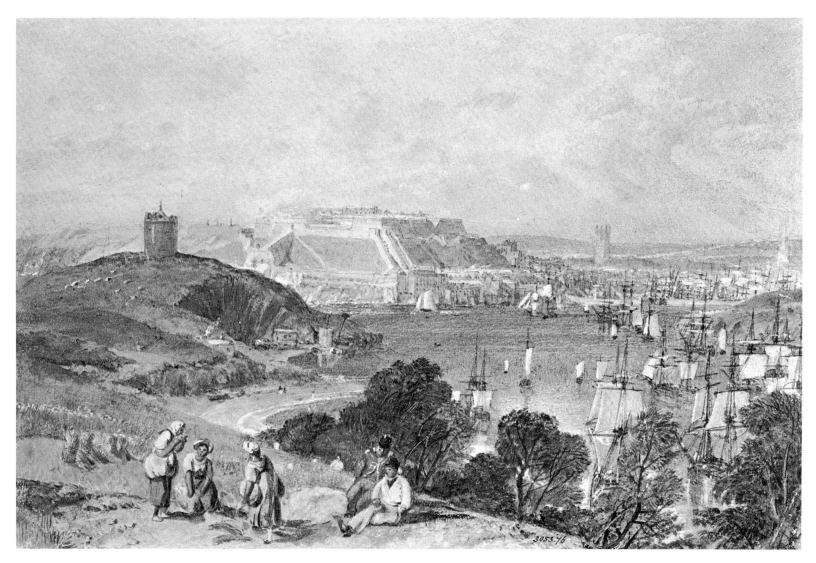

27 PLYMOUTH, WITH MOUNT BATTEN Victoria and Albert Museum, London

'Southern Coast'

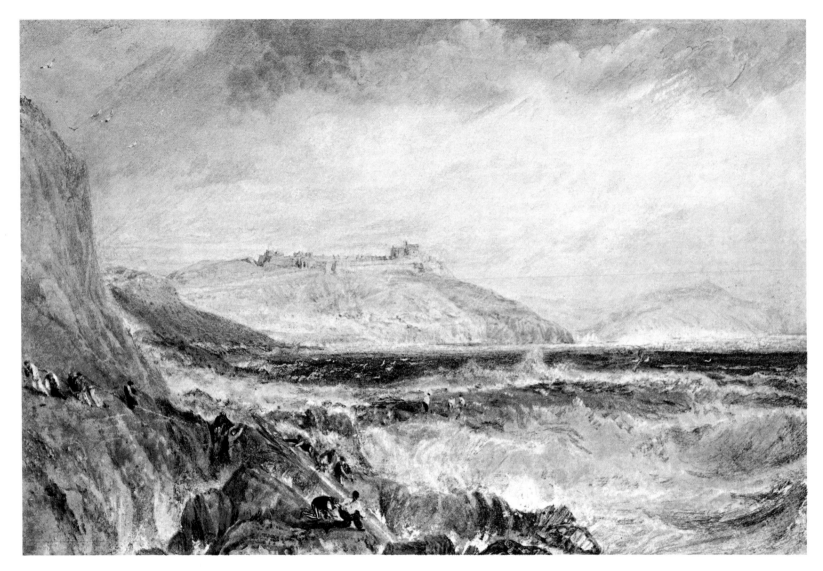

28 PENDENNIS CASTLE, CORNWALL; SCENE AFTER A WRECK Private Collection, U.K.

'Southern Coast'

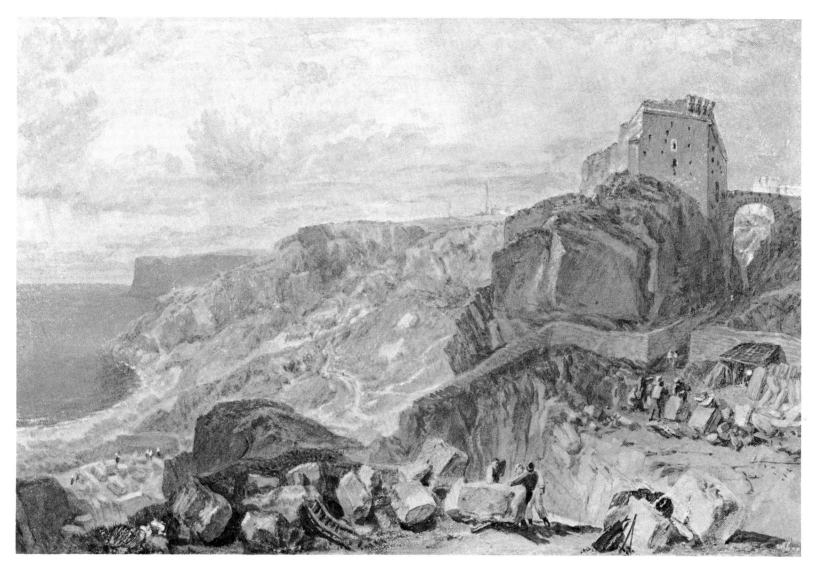

29 BOW AND ARROW CASTLE, ISLAND OF PORTLAND University of Liverpool, U.K.

'Southern Coast'

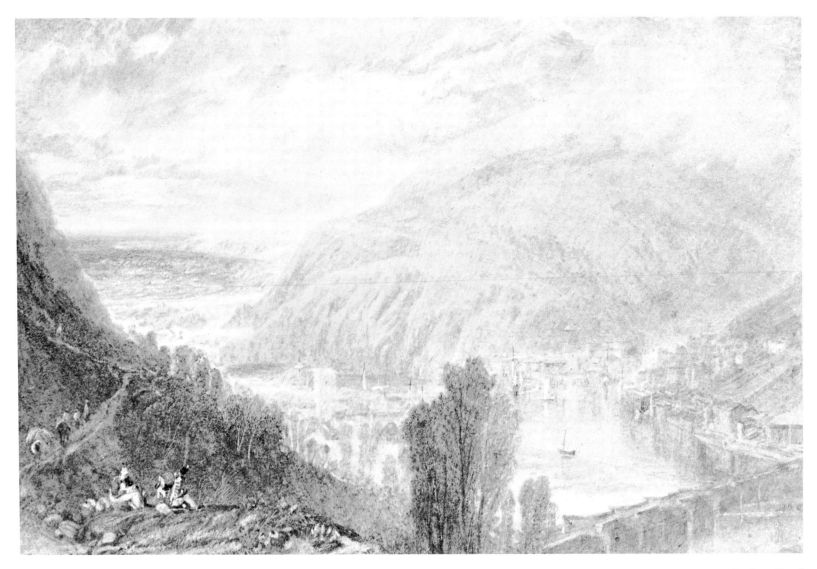

30 EAST AND WEST LOOE, CORNWALL Manchester City Art Gallery

'Southern Coast'

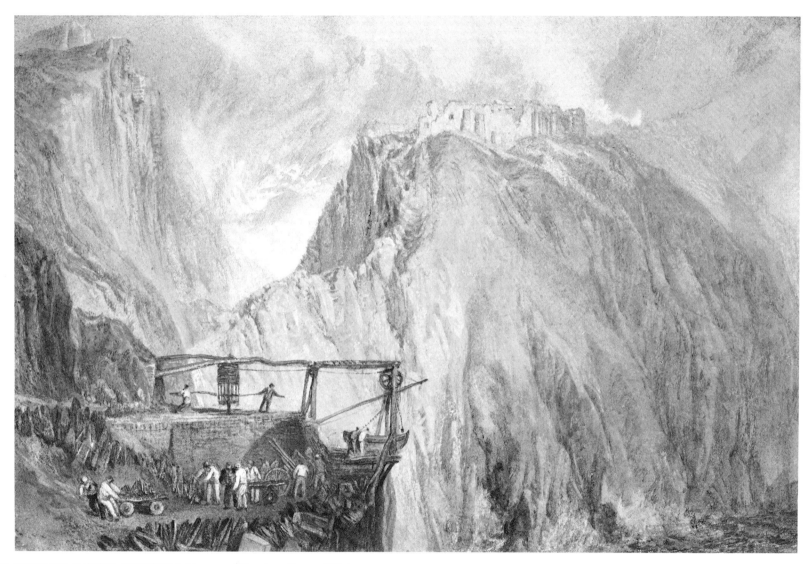

31 TINTAGEL CASTLE, CORNWALL Museum of Fine Arts, Boston, U.S.A.

'Southern Coast'

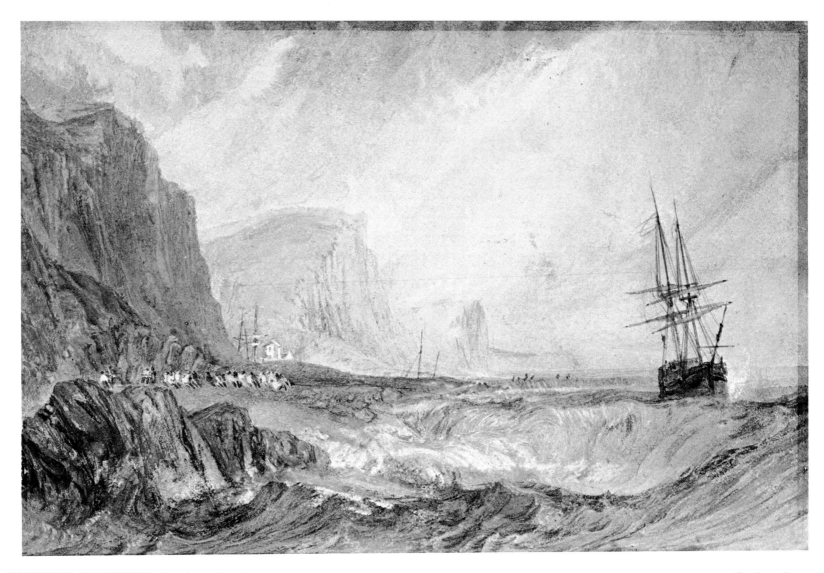

32 BRIDPORT, DORSETSHIRE Bury Art Gallery, Bury, U.K.

'Southern Coast'

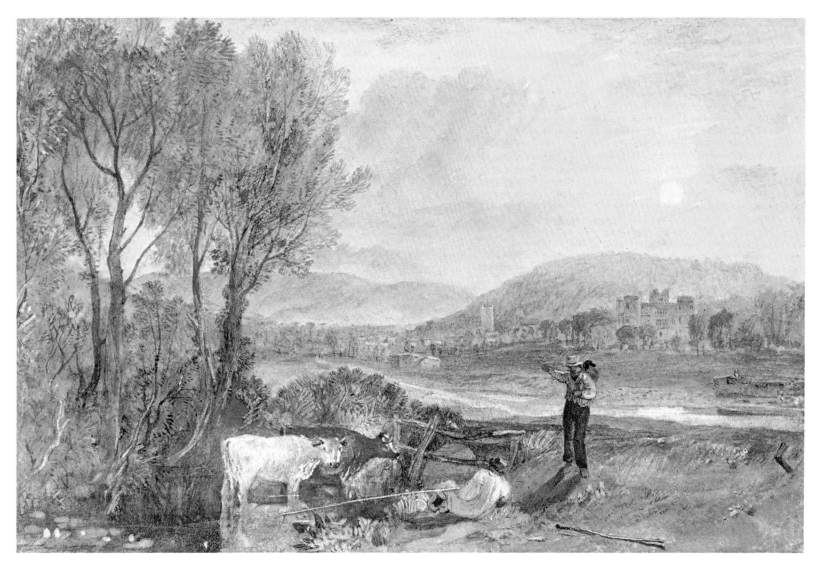

33 LULWORTH CASTLE, DORSETSHIRE Yale Center for British Art, Paul Mellon Collection, U.S.A.

'Southern Coast'

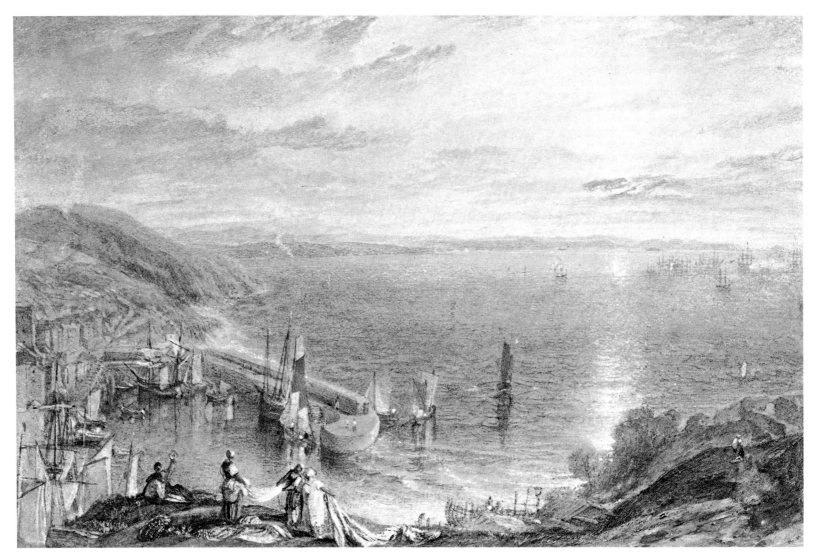

34 TORBAY, SEEN FROM BRIXHAM, DEVONSHIRE Fitzwilliam Museum, Cambridge

'Southern Coast'

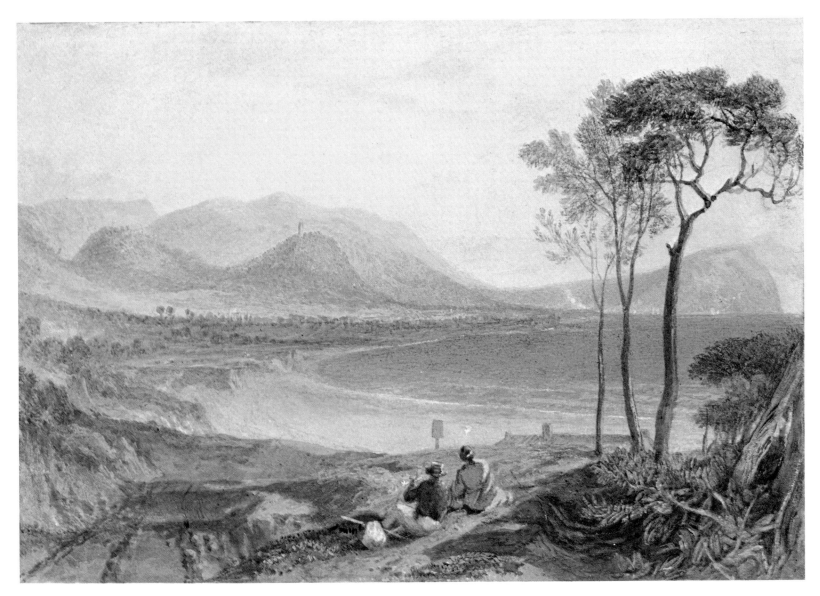

35 MINEHEAD, SOMERSETSHIRE Lady Lever Art Gallery, Port Sunlight, U.K.

'Southern Coast'

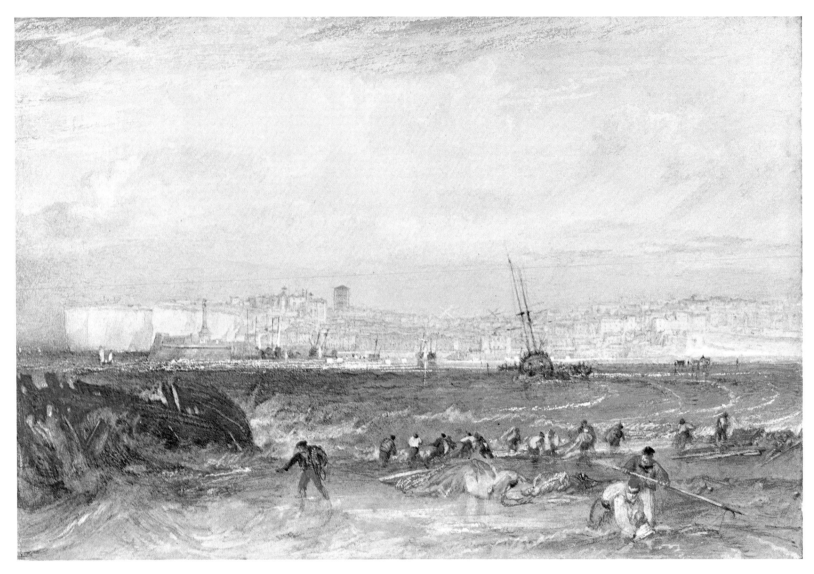

36 MARGATE, KENT Yale Center for British Art, Paul Mellon Collection, U.S.A

'Southern Coast'

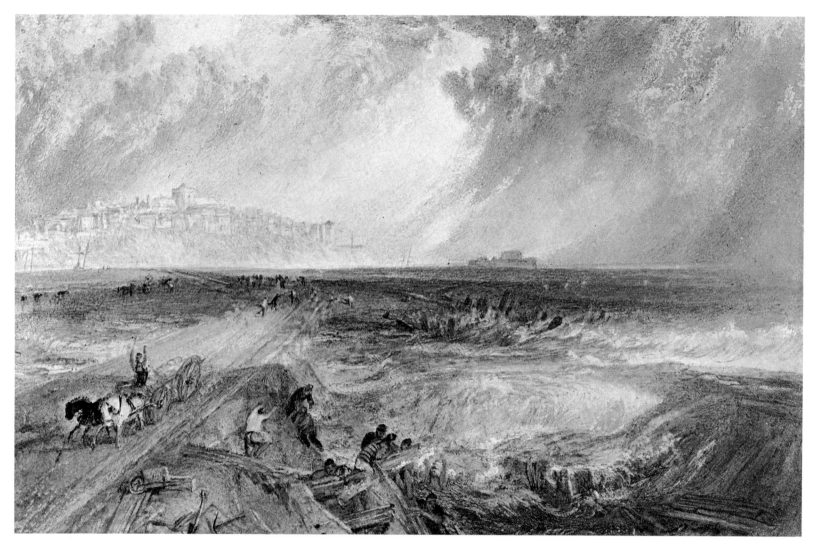

37 RYE, SUSSEX National Museum of Wales, Cardiff

'Southern Coast'

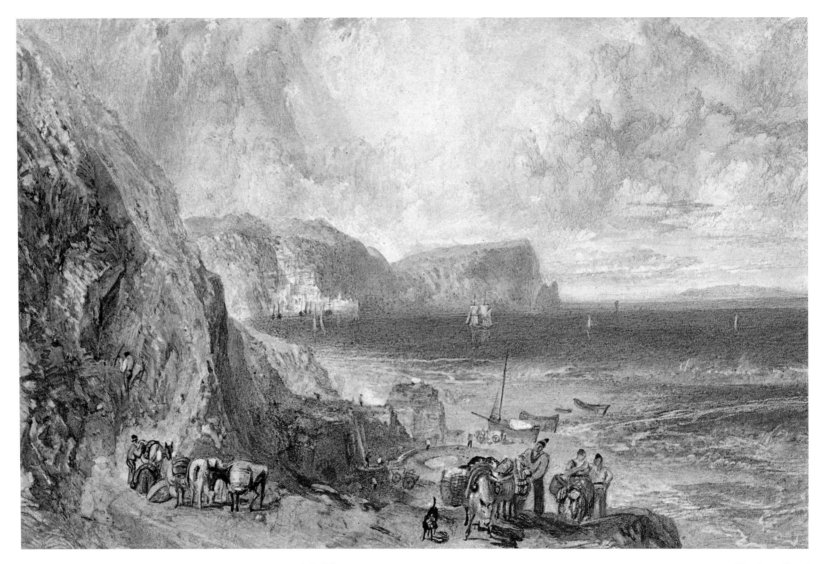

38 CLOVELLY BAY, DEVONSHIRE National Gallery of Ireland, Dublin

'Southern Coast'

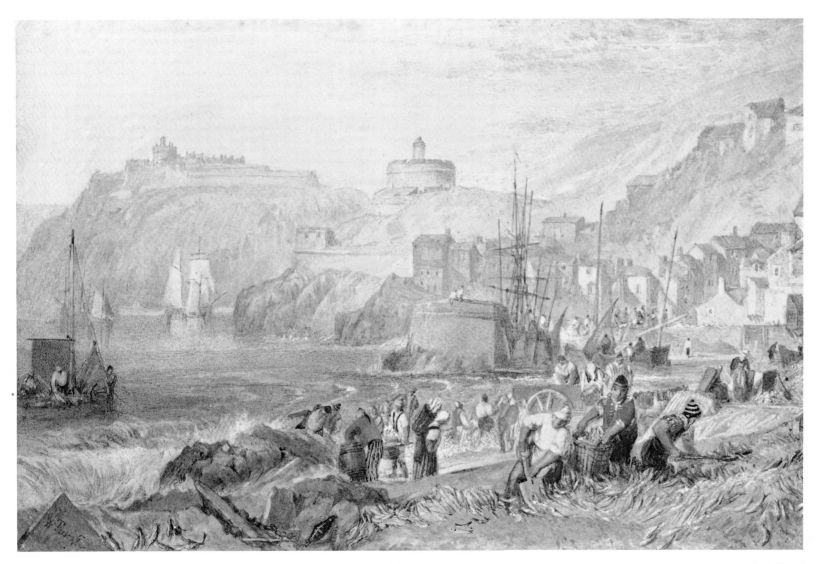

39 ST. MAWES, CORNWALL Yale Center for British Art, Paul Mellon Collection, U.S.A.

'Southern Coast'

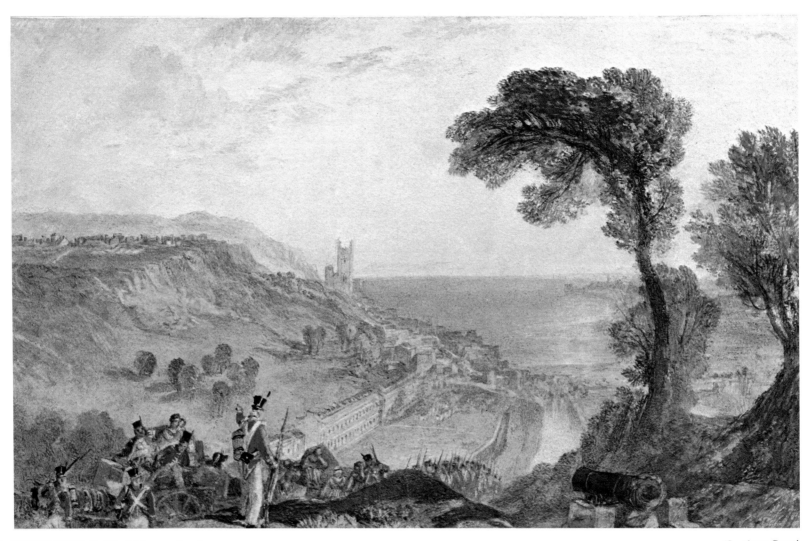

40 HYTHE, KENT Guildhall Museum, London

'Southern Coast'

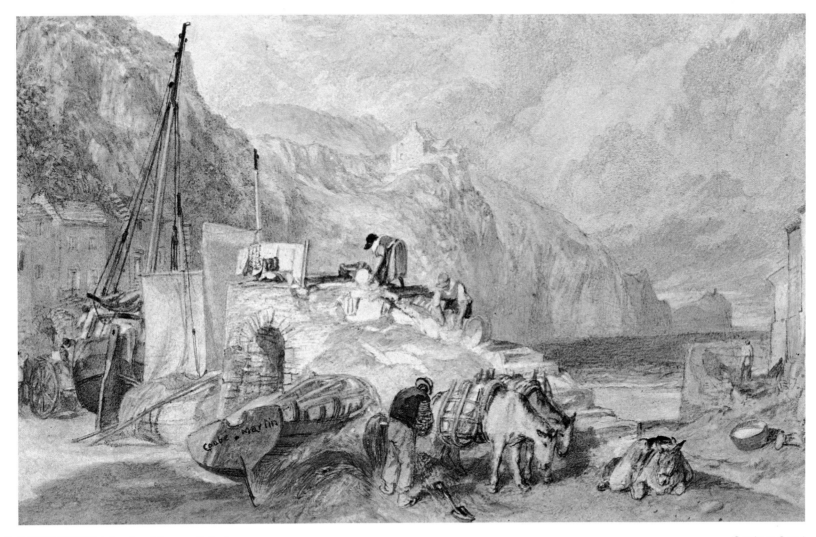

41 COMB MARTIN Ashmolean Museum, Oxford

'Southern Coast'

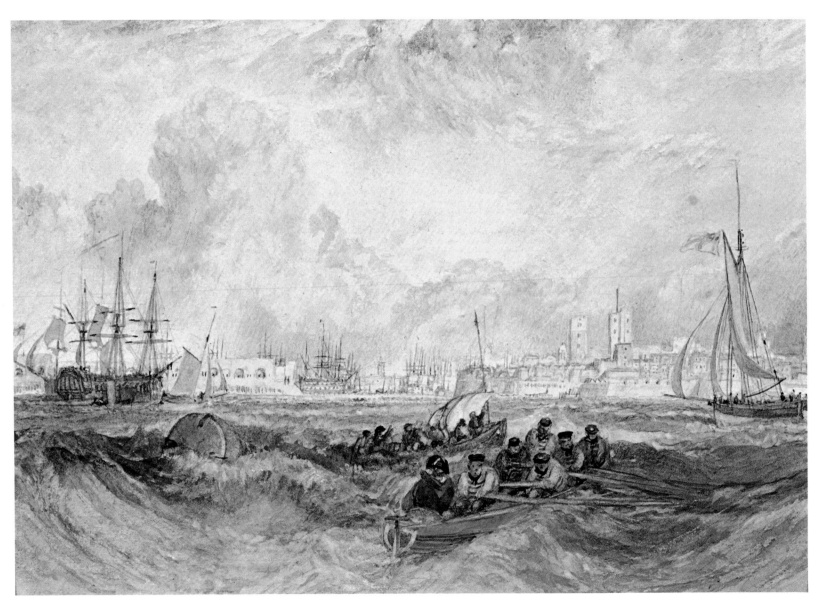

42 PORTSMOUTH, HAMPSHIRE Lady Lever Art Gallery, Port Sunlight, U.K.

'Southern Coast'

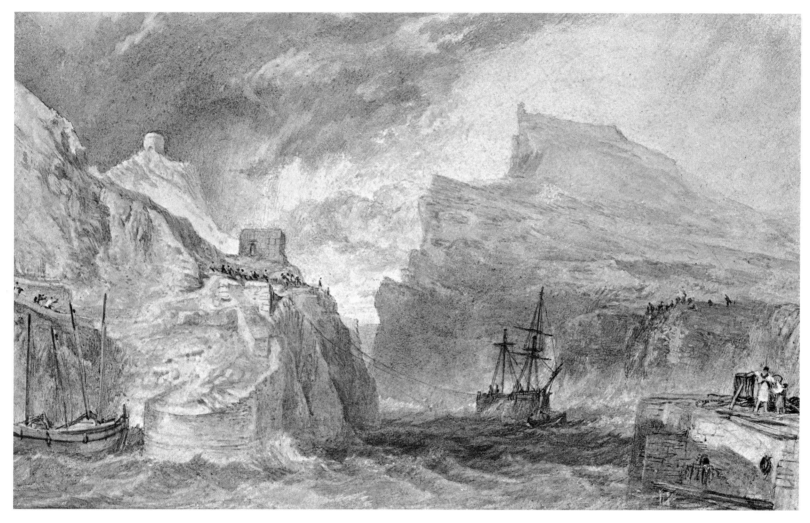

43 BOSCASTLE, CORNWALL Ashmolean Museum, Oxford

'Southern Coast'

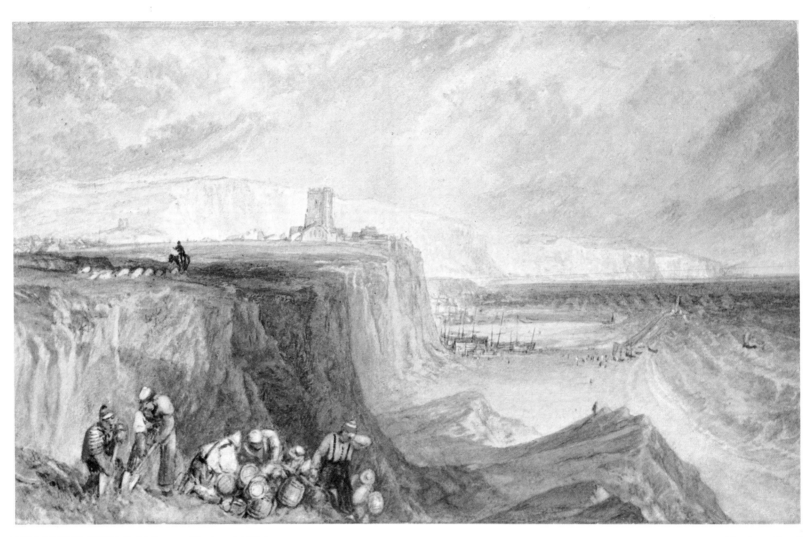

44 FOLKESTONE, KENT Taft Museum, Cincinnati, U.S.A.

'Southern Coast'

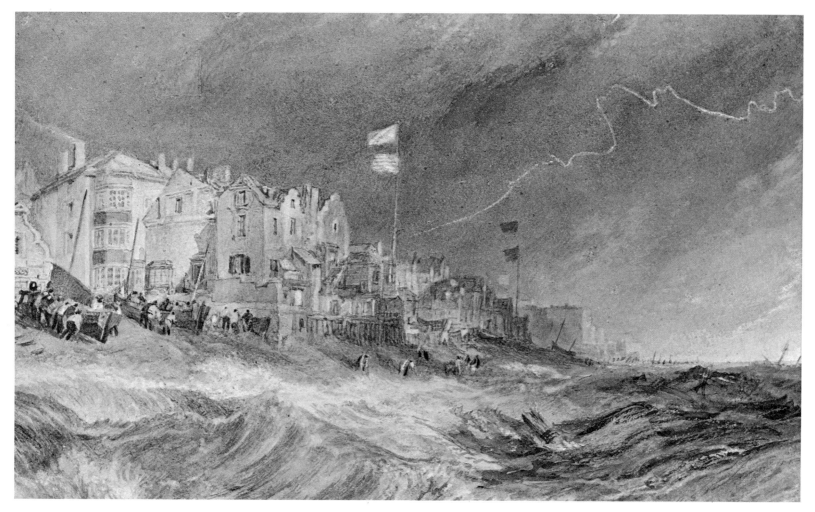

45 DEAL, KENT Private Collection, U.K.

'Southern Coast'

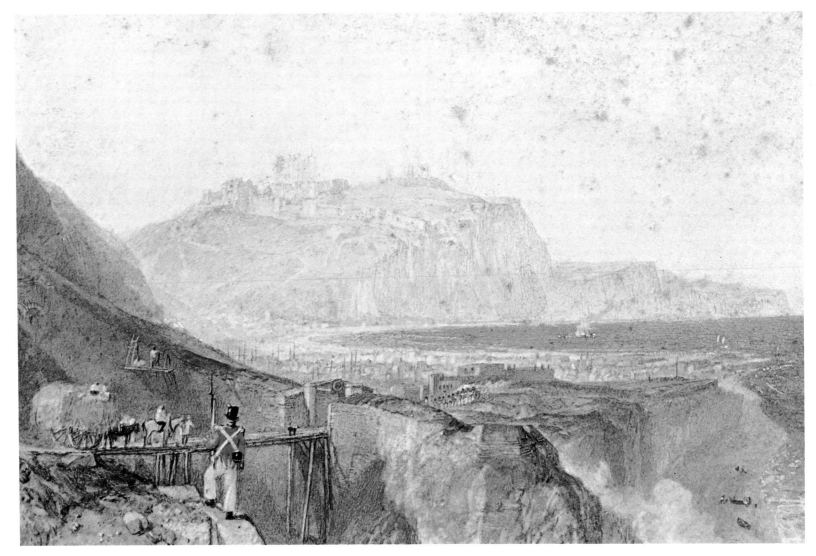

46 DOVER FROM SHAKESPEARE'S CLIFF George C. White, Esq.

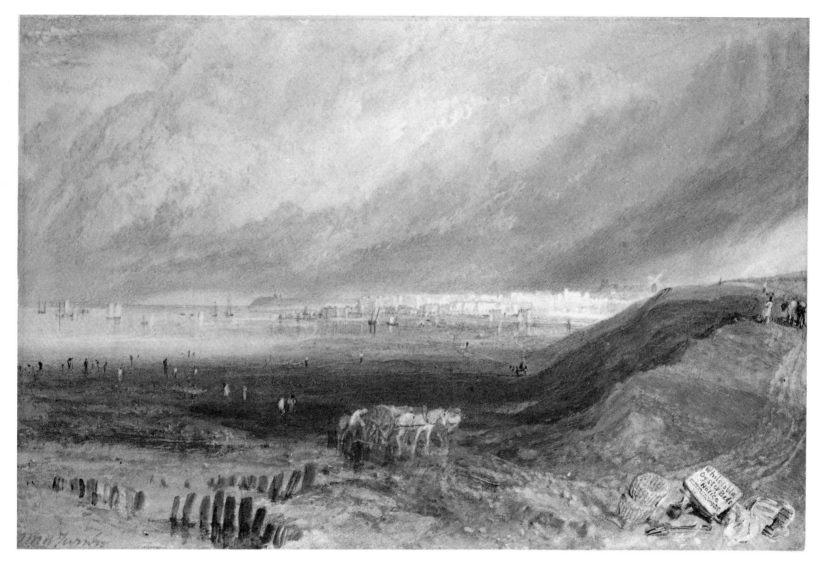

47 WHITSTABLE, KENT Private Collection, U.K.

'Southern Coast'

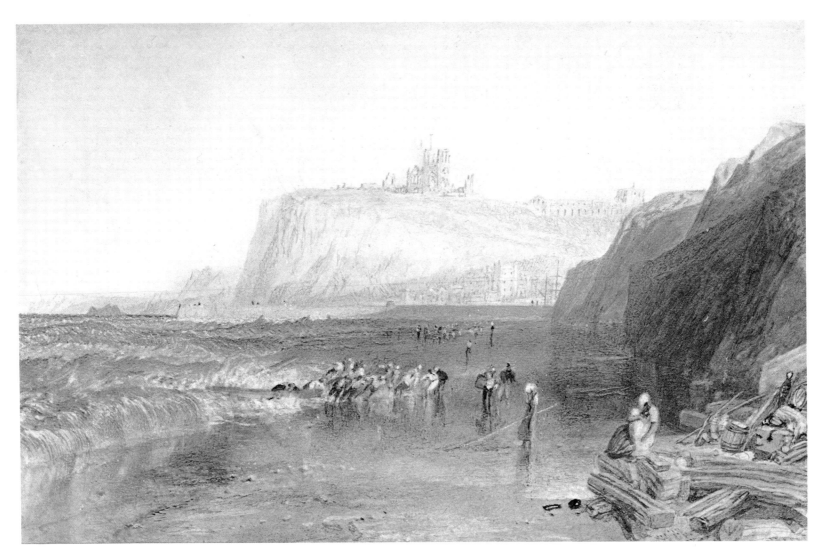

48 WHITBY Private Collection, U.K.

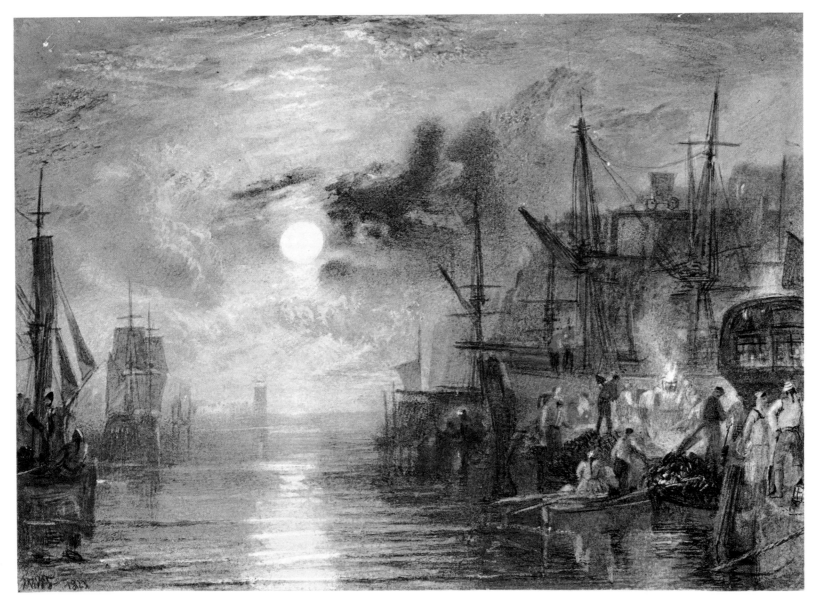

49 SHIELDS, ON THE RIVER TYNE British Museum, London (Turner Bequest)

'The Rivers of England'

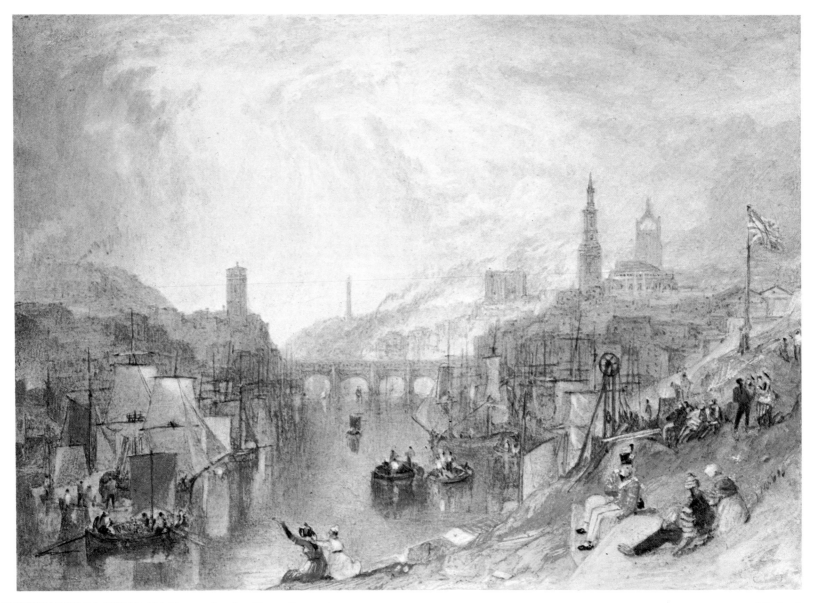

50 NEWCASTLE-ON-TYNE British Museum, London (Turner Bequest)

'The·Rivers of England'

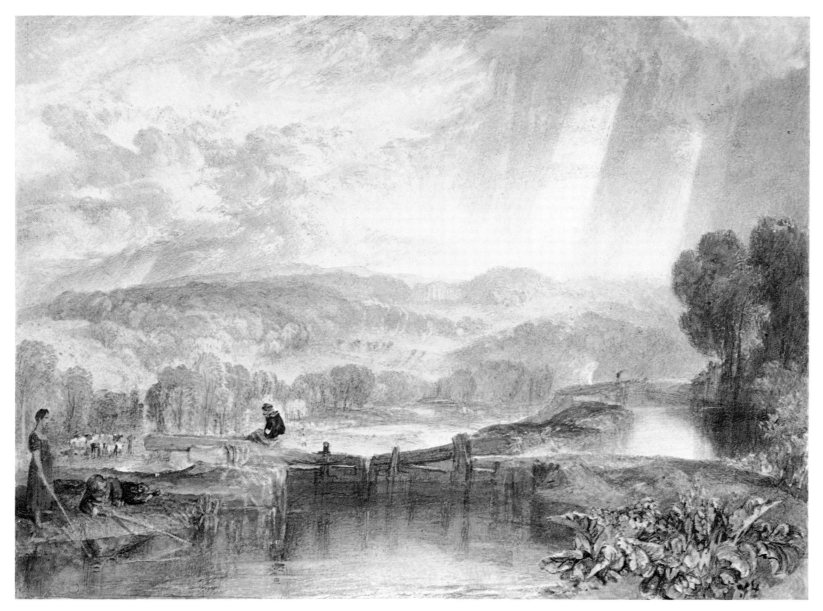

51 MORE PARK, NEAR WATFORD, ON THE RIVER COLNE British Museum, London (Turner Bequest) 'The Rivers of England'

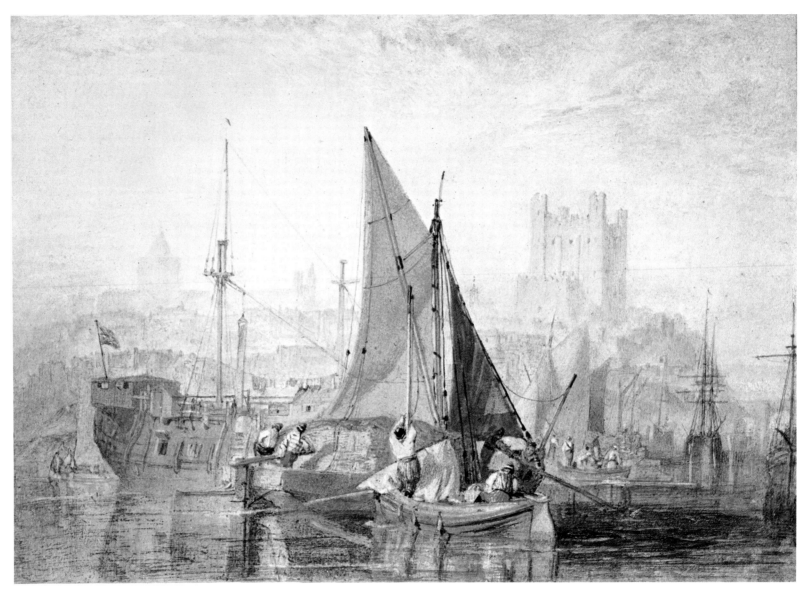

52 ROCHESTER, ON THE RIVER MEDWAY British Museum, London (Turner Bequest)

'The Rivers of England'

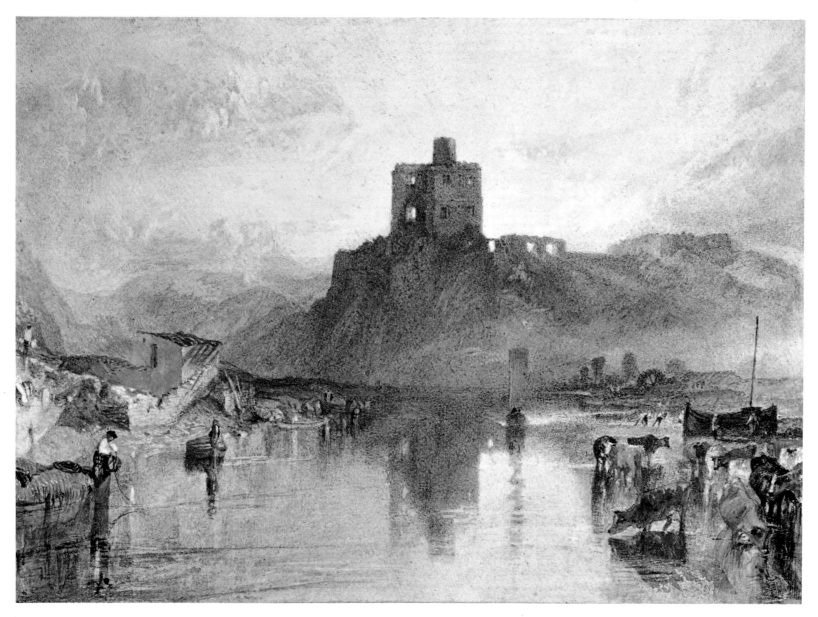

53 NORHAM CASTLE, ON THE RIVER TWEED British Museum, London (Turner Bequest)

'The Rivers of England'

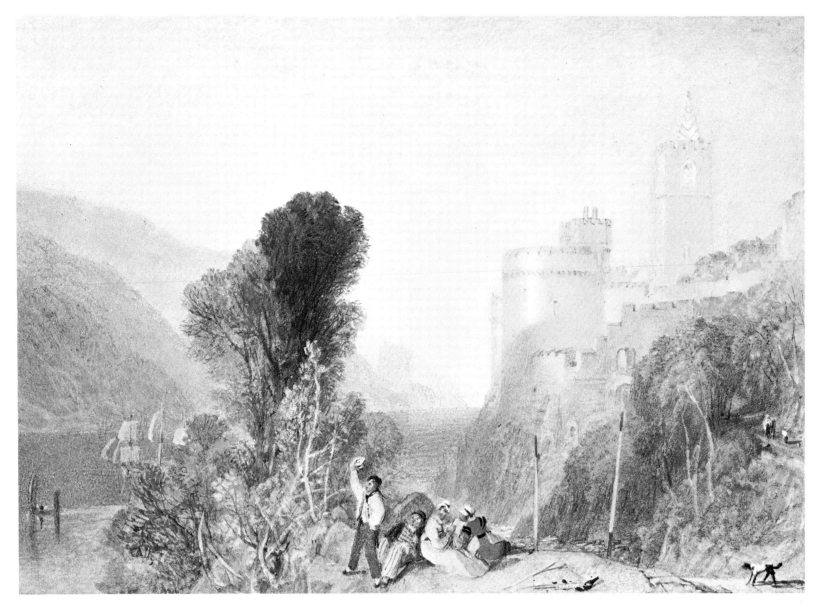

54 DARTMOUTH CASTLE, ON THE RIVER DART British Museum, London (Turner Bequest)

'The Rivers of England'

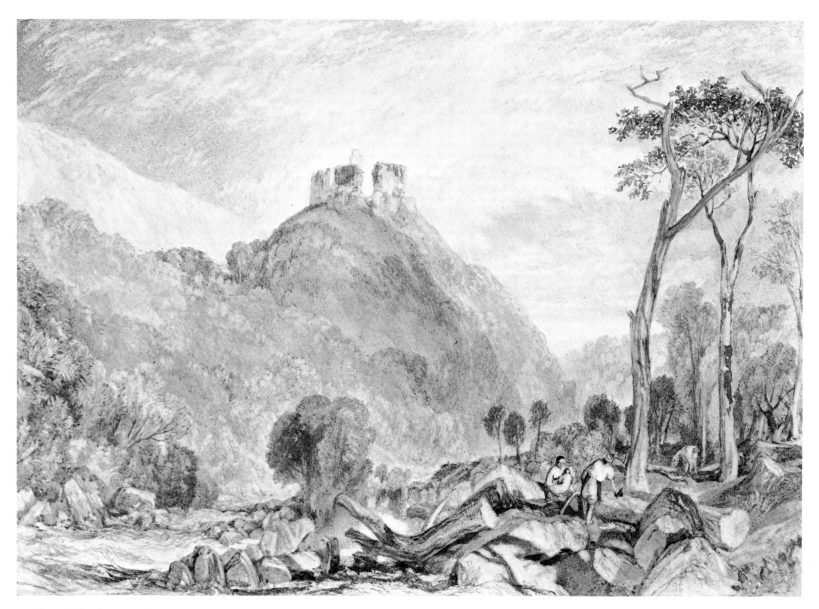

55 OKEHAMPTON CASTLE, ON THE RIVER OKEMENT British Museum, London (Turner Bequest) 'The Rivers of England'

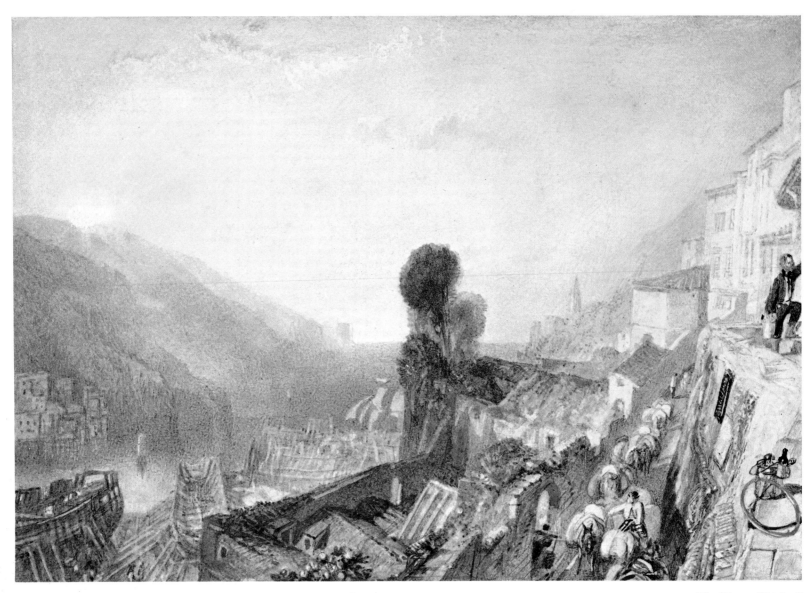

56 DARTMOUTH, ON THE RIVER DART British Museum, London (Turner Bequest)　　　　　　　　　　　　　　　　　'The Rivers of England'

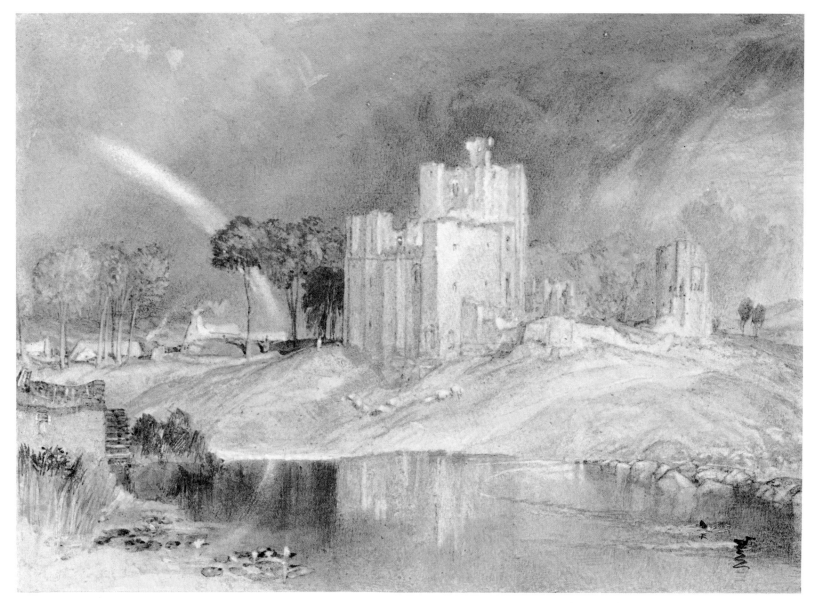

57 BROUGHAM CASTLE, NEAR THE JUNCTION OF THE RIVERS EAMONT AND LOWTHER British Museum, London (Turner Bequest) 'The Rivers of England'

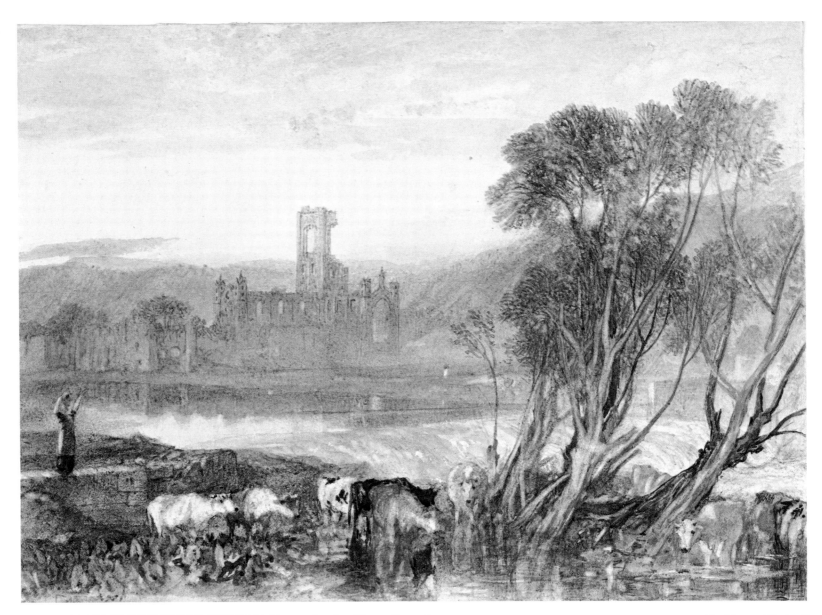

58 KIRKSTALL ABBEY, ON THE RIVER AIRE British Museum, London (Turner Bequest)

'The Rivers of England'

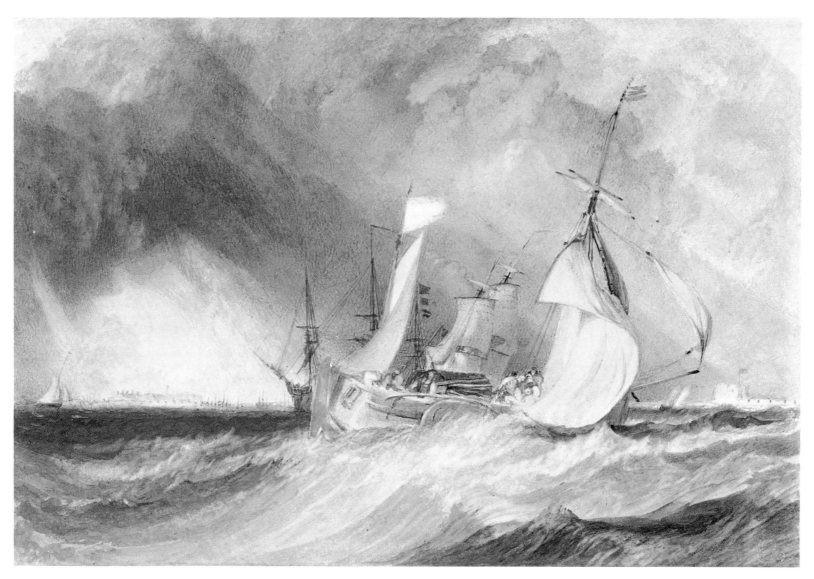

59 MOUTH OF THE RIVER HUMBER British Museum, London (Turner Bequest)

'The Rivers of England'

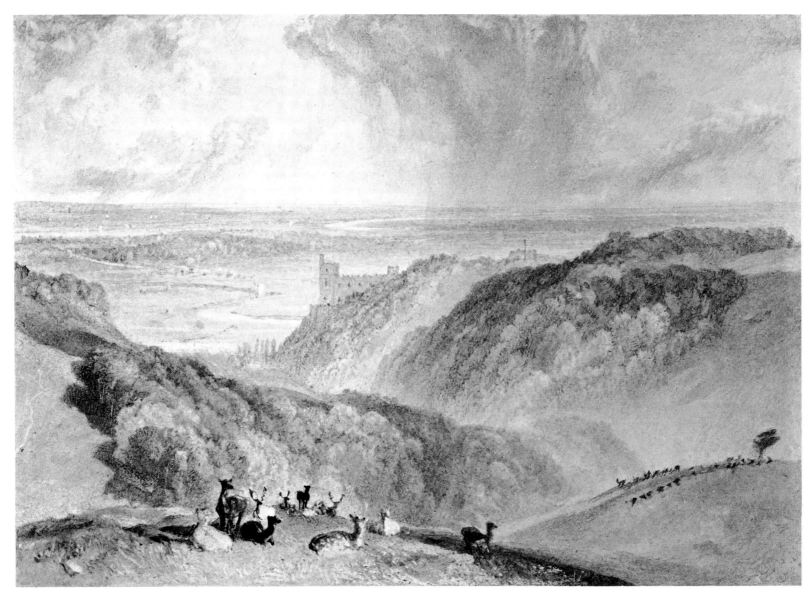

60 ARUNDEL CASTLE, ON THE RIVER ARUN British Museum, London (Turner Bequest)

'The Rivers of England'

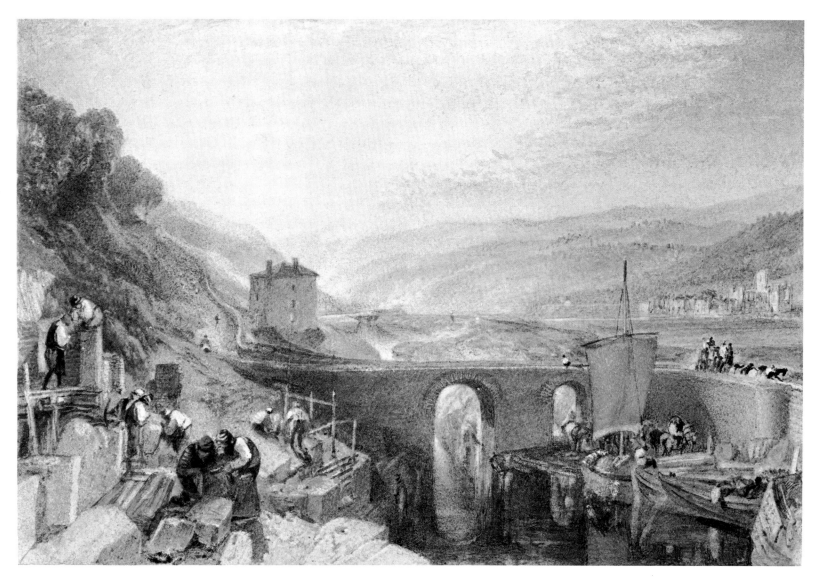

61 KIRKSTALL LOCK, ON THE RIVER AIRE British Museum, London (Turner Bequest) 'The Rivers of England'

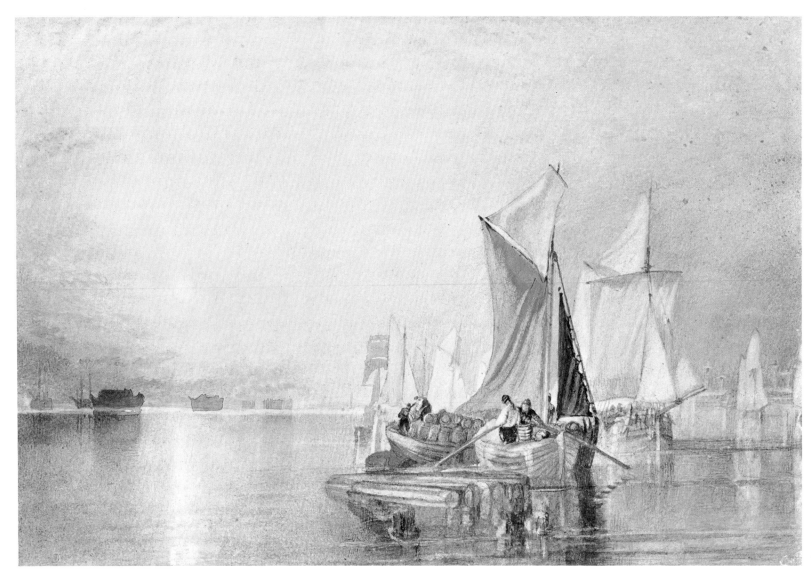

62 STANGATE CREEK, ON THE RIVER MEDWAY British Museum, London (Turner Bequest) 'The Rivers of England'

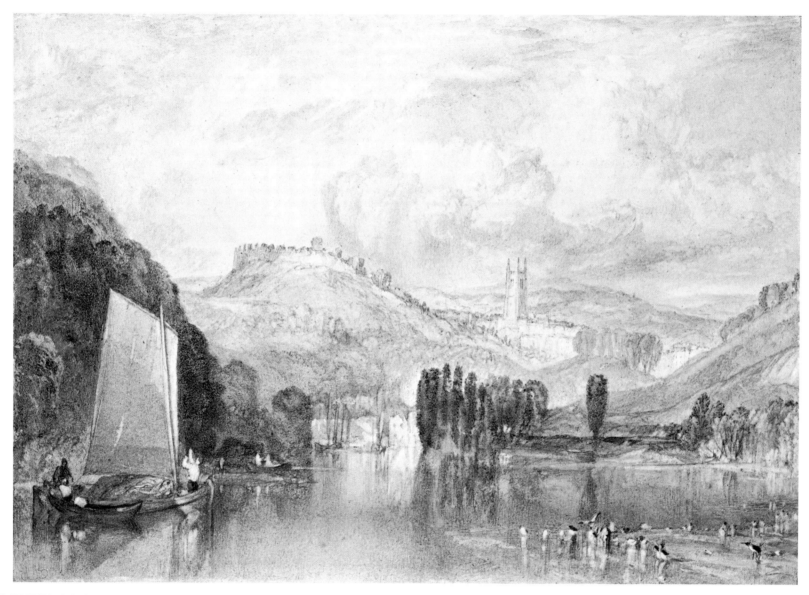

63 TOTNES, ON THE RIVER DART British Museum, London (Turner Bequest) 'The Rivers of England'

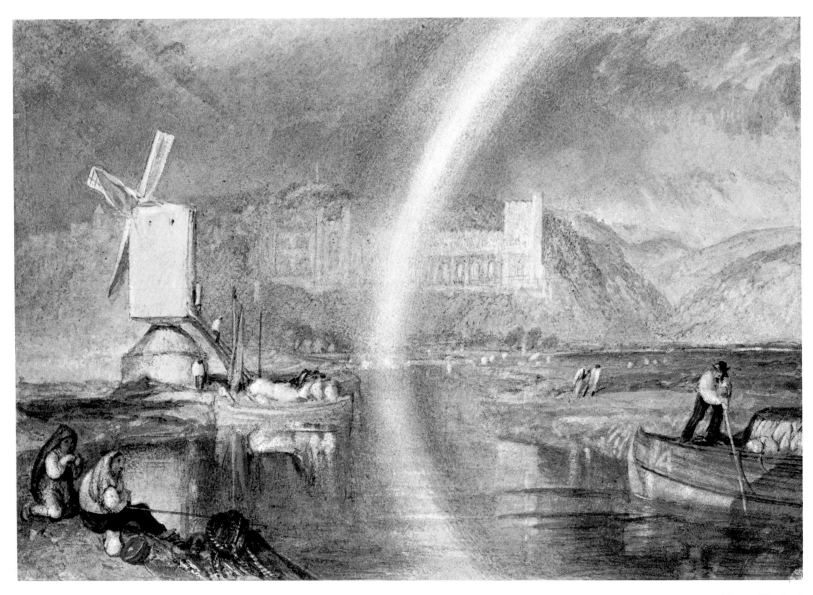

64 ARUNDEL CASTLE, WITH RAINBOW British Museum, London (Turner Bequest)

'The Rivers of England'

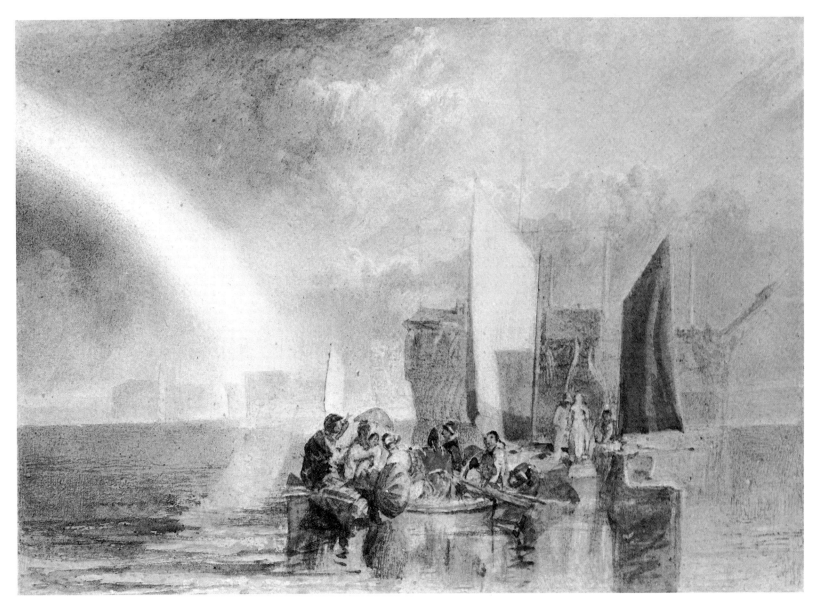

65 THE MEDWAY British Museum, London (Turner Bequest)

'The Rivers of England'

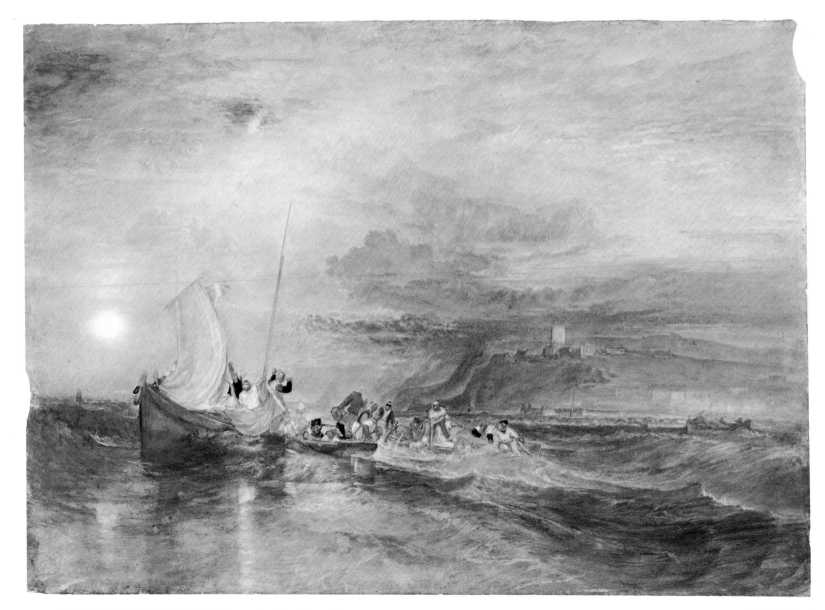

66 FOLKESTONE FROM THE SEA British Museum, London (Turner Bequest)

'Marine Views'

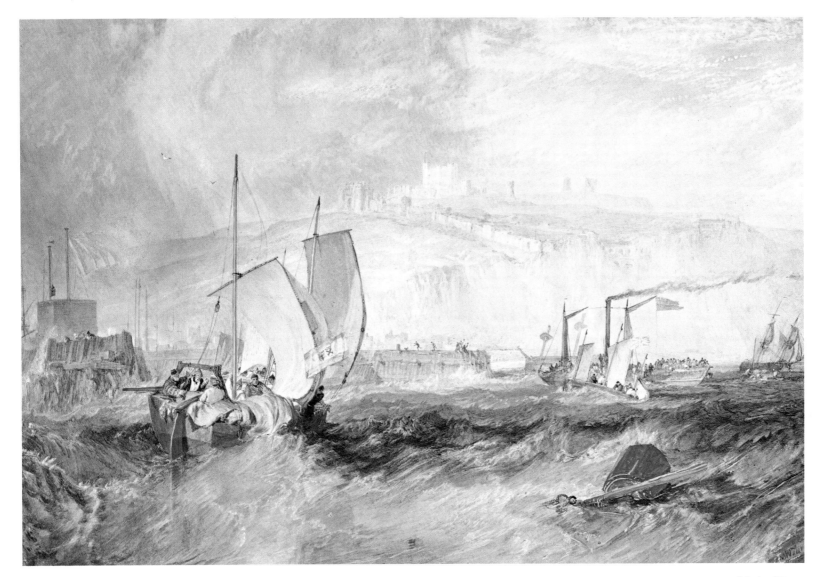

67 DOVER CASTLE Museum of Fine Arts, Boston, U.S.A.

'Marine Views'

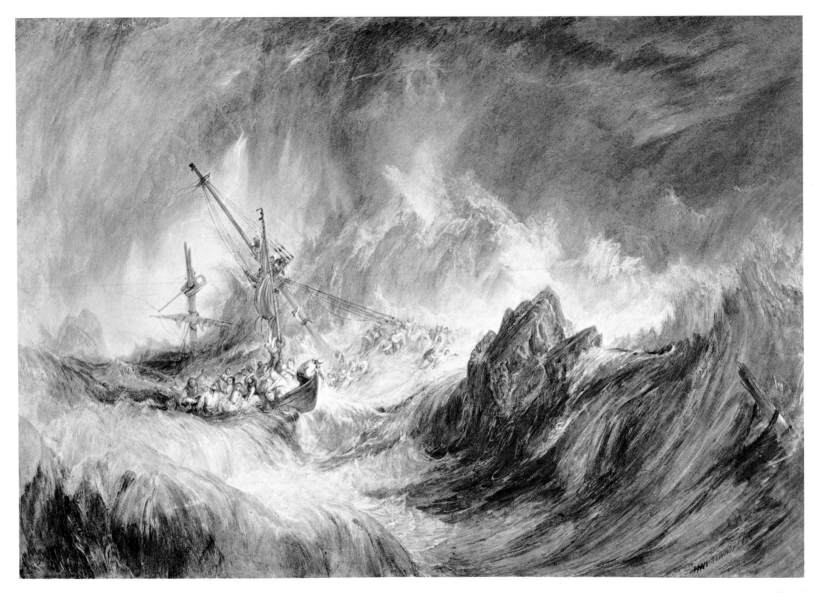

68 A STORM (SHIPWRECK) British Museum, London

'Marine Views'

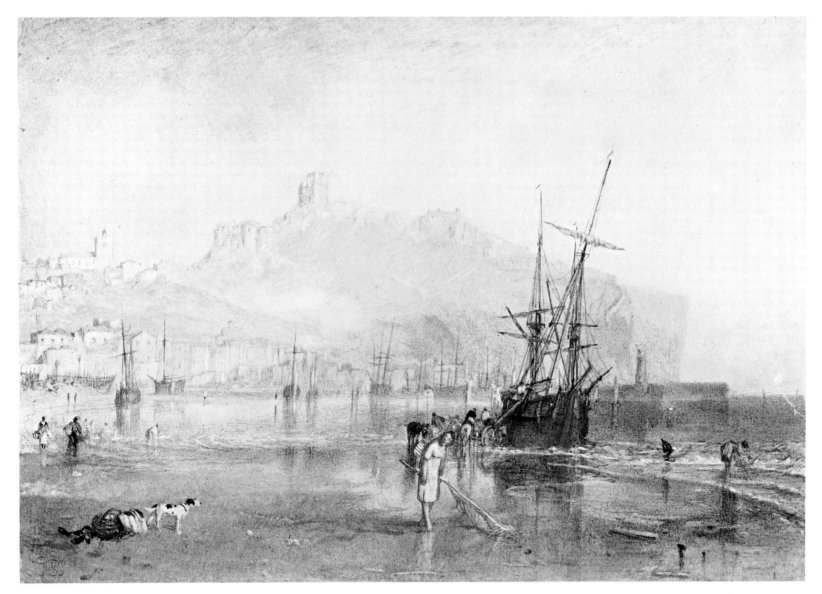

69 SCARBOROUGH British Museum, London (Turner Bequest) 'The Ports of England'

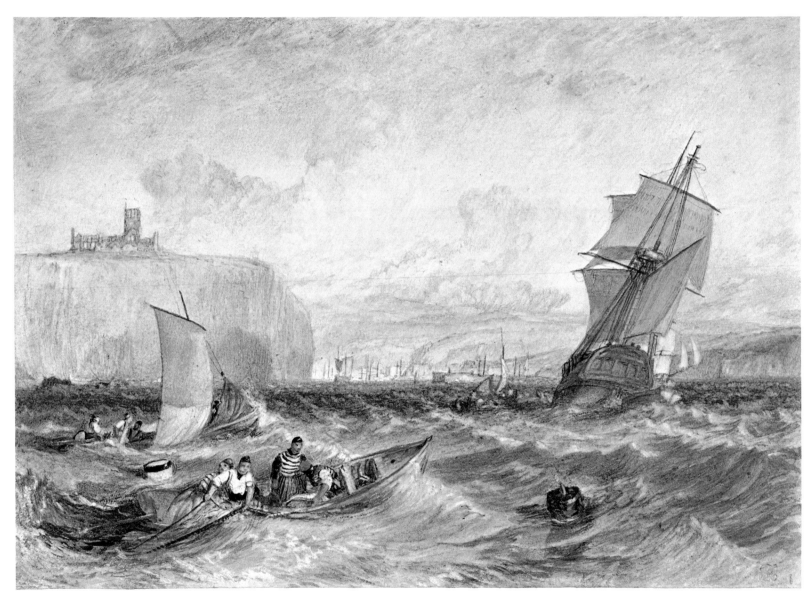

70 WHITBY British Museum, London (Turner Bequest)

'The Ports of England'

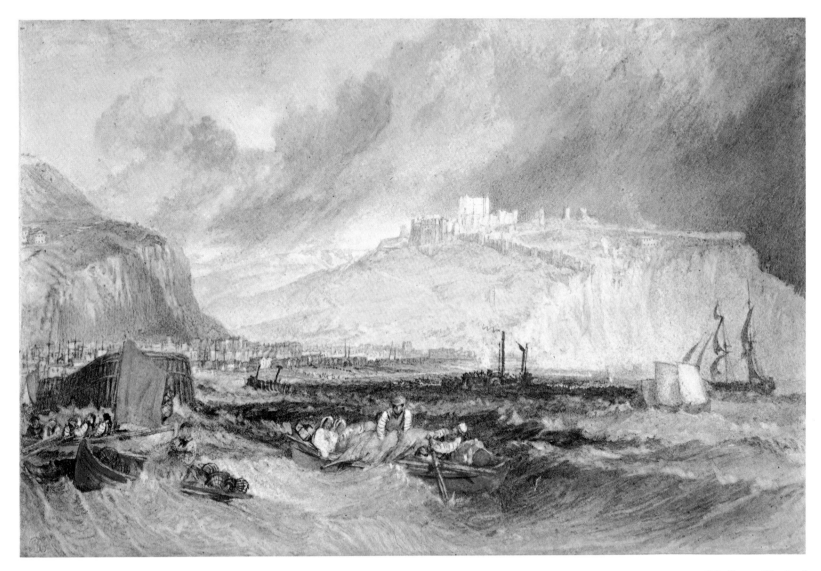

71 DOVER British Museum, London (Turner Bequest) 'The Ports of England'

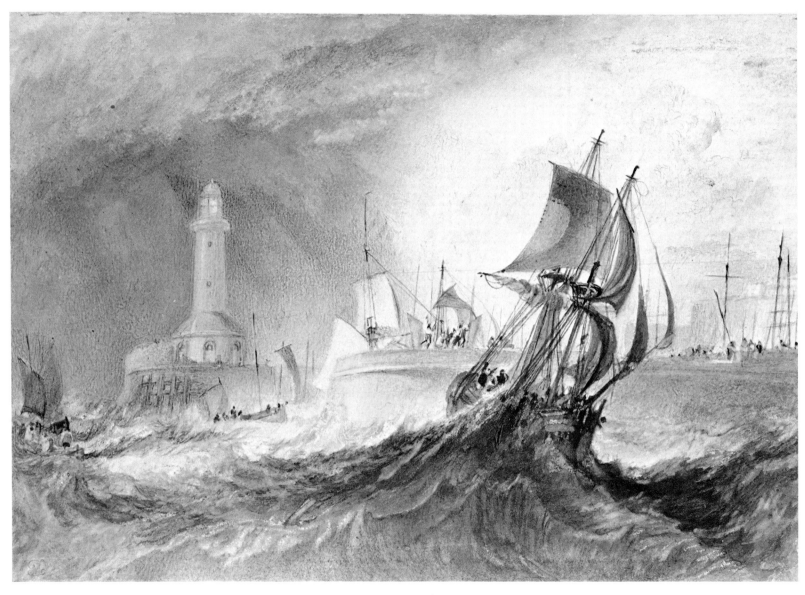

72 RAMSGATE British Museum, London (Turner Bequest)

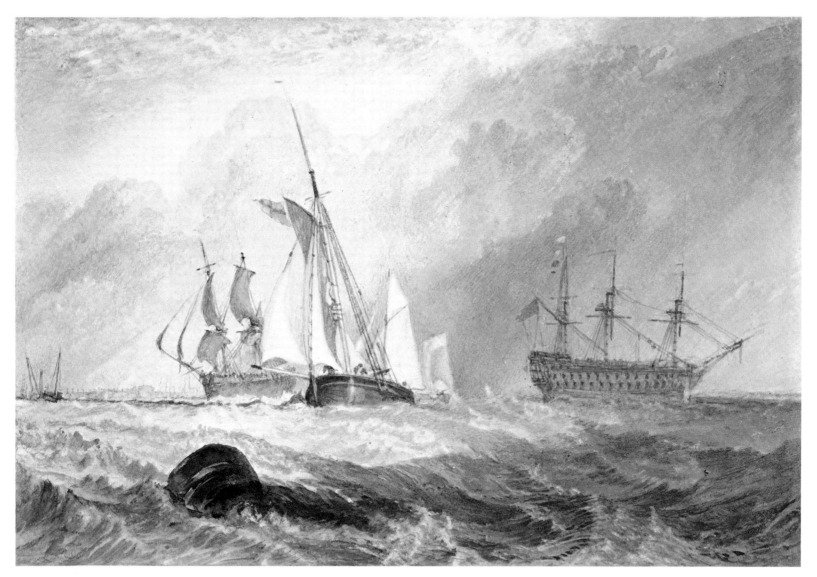

73 SHEERNESS British Museum, London (Turner Bequest)

'The Ports of England'

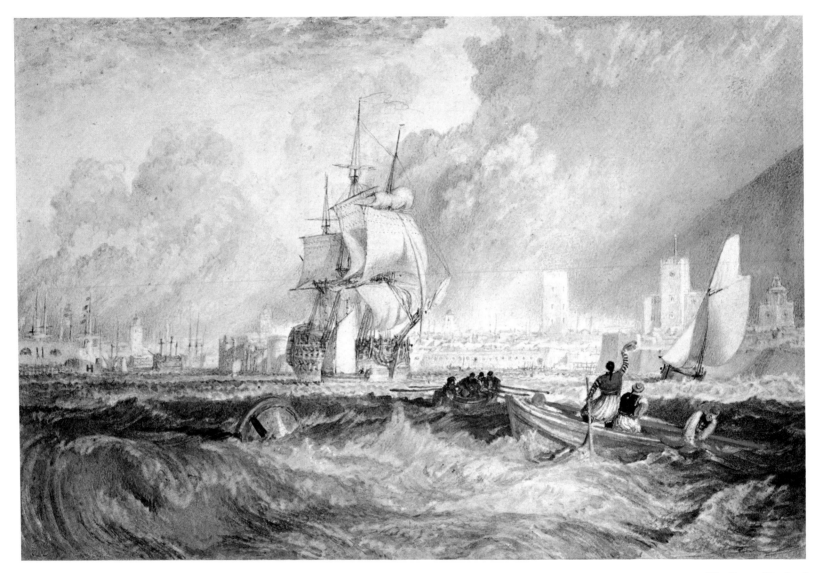

74 PORTSMOUTH British Museum, London (Turner Bequest)

'The Ports of England'

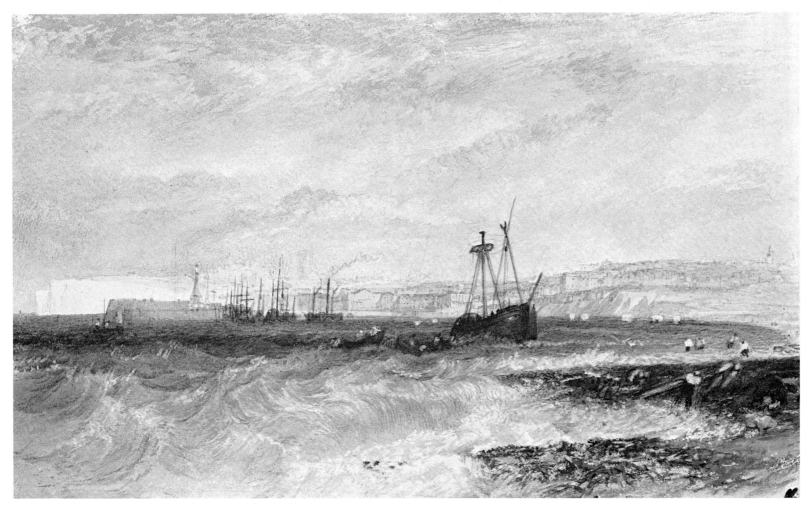

75 MARGATE Ashmolean Museum, Oxford

'The Ports of England'

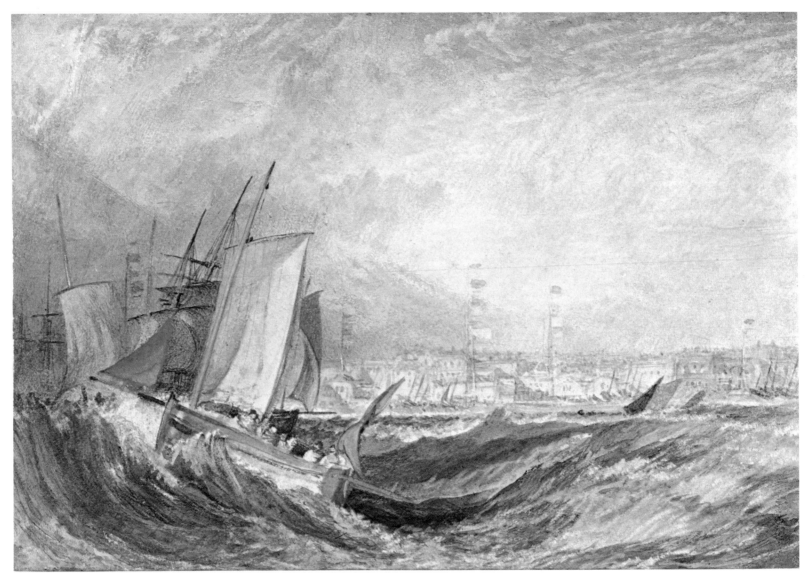

76 DEAL Walker Art Gallery, Liverpool, U.K.

'The Ports of England'

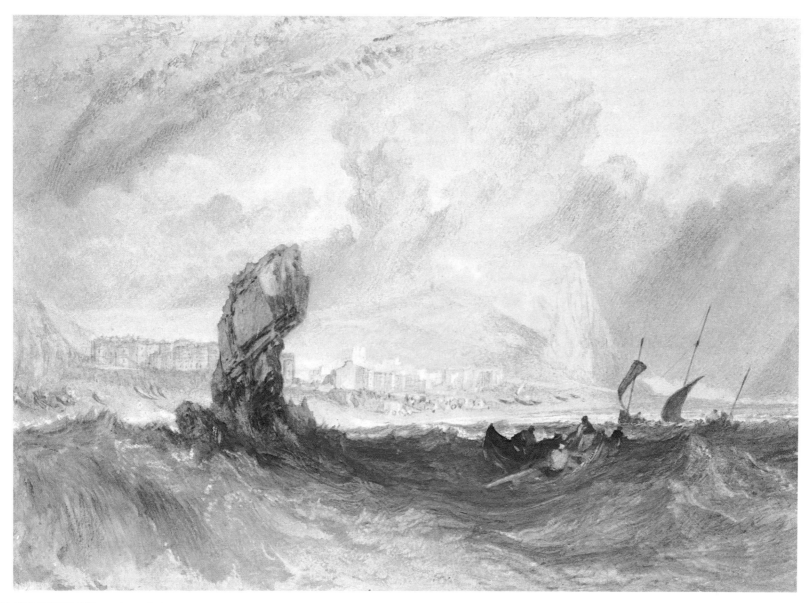

77 SIDMOUTH Whitworth Art Gallery, Manchester, U.K.

'The Ports of England'

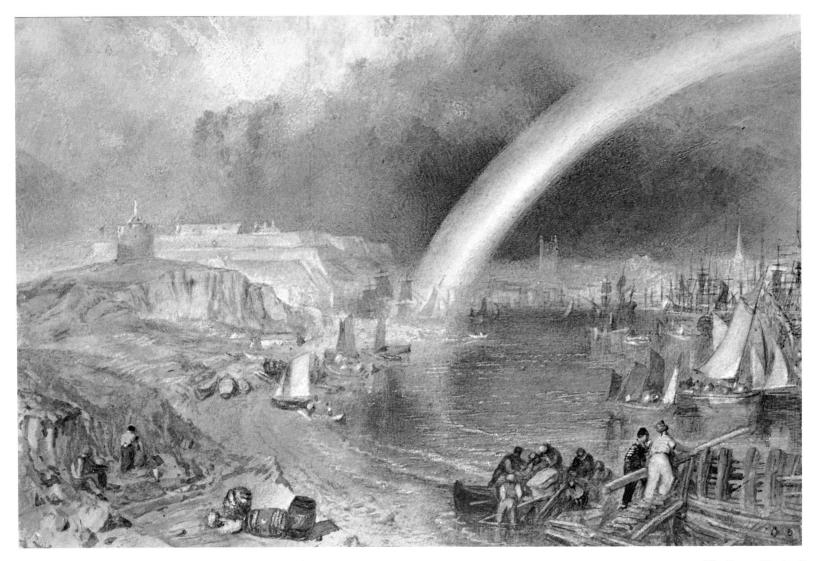

78 PLYMOUTH Fundaçao Calouste Gulbenkian, Lisbon, Portugal

'The Ports of England'

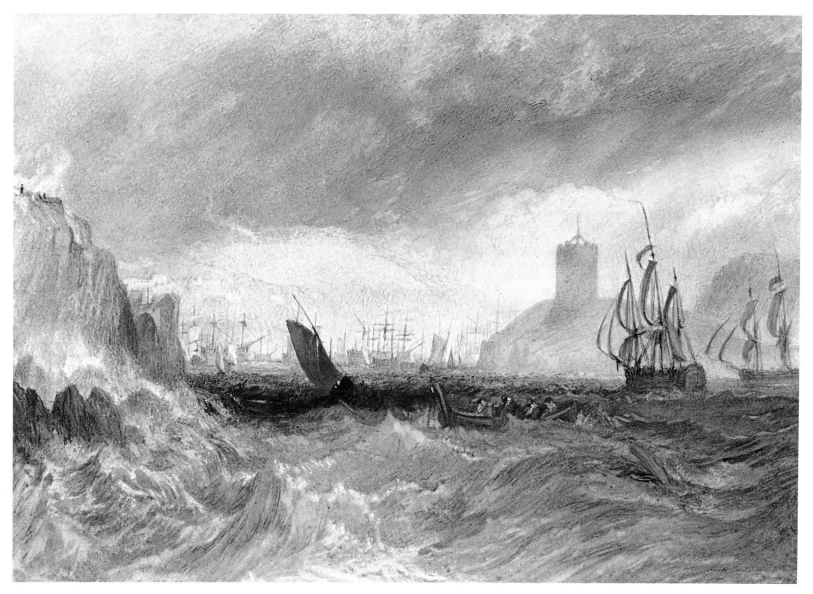

79 CATWATER, PLYMOUTH Allport Library and Museum of Fine Arts, Hobart, Tasmania

'The Ports of England'

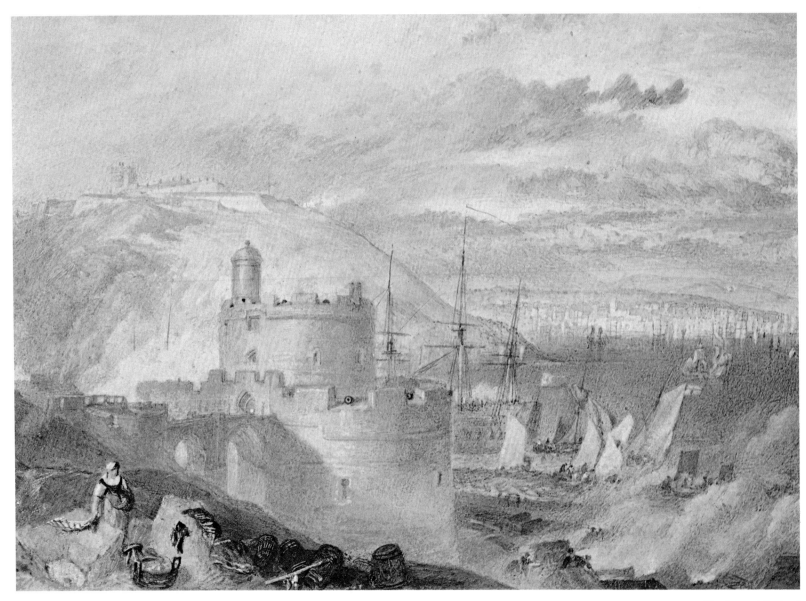

80 FALMOUTH Private Collection, U.K.

'The Ports of England'

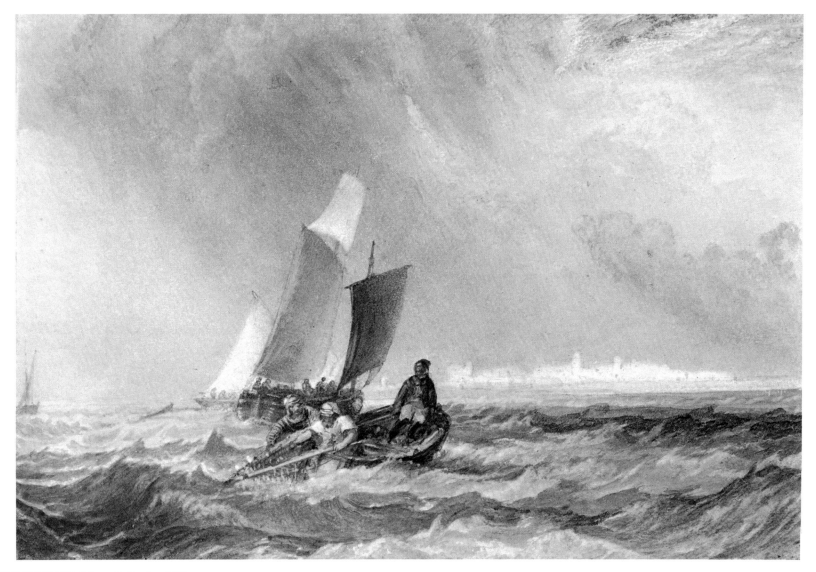

81 RAMSGATE Private Collection, U.K.

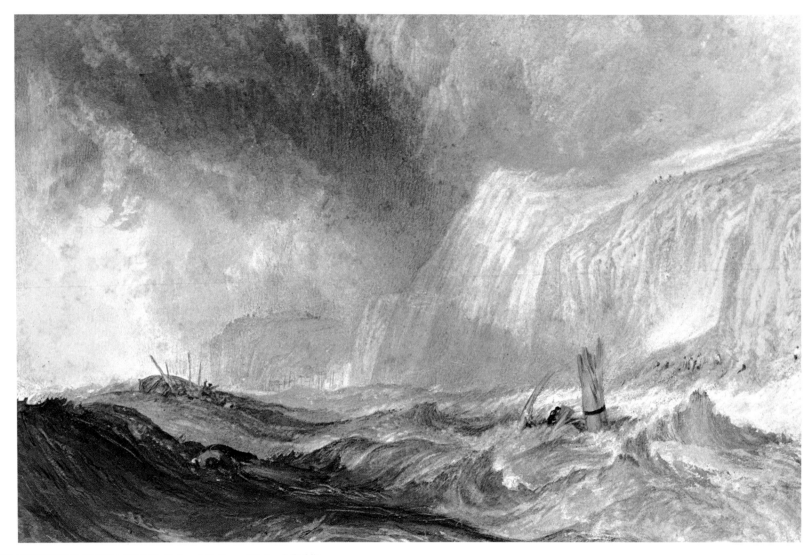

82 SHIPWRECK OFF HASTINGS National Gallery of Ireland, Dublin

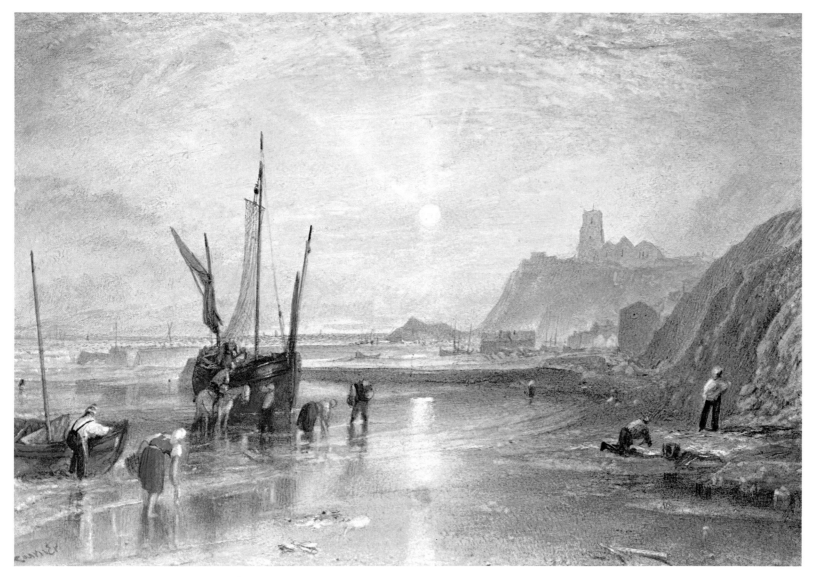

83 FOLKESTONE National Gallery of Ireland, Dublin

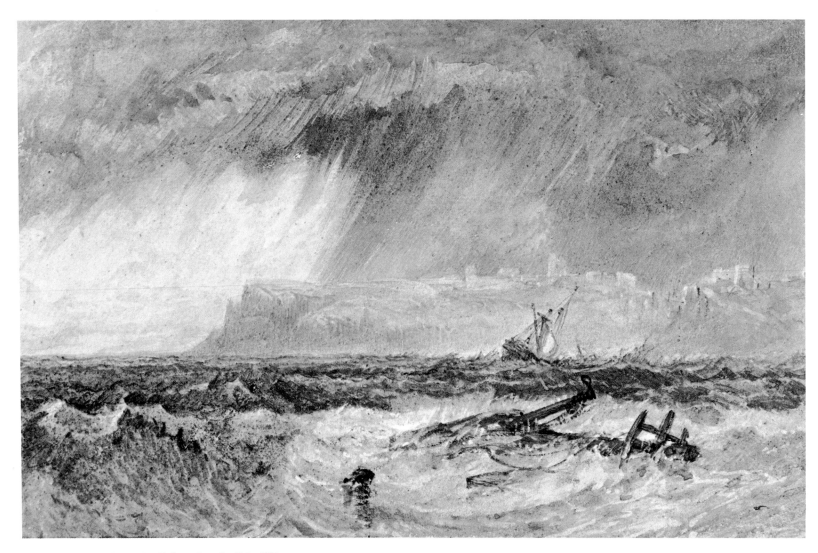

84 OFF DOVER Lady Lever Art Gallery, Port Sunlight, U.K.

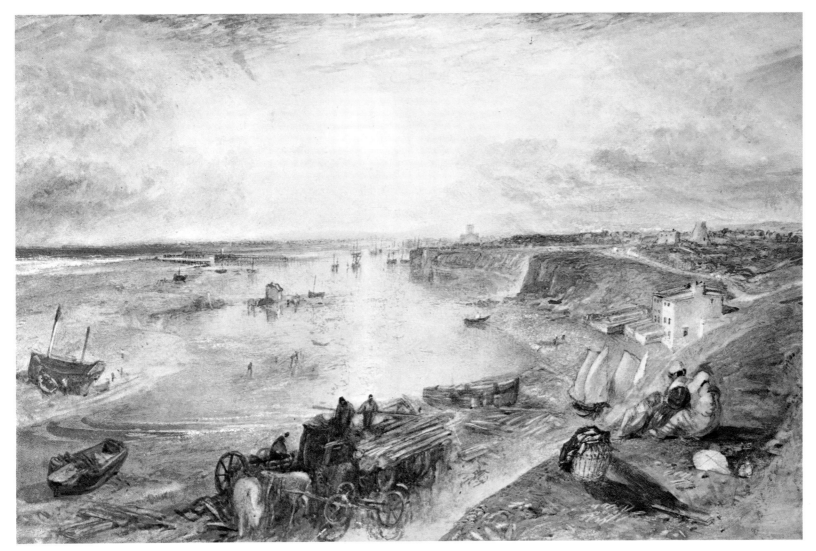

85 SHOREHAM Art Gallery and Museum, Blackburn, U.K.

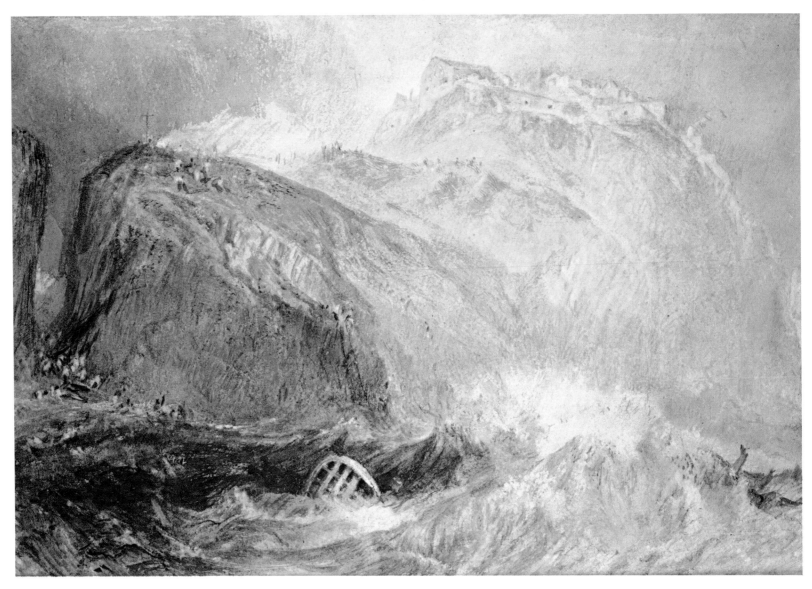

86 TINTAGEL CASTLE Thos. Marc Futter, Esq.

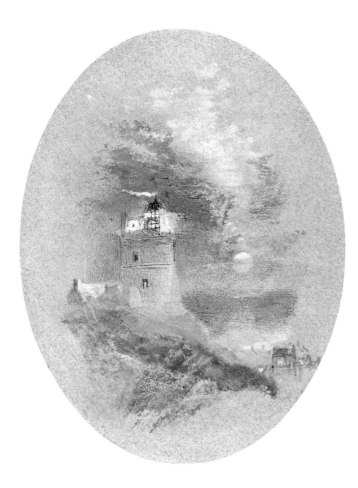

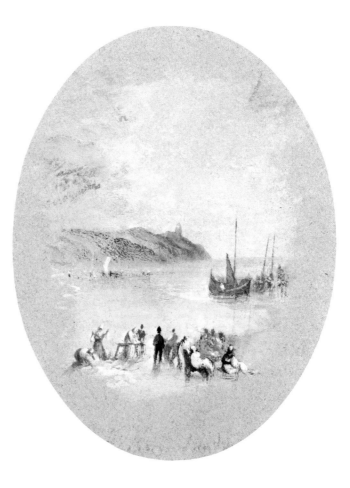

87 LOWESTOFFE LIGHTHOUSE On loan to the Indianapolis Museum
of Art from the Pantzer Collection, U.S.A. 'East Coast'

88 HASBORO SANDS Private Collection, U.S.A 'East Coast'

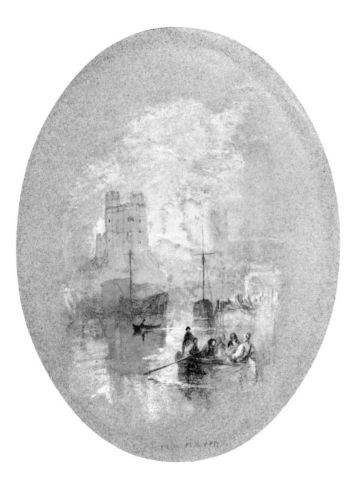

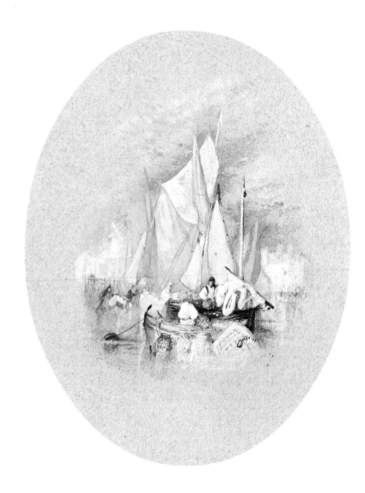

89 ORFORD HAVEN On loan to the Indianapolis Museum of Art from
the Pantzer Collection, U.S.A. 'East Coast'

90 GREAT YARMOUTH FISHING BOATS Private Collection, U.S.A.

'East Coast'

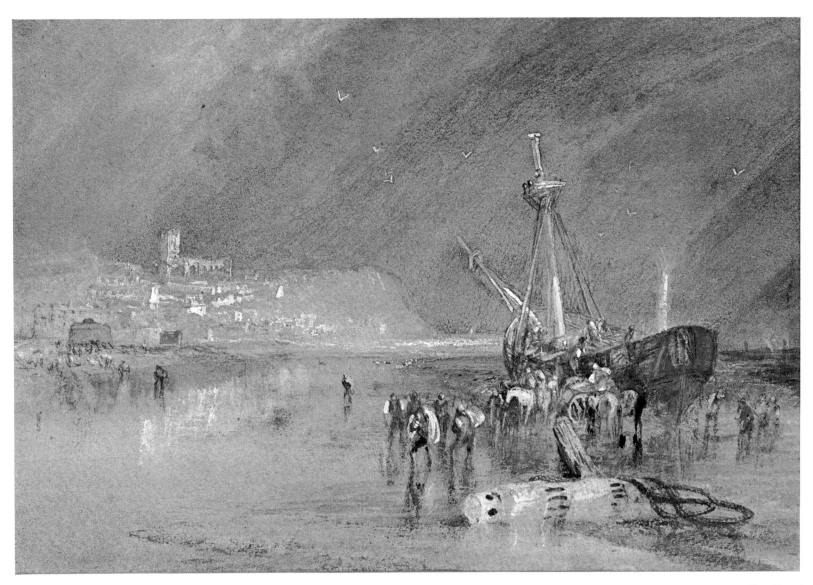

91 ALDBOROUGH Private Collection, U.K. 'East Coast'

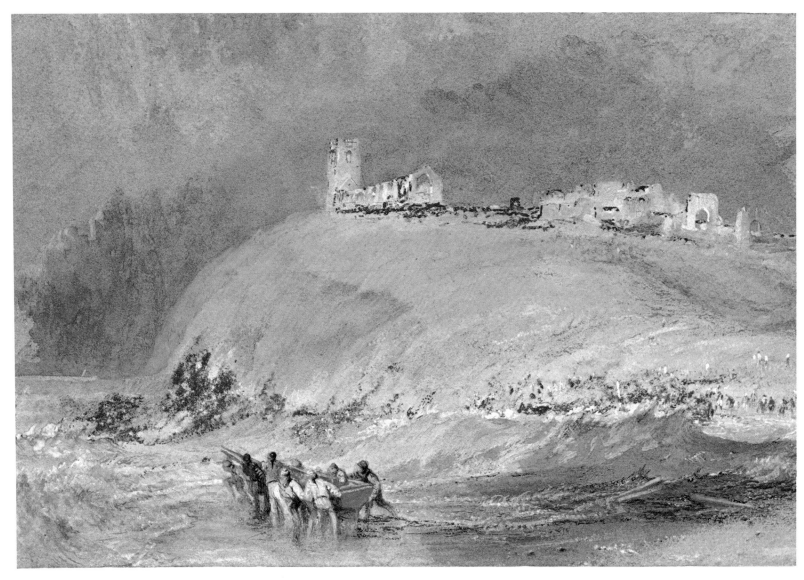

92 DUNWICH Manchester City Art Gallery, U.K.

'East Coast'

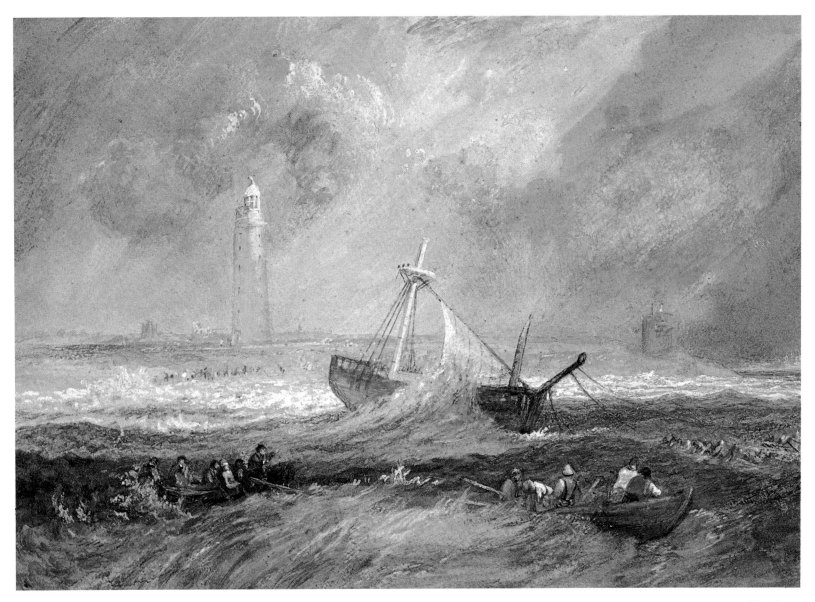

93 ORFORDNESS Private Collection, U.K.

'East Coast'

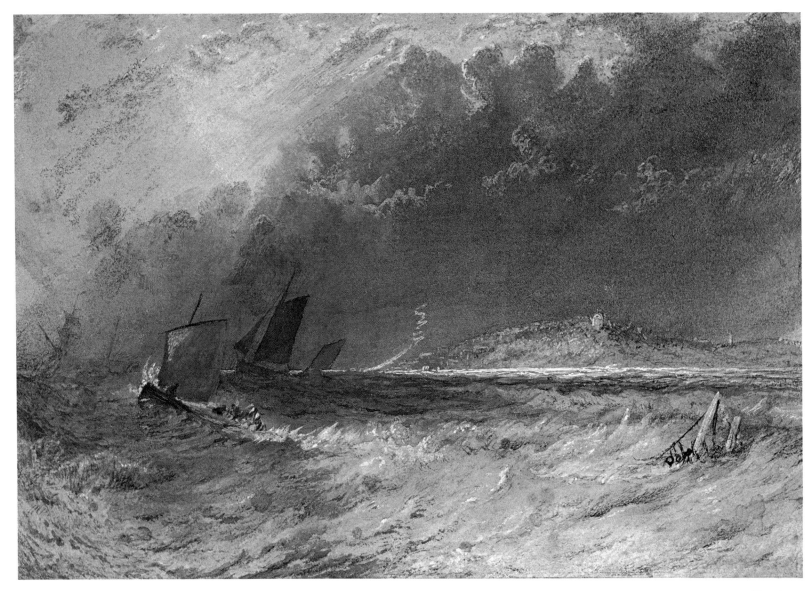

94 LOWESTOFFE Private Collection, U.K.

'East Coast'

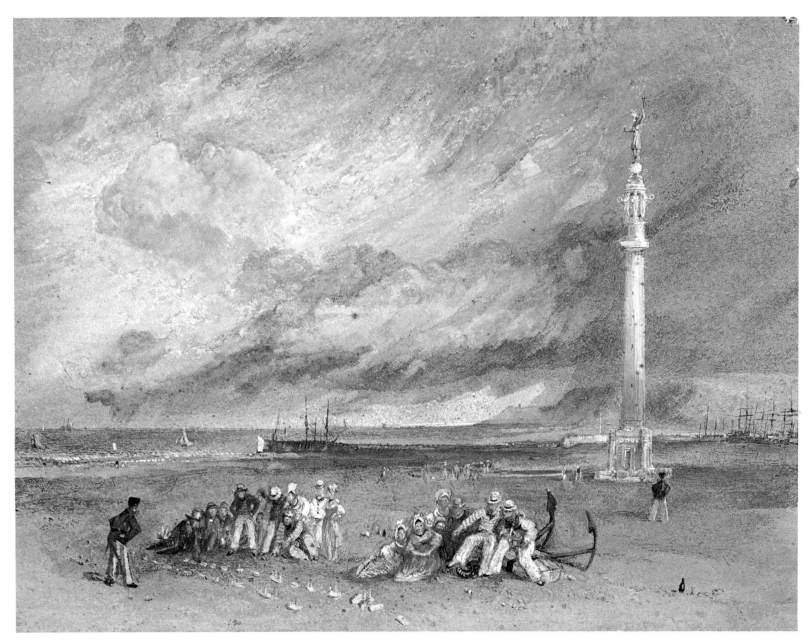

95 YARMOUTH SANDS Fitzwilliam Museum, Cambridge

'East Coast'

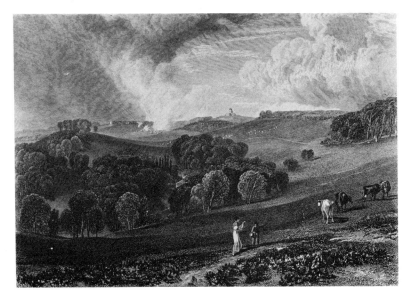

96 BATTLE ABBEY, THE SPOT WHERE HAROLD FELL (engraving)
British Museum, London 'Views in Sussex'

97 THE OBSERVATORY AT ROSEHILL, SUSSEX, THE SEAT OF JOHN
FULLER, ESQ. (engraving) British Museum, London 'Views in Sussex'

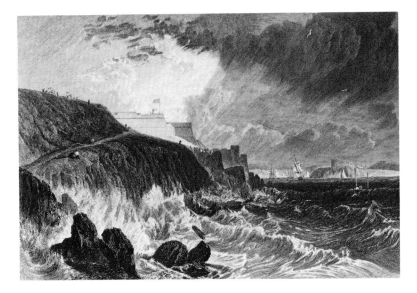

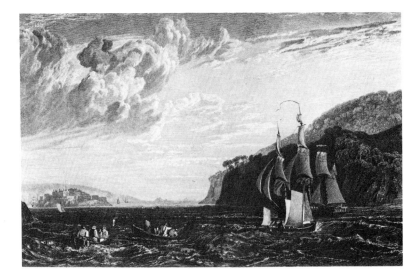

98 PLYMOUTH CITADEL (engraving) British Museum, London
'The Rivers of Devon'

99 PLYMOUTH SOUND (engraving) British Museum, London
'The Rivers of Devon'

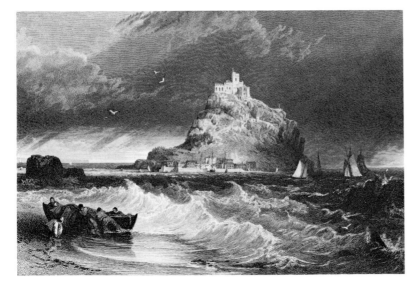

100 ST. MICHAEL'S MOUNT, CORNWALL (engraving) 'Southern Coast'

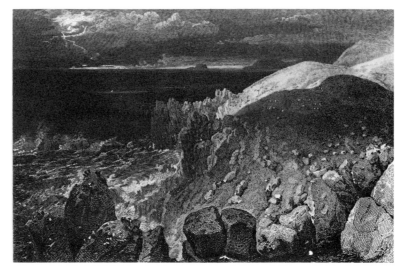

101 LAND'S END, CORNWALL (engraving) British Museum, London 'Southern Coast'

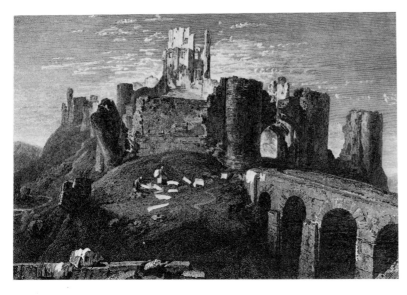

102 CORFE CASTLE, DORSETSHIRE (engraving) British Museum, London 'Southern Coast'

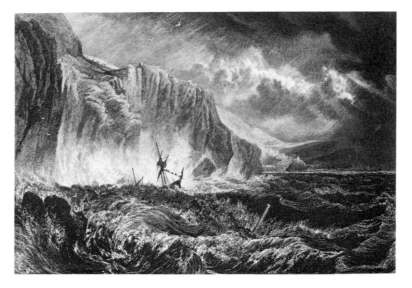

103 ILFRACOMBE, NORTH DEVON (engraving) British Museum, London 'Southern Coast'

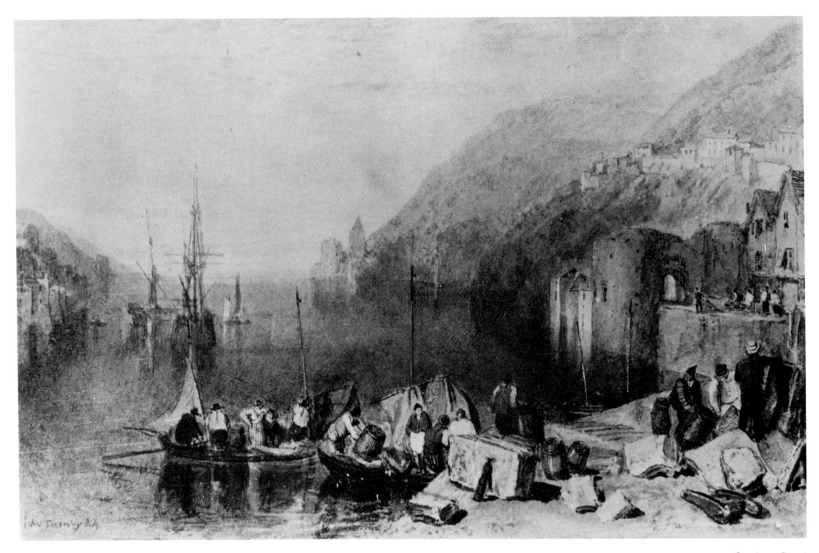

104 DARTMOUTH, DEVON Present whereabouts unknown

'Southern Coast'

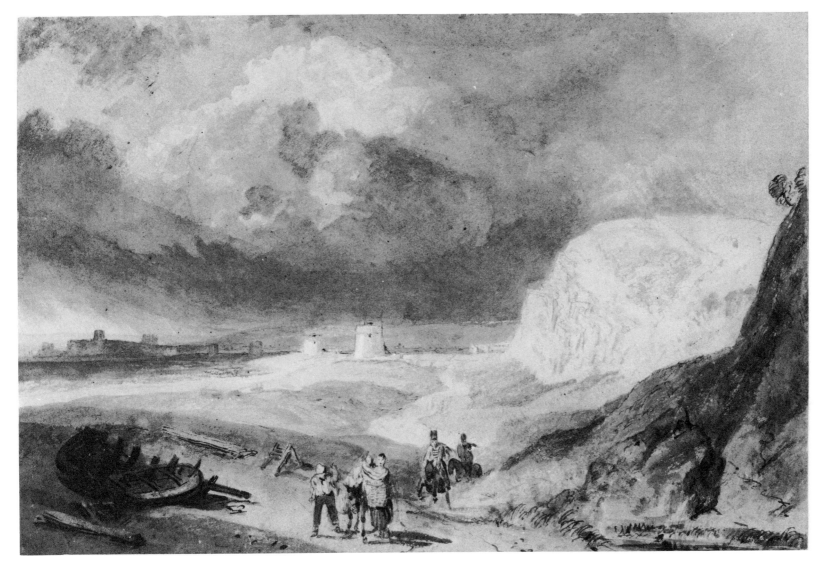

105 MARTELLO TOWERS NEAR BEXHILL, SUSSEX British Museum, London (Turner Bequest)

'Southern Coast'

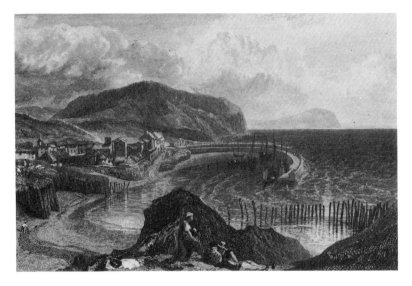

106 WATCHET, SOMERSETSHIRE (engraving) British Museum, London

'Southern Coast'

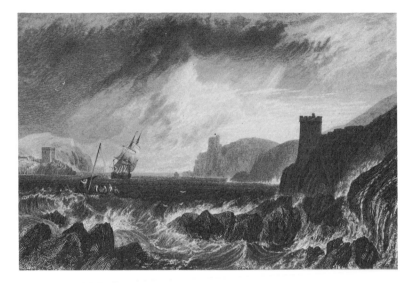

107 ENTRANCE OF FOWEY HARBOUR, CORNWALL (engraving)
British Museum, London 'Southern Coast'

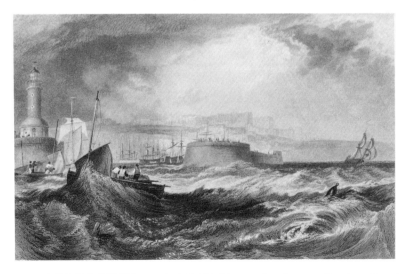

108 RAMSGATE, KENT (engraving) British Museum, London 'Southern Coast'

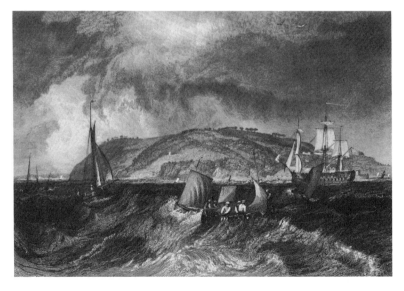

109 MOUNT EDGECOMB, DEVONSHIRE (engraving) British Museum, London
'Southern Coast'

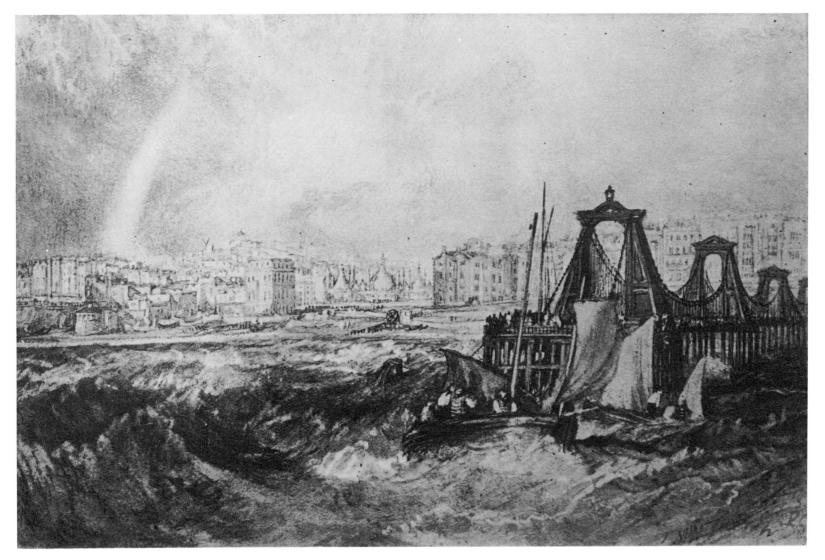

110 BRIGHTHELMSTON, SUSSEX Present whereabouts unknown

'Southern Coast'

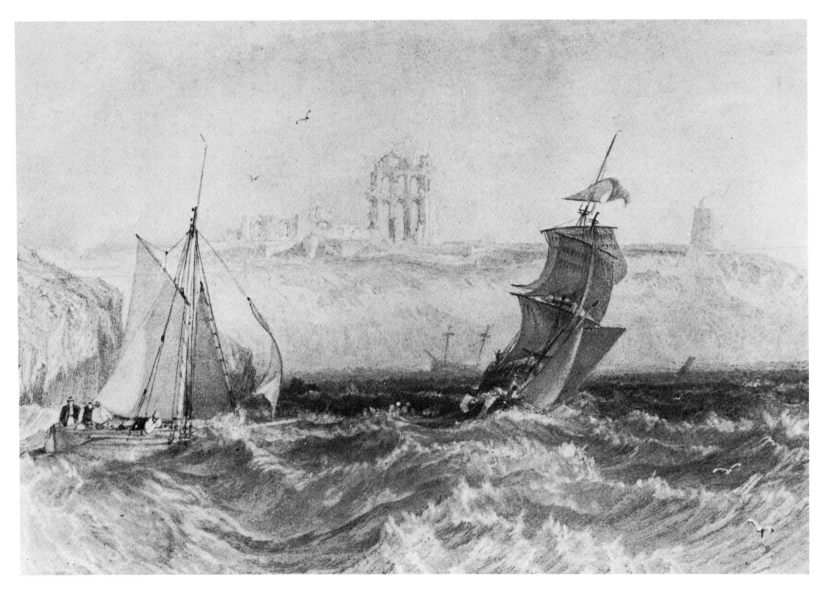

111 TYNEMOUTH PRIORY Private Collection, U.K.

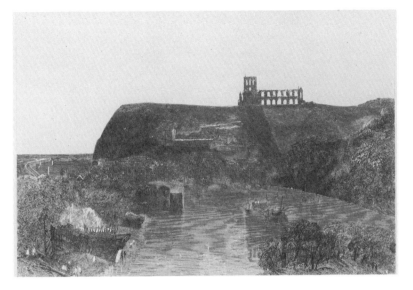

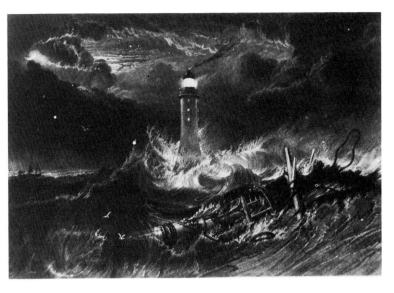

112 WHITBY (engraving) British Museum, London 'East Coast' **113** THE EDDYSTONE LIGHTHOUSE (engraving) British Museum, London,

'Marine Views'

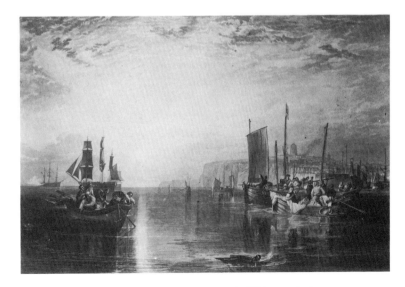

114 SUN-RISE. WHITING FISHING AT MARGATE (engraving)
British Museum, London 'Marine Views'

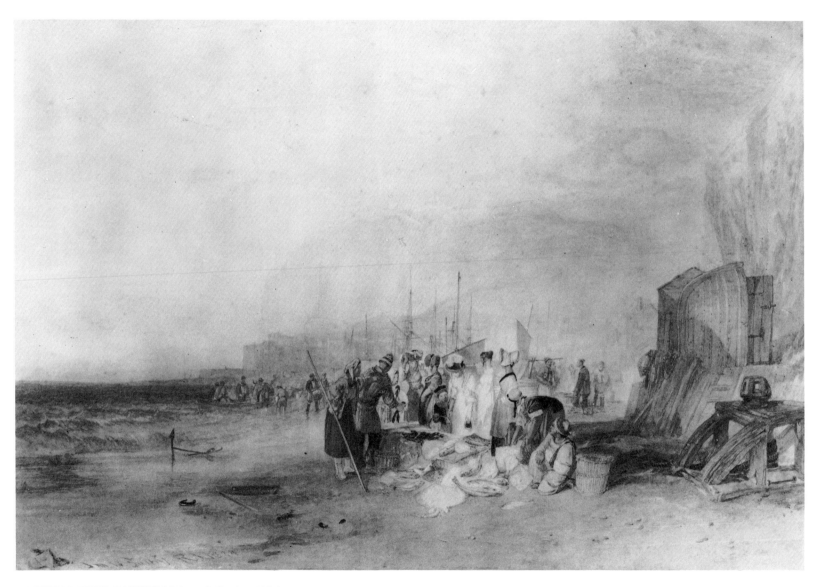

115 FISH-MARKET, HASTINGS Private Collection, U.S.A.

'Marine Views'

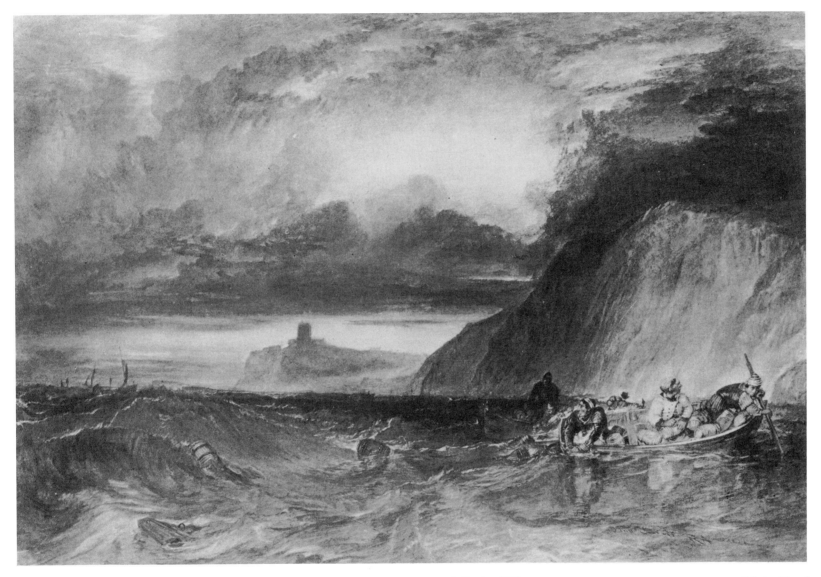

116 TWILIGHT—SMUGGLERS OFF FOLKESTONE FISHING UP SMUGGLED GIN Private Collection, U.K.

'Marine Views'

CONCORDANCE OF WATERCOLOURS TO THEIR ORIGINAL SKETCHES

This correlates the drawings in this book with the original sketches upon which they were based. The Roman numeral, title and date below is that assigned to each sketchbook by A. J. Finberg in his 1909 inventory of the Turner Bequest. Below this is listed across the page (from left to right) the number of the reproduction of the final work in this book; the drawing's title; and the corresponding page number of the sketch (or group of sketches) in the sketchbook to which the drawing can confidently be assigned. For reasons of space the watercolour or engraving titles have been abbreviated.

Plate		Sketchbook Page

XXXIV 'North of England' 1797

| 111 | *Tynemouth* | 35 |
| 1 | *Warkworth Castle* | 40 |

XCI 'Hurstmonceux and Pevensey' c.1804-6

| 105 | *Martello towers near Bexhill* | 11 |

XCVI 'River' c. 1807

| 51 | *More Park* | 49 |

CVII 'Kirkstall' c. 1808-9

| 58 | *Kirkstall Abbey* | 2 |

CXXIII 'Devonshire Coast No. 1' 1811

54	*Dartmouth Castle*	3
19	*Poole*	14 (see also CXXIV)
20	*Weymouth*	44, 44a
32	*Bridport*	47a
63	*Totnes*	91a
25	*Falmouth*('Coast' series)	110, 111
30	*Looe*	112a, 113 (see also CXXV)
39	*St. Mawes*	133
80	*Falmouth* ('Ports' series)	145a
41	*Comb Martin*	147
16	*Ivy Bridge*	153 (see also CXXXIII)
35	*Minehead*	162a
106	*Watchet*	170a
43	*Boscastle*	182
77	*Sidmouth*	203a, 205
28	*Pendennis Castle*	218
38	*Clovelly bay*	223
104	*Dartmouth*	239
23	*Teignmouth*	239a

CXXIV 'Corfe to Dartmouth' 1811

19	*Poole*	10 (see also CXXIII)
102	*Corfe Castle*	17
33	*Lulworth Castle*	19
21	*Lulworth Cove*	22
29	*Bow and Arrow Castle*	26
22	*Lyme Regis*	29a
23	*Teignmouth*	36a-37 (see also CXXIII)
34	*Torbay from Brixham*	48

CXXV 'Ivy Bridge to Penzance' 1811

26	*Plymouth Dock*	10a-11
27, 78	*Plymouth*	11a-12
30	*Looe*	17 (see also CXXIII)
107	*Fowey Castle*	18a-19
28	*Pendennis Castle*	27, 27a (see also CXXIII)
39	*St. Mawes*	30 (see also CXXIII)
100	*St. Michael's Mount*	32, 43a, 44

Add. CXXVA 'Cornwall and Devon' 1811

101	*Land's End*	22
31, 83	*Tintagel*	32, 33, 34
38	*Clovelly*	43, 44, 45, 64, 65 (see also CXXIII)
103	*Ilfracombe*	37, 37a, 38, 39, 40

CXXXIII 'Devon Rivers, No. 2' c. 1812-5

| 16 | *Ivy Bridge* | 45 (see also CXXIII) |

CXXXIV 'Devonshire Rivers No. 3 and Wharfedale' c. 1812-5

| 55 | *Okehampton Castle* | 71 |

CXXXVII 'Vale of Heathfield' c. 1809-16

Finberg assigns the usage of this sketchbook to 1810-6 but the sketches of Brougham date from Turner's tour of the north of England in 1809.

10	*Bodiham Castle*	6a, 7a (synthesis)
14	*Eridge Castle*	14a, 15
97	*Brightling Observatory*	36a-37
113	*Eddystone Lighthouse*	39, 40, 40a-41
9	*Vale of Heathfield*	41a-42
11	*Vale of Ashburnham*	68a-69
18	*River Tavey*	53
57	*Brougham Castle*	70, 71

CXXXVIII 'Views in Sussex' c. 1810-6

This sketchbook was thought by Finberg to be in use only from 1815-6 (the paper is watermarked 1801). However, it contains the antecedent sketches of drawings made for Fuller in 1810 and page 10 contains the study upon which the 1810 oil-painting of Rosehill was based. As Finberg noted (*op.cit.* p.397) other pages from this sketchbook were used in 1811 (CXXVI).

5	*Battle Abbey*	2, 3
6	*Hurstmonceux*	5
15	*Pevensey Castle*	7
7	*Pevensey Bay*	8, 9
Ill. 2	*Rosehill* (oil-painting)	10
96	*Battle Abbey*	11
3	*Ashburnham*	17
4	*Beauport*	18
2	*Rosehill*	19

CXXXIX 'Hastings' 1815-6

36	*Margate*	16a-17
40	*Hythe*	19a-20
37	*Rye*	21a-22
13	*Hastings*	22a-23, 24a-25
8	*Rosehill, Sussex*	33a-34

CXL 'Hastings to Margate' 1815-6

72, 108	*Ramsgate*	24a-25 (drawn from a boat off the harbour-mouth) also 80, 89, 90
86	*Folkestone*	36a
12	*Winchelsea*	55a, 56a
37	*Rye*	54a, 55 (see also CXXXIX)

CLXVII 'Scotch Antiquities' 1818

| 50 | *Newcastle* | 2 |

CXCVI 'Colour beginnings and miscellaneous' 1802-20

| 96 | *Battle Abbey* | D |
| 24 | *Mewstone* | F |

CXCVII 'Colour beginnings' 1802-20

| 13 | *Hastings* | J, K |

CXCVIII 'Folkestone' c. 1821

| 52 | *Rochester* | 10, 18, 18a, 19, 20 (synthesis) |

CC 'King's visit to Scotland' 1822

In this book Turner made a number of extremely loose sketches which were possibly used for various drawings. They include views from the sea of Orford, Aldeburgh, Lowestoft, Yarmouth, Happisburgh, Scarborough and Spurn Point (seen from the sea in *Mouth of the River Humber*, 59).

| 95 | *Yarmouth Sands* | 2 |
| 70 | *Whitby* | 41, 83a, 84 (synthesis) |

APPENDIX A

Letter from W. B. Cooke to Turner, January 1, 1827 (first printed in W. Thornbury *The Life and Correspondence of J. M. W. Turner* (London, 1862), Vol. 1, pp. 400-3.

January 1, 1827

Dear Sir,

I cannot help regretting that you persist in demanding twenty-five sets of India proofs before the letters of the continuation of the work of the 'Coast', besides being paid for the drawings. It is like a film before your eyes, to prevent your obtaining upwards of two thousand pounds in a commission for drawings for that work.

Upon mature reflection, you must see I have done all in my power to satisfy you of the total impossibility of acquiescing in such a demand. It would be unjust both to my subscribers and to myself.

The 'Coast' being my own original plan, which cost me some anxiety before I could bring it to maturity, and an immense expense before I applied to you, when I gave a commission for drawings to upwards of 400l. *at my own entire risk,* in which the shareholders were not willing to take any part, I did all I could to persuade you to have one share; and which I did from a firm conviction that it would afford some remuneration for your exertions on the drawings in addition to the amount of the contract. The share was, as it were, forced upon you by myself, with the best feeling in the world; and was, as you well know, repeatedly refused, under the idea that there was a possibility of losing money by it. You cannot deny the result: a constant dividend of profit has been made to you at various times, and will be so for some time to come.

On Saturday last, to my utter astonishment, you declared in my print-rooms, before three persons who distinctly heard it, as follows:— 'I will have my terms! or I will oppose the work by doing another "Coast"!' These were the words you used; and everyone must allow them to be a *threat.*

And this morning (Monday) you show me a note of my own handwriting, with these words (or words to this immediate effect): 'The drawings for the future "Coast" shall be paid twelve guineas and a half each'.

Now, in the name of common honesty, how can you apply the above note to any drawings for the first division of the work, called the 'Southern Coast', and tell me I owe you two guineas on each of those drawings? Did you not agree to make the whole of the 'South Coast' drawings at 7l.10s. each? and did I not continue to pay you that sum for the first four numbers? When a meeting of the partners took place, to take into consideration the great exertions that myself and my brother had made on the plates, to testify their entire satisfaction, and considering the difficulties I had placed myself in by such an agreement as I had made (dictated by my enthusiasm for the welfare of a work which had been planned and executed with so much zeal, and of my being paid the small sum only of twenty-five guineas for each plate,

including the loan of the drawings, for which I received no return or consideration whatever on the part of the shareholders), they unanimously (excepting on your part) and very liberally increased the price of each plate to 40l.; and I agreed, on my part, to pay you ten guineas for each drawing after the fourth number. And have I not kept this agreement? Yes; you have received from me, and from Messrs. Arch on my account, the whole sum so agreed upon, and for which you have given me and them receipts. The work has now been finished upwards of six months, when you show me a note of my own handwriting, and which was written to you in reply to a part of your letter, where you say, 'Do you imagine I shall go to John O'Groat's House for the same sum I receive for the Southern part?' Is this *fair* conduct between man and man, to apply the note (so explicit in itself) to the former work, and to endeavour to make me believe I still owe you two guineas and a half on each drawing? Why, let me ask you, should I promise you such a sum? What possible motive could I have in heaping gold into your pockets when you have always taken such especial care of your interests, even in the case of 'Neptune's Trident', which I can declare you *presented* to me; and in the spirit of *this* understanding I presented it again to Mrs Cooke. You may recollect afterwards charging me two guineas for the loan of it, and requesting me, at the same time, to return it to you; which has been done.

The ungracious remarks I experienced this morning at your house, when I pointed out to you the meaning of my former note—'that it referred to the future part of the work, and not to the "Southern Coast"'—were such as to convince me that you maintain a mistaken and most unaccountable idea of profit and advantage in the new work of the 'Coast'; and that no estimate or calculation will convince you to the contrary. Ask yourself if Hakewill's 'Italy', 'Scottish Scenery' or 'Yorkshire' work have either of them succeeded in the return of the capital laid out on them.

These works have had in them as much of your individual talent as the 'Southern Coast', being modelled on the principle of it, and although they have answered your purpose by the commissions for drawings, yet there is considerable doubt remaining whether they will ever return their expenses, and whether the shareholders and proprietors will ever be reinstated in the money laid out on them. So much for the profit of works.

I assure you I must turn over an entirely new leaf to make them ever return their expenses.

To conclude, I regret exceedingly the time I have bestowed in endeavouring to convince you in a calm and patient manner of a number of calculations made for *your* satisfaction; and I have met in return such hostile treatment that I am positively disgusted at the mere thought of the trouble I have given myself on such a useless occasion.

I remain, your obedient Servant,
W. B. Cooke

APPENDIX B

Account Books of W. B. Cooke (first published in W. Thornbury, *op. cit.* 1862, Vol. 2, pp. 423-5).

Account-books of Mr. W. B. Cooke.

W. B. Cooke, Dr. to J. M. W. Turner.

1817.	£	s.	d.
February 20			
Drawing of Ilfracombe Coast	10	10	0
March 1.			
Loan of Drawing of the Eddystone for Rivers of Devon	5	5	0
Loan of Drawing of Junction of Tamar for Rivers of Devon	5	5	0
Loan of Drawing of Plymouth Sound for Rivers of Devon	5	5	0
June.			
Brixham, Coast	10	10	0
Fowey, Coast	10	10	0
Love	10	10	0
July.			
Tintagel, Coast	10	10	0
Bridport, Coast	10	10	0
Winchelsea	6	6	0
Arisbantony (?)	6	6	0
Two Drawings of Vesuvius for Pompei	31	10	0
	£122	**17**	**0**

1817.	£	s.	d.
Paid August 4	40	0	0
1818.			
Paid Mr. Turner for one Drawing of Vesuvius (Pompeii)	15	15	0
August 21.			
Paid Mr. Turner for another Drawing of Vesuvius, for Pompeii	15	15	0
August 21.			
Paid Mr. Turner	51	7	0
	£122	**17**	**0**

W. B. Cooke, Dr.

1818.	£	s.	d.
July.			
Battle Abbey	6	6	0
August 31.			
Hastings from the Sea, for Mr. Fuller's Work	42	0	0
Watchet, Coast	10	10	0
Dunster	10	10	0
Mount Edgecombe	10	10	0
	£79	**16**	**0**

1818. Cr.	£	s.	d.
August 29.			
Paid Mr. Turner in Bills as follows:—			
One at six months for	43	10	0
One at nine months for	30	0	0
Copper for 'Liber Studiorum' (three plates)	1	1	6
Recd. Gairdner's Views on the Rhine, charged in Arches Account	1	4	0
	£75	**15**	**6**

W. B. Cooke, Dr.

	£	s.	d.
Three Drawings (Rhine)	85	1	0
Lulworth Castle	10	10	0
Margate	10	10	0
Dover. — Large Drawing for Exhibition 1823: Shipwreck and Margate, Sunrise	189	0	0
Touching Tomkinson's Cuyp	2	2	0
Touching Chelsea Reach	2	2	0
Colne	8	8	0
Rochester	8	8	0
Norham	8	8	0
Coast, St. Mawes	10	10	0
Touching Cuyp's Horse	2	2	0
Do. Boat	2	2	0
Girtin's Kirkstone	2	2	0
Dartmouth	8	8	0
Rivers, do	8	8	0
1824.			
Folkestone	68	0	0
	£96	**12**	**0**
Rye	10	10	0
Coville Bay	10	10	0
Hythe	10	10	0
Ramsgate	10	10	0
	£138	**12**	**0**

W. B. Cooke, Dr. to J. M. W. Turner.

1822	£	s.	d.
Three Drawings of the Rhine	85	1	0
Lulworth Castle, Coast	10	10	0
Margate, Coast	10	10	0
Dover. — Large Drawing for the Exhibition 1823: Shipwreck and Margate, Sunrise	189	0	0
Touching Tomkinson's Cuyp	2	2	0
Touching Chelsea Reach	2	2	0
Loan of More Park, Rivers	8	8	0
Do. Rochester, do.	8	8	0
Do. Norham, do.	8	8	0
St. Mawes, Coast	10	10	0
Carried forward	**£334**	**19**	**0**

1822.	£	s.	d.
September.			
Bill four months for three Drawings (Rhine)	85	1	0
Paid Mr. Turner for Lulworth Castle and Margate	21	0	0
1823.			
March 18.			
Bill at two months	50	0	0
July 27.			
A Bill at two months for the loan of two Drawings, No. 1 Rivers, and touching Tomkinson's Cuyp and Girtin's Chelsea Reach	21	0	0
September 5th.			
Bill at four months	69	10	0
Do. at five months	69	10	0
October 1.			
Bill at two months for Loan of three Drawings for No. 2 Rivers	25	4	0
Liber Studiorum, Arches paid	31	10	0

1822. Cr.	£	s.	d.
September.			
Bill at four months for three Drawings of the Rhine	85	1	0
Paid Mr. Turner for Lulworth Castle and Margate	21	0	0
1823.			
March 18.			
Bill at two months	50	0	0
July 27.			
Bill at two months for the Loan of two drawings (Rivers) and touching Tomkinson's Cuyp and Chelsea Reach	21	0	0
Carried forward	**£177**	**1**	**0**

	£	s.	d.
Brought forward	334	19	0
1822.			
Touching Traveller, Cuyp	2	2	0
1824.			
Large Drawing of Smugglers Fishing Gin	63	0	0
Rye, Coast	10	10	0
Clovelly Bay, do.	10	10	0
Ramsgate do.	10	10	0
'Liber Studiorum,' fourteen numbers at 1l. 1s.: twenty per cent. allowed	11	15	0
	£474	**16**	**0**

	£	s.	d.
Brought forward	177	1	0
1822. Sept. 5.			
Bill at four months	69	10	0
Do. at five months	69	10	0
October 1.			
Bill at two months, paid at Oxford, for Loan of More Park, Rochester, and Norham Castle	25	4	0
Arch paid for Rye, Clovelly Bay, and Hythe Coast	31	10	0
Arch to pay Ramsgate	10	10	0
1824.			
July 17.			
Two Bills as follows, for balance, one dated June 25th, at four months, another dated June 25, at five months, each for 45l. 15s. 6d.	91	11	0
	£474	**16**	**0**

1824. W. B. Cooke, Dr.

July 22.	£	s.	d.
Loan of three drawings for Rivers, as follows:			
Brougham Castle	8	8	0
Totness	8	8	0
Okehampton Castle	8	8	0
	£25	**4**	**0**

1825.	£	s.	d.
Jan. 14			
Loan of two Drawings, as follows:			
Rainbow (Arundel Castle)	8	8	0
Bromleys (Kirkstall Abbey)	8	8	0
	16	**16**	**0**

1824. Cr.	£	s.	d.
July 22.			
Bill at two months, for Broughton Castle, Totness, Okehampton	25	4	0

1825. Cr.	£	s.	d.
Jan. 14.			
Bill at two months for Arundel Castle and Kirkstall Abbey	16	16	0

CHRONOLOGY OF THE ENGRAVINGS

The following list shows the chronological order of the completed engravings of the majority of the drawings in this book. The dates given are either the probable date of completion of the unpublished engravings (marked with an asterisk) or else their publication date. These abbreviations denote the series to which the engravings belong: S.C. Southern Coast; R.D. The Rivers of Devon; V.S. Views in Sussex; R.E. The Rivers of England; P.E. The Ports of England; M.V. Marine Views; E.C. East Coast; D.B. Dr Broadley's poems; V.H. Views at Hastings. The number accorded to each engraving is that assigned to the work by W. G. Rawlinson in his catalogue *The Engraved Work of J. M. W. Turner*, 2 Vols. (London, 1908 and 1913). Also appended is the name of the engraver. For reasons of space the engraving titles have been abbreviated.

Date		Title	Series	Rawlinson Number	Engraver
1810-8[98]		Rosehill	*	R822	J. C. Stadler
		Ashburnham	*	R823	J. C. Stadler
		Beauport	*	R824	J. C. Stadler
		Battle Abbey	*	R825	J. C. Stadler
1814	1 Jan.	St. Michael's Mount	S.C.	R88	W. B. Cooke
	1 Jan	Poole	S.C.	R89	G. Cooke
	1 March	Lands End	S.C.	R90	G. Cooke
	1 March	Weymouth	S.C.	R91	W. B. Cooke
	1 June	Lulworth Cove	S.C.	R92	W. B. Cooke
	1 Nov.	Corfe Castle	S.C.	R93	G. Cooke
	1 Nov.	Lyme Regis	S.C.	R94	W. B. Cooke
1815	1 June	Teignmouth	S.C.	R95	G. Cooke
	1 June	Dartmouth	S.C.	R96	W. B. Cooke
1816	1 Feb.	Mew Stone	S.C.	R97	W. B. Cooke
	1 March	Falmouth	S.C.	R98	W. B. Cooke
	1 Oct.	Plymouth Dock	S.C.	R99	W. B. Cooke
1817	1 May	Plymouth	S.C.	R100	W. B. Cooke
	1 May	Pendennis Castle	S.C.	R101	G. Cooke
	1 May	Bow and Arrow Castle	S.C.	R102	W. B. Cooke
	1 May	Martello Towers, Bexhill	S.C.	R103	W. B. Cooke
		Bodiham Castle	V.H.*	R134	W. B. Cooke
		Winchelsea	V.H.*	R136	W. B. Cooke
1818	1 July	East and West Looe	S.C.	R104	W. B. Cooke
	1 July	Ilfracombe	S.C.	R105	W. B. Cooke
	1 July	Tintagel	S.C.	R106	G.Cooke
1819	1 March	Frontispiece etching	V.S.	R128	J. C. Allen/ Turner
	1 March	Battle Abbey	V.S.	R129	W. B. Cooke
	1 March	Brightling Observatory	V.S.	R130	W. B. Cooke
	1 March	Vale of Ashburnham	V.S.	R131	W. B. Cooke
	1 March	Pevensey Bay	V.S.	R132	W. B. Cooke
	1 March	Vale of Heathfield	V.S.	R133	W. B. Cooke
1820	1 April	Watchet	S.C.	R107	G. Cooke
	1 April	Bridport	S.C.	R108	W. B. Cooke
	1 April	Fowey	S.C.	R109	W. B. Cooke
		Hurstmonceux	V.H.*	R135	W. B. Cooke
1821	1 Jan.	Lulworth Castle	S.C.	R110	G. Cooke
	1 Jan.	Torbay/Brixham	S.C.	R111	W. B. Cooke
	1 Jan.	Minehead	S.C.	R112	W. B. Cooke
	4 June	Ivy Bridge	R.D.	R139	J. C. Allen
1823	1 March	Plymouth Citadel	R.D.	R137	W. B. Cooke
	1 March	Plymouth Sound	R.D.	R138	W. B. Cooke
	2 June	Shields/Tyne	R.E.	R752	C. Turner
	2 June	Newcastle	R.E.	R753	T. Lupton
1824	1 Jan.	More Park	R.E.	R754	C. Turner
	1 Jan.	Rochester	R.E.	R755	T. Lupton
	1 Jan.	Norham Castle	R.E.	R756	C. Turner
	1 Jan.	Dartmouth Castle	R.E.	R757	T. Lupton
	? Feb.	Margate	S.C.	R113	G. Cooke
	1 March	Eddystone Lighthouse	M.V.	R771	T. Lupton
	1 March	Rye	S.C.	R114	E. Goodall
	1 March	Clovelly	S.C.	R115	W. Miller
	Sept.	St. Mawes	S.C.	R116	J. C. Allen
	20 Dec.	Ramsgate	S.C.	R117	R. Wallis
	20 Dec.	Hythe	S.C.	R118	G. Cooke
1825	1 Jan.	Comb Martin	S.C.	R119	W. Miller
	15 Feb.	Portsmouth	S.C.	R120	W. Miller
	1 March	Okehampton	R.E.	R758	C. Turner
	1 March	Totnes (subsequently cancelled)	R.E.	R767	C. Turner
	10 March	Boscastle	S.C.	R121	E. Goodall
	1 June	Dartmouth	R.E.	R759	S. W. Reynolds
	1 June	Brougham Castle	R.E.	R760	W. Say
		Sunrise, Margate	M.V.	R770	T. Lupton
		Neptune's Trident	M.V.	R771	T. Lupton?
1826	24 Feb.	Folkestone	S.C.	R123	R. Wallis
	1 April	Deal	S.C.	R124	W. Radcliffe
	1 April	Wrapper Vignette	P.E.	R778	T. Lupton?
	1 April	Scarborough	P.E.	R779	T. Lupton
	1 April	Whitby	P.E.	R780	T. Lupton
	12 April	Mt. Edgecomb	S.C.	R125	E. Goodall
	6 May	Dover	S.C.	R126	G. Cooke
	8 May	Whitstable	S.C.	R127	J. Horsburgh
	31 Oct	Kirkstall Abbey	R.E.	R761	J. Bromley
	31 Oct	Warkworth Castle	R.E.	R762	T. Lupton
	1 Oct.	Mouth/Humber	R.E.	R763	G. H. Phillips
1827	1 Jan.	Arundel Castle	R.E.	R764	G. H. Phillips
	1 Jan.	Kirkstall Lock	R.E.	R765	W. Say
	1 Jan.	Stangate Creek	R.E.	R766	T. Lupton
		Dover	P.E.	R781	T. Lupton
		Ramsgate	P.E.	R782	T. Lupton
1827-30?		Sheerness	P.E.	R783	T. Lupton
		Portsmouth	P.E.	R784	T. Lupton
		Lowestoffe Lighthouse	E.C.*	R305	J. C. Allen
		Hasboro Sands	E.C.*	R306	J. C. Allen
		Orford Castle [Haven]	E.C.*	R307	J. C. Allen
		Aldborough	E.C.*	R308	J. C. Allen
		Dunwich	E.C.*	R309	J. C. Allen
		Orfordness	E.C.*	R310	J. C. Allen
1844		Whitby	D.B.	R639	J. Cousen
		Tynemouth Priory	D.B.	R641	W. Miller
		Folkestone	D.B.	R643	J. Cousen
1850	1 Feb.	Tamar/Torridge	originally R.D.	R140	W. B. Cooke

NOTES TO **MESSRS FULLER, COOKE AND LUPTON** AND **MR TURNER**

1 Farington mistakenly gave it in his diary as 'Suffolk' (typescript of Farington's diary, Dept. of Prints and Drawings, British Museum, London).

2 He must have underlined the word 'use' because he was so impressed by the high amount Turner was able to obtain merely for the hire of his drawings. That *Rosehill* (2), *Ashburnham* (3), *Beauport* (4) and *Battle Abbey* (5) do date from 1810 (and not later as has been thought by several writers on Turner) is attested to by three factors. Turner received the extremely lucrative commission for drawings in the spring of 1810. He would hardly have kept Fuller waiting long for his pictures. Four aquatints of these watercolours were then produced, separately from the engravings of any of Fuller's other drawings. The coincidence, between the 'three or four views' ordered (to be made 'use of') and the *four* aquatints, seems conclusive. Furthermore, on stylistic grounds alone, these drawings stand apart from all the other works made for Fuller and clearly date from earlier.

3 It is today known as *Hastings—Fishmarket on the Sands* M. Butlin and E. Joll, *The Paintings of J. M. W. Turner* (London and New Haven, 1977—No. 105) although there is nothing to identify the scene with Hastings. It now belongs to the William Rockhill Nelson Gallery and Atkins Museum of Fine Arts, Kansas City, U.S.A.

4 TB CXXII, 'Finance' Sketchbook, p.4.

5 Rawlinson Nos. 822-5 (W. G. Rawlinson, *The Engraved Work of J. M. W. Turner,* 2 Vols. London, 1908 and 1913).

6 Farington wrote 'Stadler I called on and saw a picture by Turner—A view of Rose Hill, Mr. Fuller's House in Sussex'. The fact that Farington refers to Fuller's 'House' differentiates the work from the drawing for the coloured aquatint (R.822) produced by Stadler (which is also called Rosehill) but which only shows the estate (see 2). This proves Evelyn Joll's contention (Butlin and Joll, *op.cit,* No. 211) that the oil of Rosehill was painted in 1810. Farington's statement has probably been overlooked by previous writers on Turner because it is indexed in connection with Stadler and not under Turner at all.

7 Memoir by P. Cunningham in J. Burnet *Turner and his works* (London, 1852) p. 34.

8 Joseph Jeckyll to Lady Gertrude Sloane-Stanley, *Correspondence* (London, 1894) p. 294.

9 TB CXI 'Hastings' Sketchbook, p. 59.

10 *The Gentleman's Magazine,* June 1834, p. 649.

11 Much of the evidence concerning Turner's dealings with W.B. Cooke over the 'Southern Coast' series is gleaned from a letter written by Cooke to Turner, dated 1 January, 1827. (Appendix A, page 153). It was first published in W. Thornbury *The Life of J. M. W. Turner,* (London, 1862) Vol. 1, pp. 400-3. More recently it has been reprinted in John Gage: *The Collected Correspondence of J. M. W. Turner* (Oxford, 1980), letter 121, pp. 104-6. As the letter makes clear, Cooke urged Turner to invest financially in the venture but he refused. Instead, Cooke seems to have paid Turner a bonus out of the profits of the scheme (see note 12, below). As John Gage's annotation to this letter suggests (p. 104, note 2) it is not clear how many drawings Cooke initially requested from Turner. Cooke writes of initially commissioning upwards of four hundred pounds-worth of drawings for the series. If these were all from Turner this would have meant Turner would have produced fifty-three of them, i.e. £400 divided by £7.10s=53 (the letter *is* ambiguous. Cooke states that 'The "Coast" being my own original plan, which cost me some anxiety before I could bring it to maturity, and an immense expense before I applied to you, when I gave a commission for drawings for upwards of £400 . . .'). However, I agree with Gage's contention that this number of works must have been *inclusive* of those contributed by the other artists to the series. There are two views on this. A. J. Finberg (*An Introduction to Turner's Southern Coast,* London, 1927, p.xiii) states, without giving sources, that 'Turner's first contract with Cooke was to supply twenty-four drawings.' On the other hand W. G. Rawlinson, *op.cit.* Vol.1,p. xxix, tells us that Turner was to make forty from the outset— again without citing sources. As the covers for the parts of the 'Southern Coast' tell us that the scheme was to consist of either forty-eight full-page plates and thirty-two vignettes, or alternatively fifty plates and thirty vignettes (the numbers varied) it seems highly unlikely that Turner would initially have been asked to make more works than were intended for engraving in the series. Moreover, if Turner had made such a number all the other artists would have been excluded. An explanation for the ambiguity is that Turner's agreement to participate was the lynch-pin upon which the decision to proceed was founded. Once his assent had been received then Cooke issued the commissions to all the artists, including Turner. That would explain the ambiguous 'when' in the extract quoted above.

12 This syndicate is listed in John Murray's ledger book 'A', p. 1. The members consisted of W. B. Cooke, George Cooke, E. Lloyd, J. Hakewill, J. and A. Arch, J. M. Richardson, B. King, E. Blore, W. Westall, W. Alexander, John Murray and Turner. However, although Turner was a member it does not seem that he had a financial share in the scheme (but see note 11, above).

13 The 'Vale of Heathfield' Sketchbook, TB CXXXVII.

14 Autograph letter in the archives of John Murray (Publishers) Ltd.

15 Cyrus Redding (1784-1870) was later to write *A History and Description of Modern Wines,* a work that was regarded by the Victorians as the authoritative book on wine. It was first published in 1833 and went through several printings up until 1871. It was re-published in 1980.

16 'The late Joseph Mallord William Turner' by Cyrus Redding, *The Gentleman's Magazine,* February 1853, p. 152.

17 Gage, *op.cit.,* letter 47, p.54 (16? or 23 November 1814).

18 1 August, 1811.

19 Better known as 'Dr Syntax', Combe was the author of an influential satire entitled 'The Tour of Dr. Syntax in search of the Picturesque'. The work was illustrated by Rowlandson.

20 A letter from W. B. Cooke to John Murray (now in the John Murray archive) dating from the end of 1814, states that Part 4 of the 'Southern Coast' was entirely sold out even though it had only been published in October and November. Cooke speculates in the letter as to the viability of further printing from the plates but also complains that '. . . the work falls desperately heavy on myself and my Brother—When and where are we to expect a sufficient remuneration?—The print only of Lyme [*Lyme Regis,* R.94] is honestly worth half a guinea to pay for the labour bestowed on it—I begin to despair of being paid half the value of time and labour even though the Works sell till the plates are utterly worn out'. He continues in this vein, pleading for greater profit from the project. The letter obviously made its point.

21 Rawlinson, *op. cit.,* Vol. 1, p.xxvi. Turner found John Pye's line-engraving of his painting *Pope's Villa at Twickenham* (R.A. 1808) a revelation and it opened his eyes to the possibilities of the medium.

22 W. B. Cooke's account books (see Appendix B, p. 154) also record that Turner made a view of the Eddystone lighthouse (hardly a river in Devon) for this series. Turner hired the drawing to Cooke for £5. The work was eventually assigned to the 'Marine Views' series (see main text below).

23 This agreement is published in full in Chapter III of Ruskin's *Dilecta.* It affords a useful glimpse of the

way that arrangements between Turner and W. B. Cooke were arrived at. Turner was to receive seventeen guineas for each drawing and an eighth share of the profits. The engravers (J. C. Allen and Cooke) were to get fifty guineas for engraving each plate. The whole work was speculative and it was to be paid for entirely out of the sale of the prints, W. B. Cooke presumably having all his capital tied up elsewhere. (His account books make clear, however, that he paid Turner twenty-seven guineas per drawing for three Rhine views (see Appendix B, p.154), rather than the seventeen guineas that Ruskin stated.)The drawings were to be sold for at least double what Turner was paid for them and the profits paid back into the common account to be shared out. One out of every seven of these works (chosen by lot) was to revert to Turner.

Turner attempted to induce Ackermann to drop his rival scheme but without success (see A. J. Finberg, *The Life of J. M. W. Turner, R.A.* 2nd edition, London, 1961, pp. 256-7). See also pp.7-8 of the *c.*1819 'Æsacus and Hesperie' Sketchbook (TBCLXIX).

24 The etched states of these works carry the dates 1816 and 1817. Vol. 1. See Rawlinson, *op.cit.*, pp. 68-72.

25 This suggests that Turner had consciously made the later Fuller drawings accord stylistically with his earlier set.

26 Both this letter and the one referred to immediately below are in the John Murray archive.

27 These facts are ascertained from Cooke's letter to Turner of 3 June, 1819, first published in A. J. Finberg *An Introduction to Turner's Southern Coast* (London, 1927) Appendix A, p. 70.

28 Finberg, *op.cit.* 1927, p.xii completely misinterpreted the cause of the break between Cooke and Murray. He thought that Murray withdrew his support for the 'Southern Coast' series because the 'Views in Sussex' was not ready on time. However, as we can see from Cooke's letter to Murray quoted above (p. 7), the engravings for the 'Views in Sussex' *were* ready well before 1819. Murray's refusal to handle the 'Sussex' scheme explains why (despite the earlier published date-line) the engravings did not appear on the market until 1820.

29 Finberg, *op.cit.*, 1927, p.70.

30 The John Murray archives contain a friendly letter from John Murray to Cooke dated 29 January, 1822.

31 Auction catalogue, Messrs. Southgate, Grimston and Wells, Friday 23 July, 1830

32 Ackermann's *Repository of the Arts*, 1 March, 1822 tells us that 'last years exhibition was rather discouraging to the proprietors'.

33 George Cooke eventually additionally engraved 1 plate by Turner for Whitaker's 'Loidis and Elmete' (R.87); 3 plates for Hakewill's 'Tour of Italy' (R.148, 156 and 158); 1 plate for Allason's 'Antiquities of Pola' (R.162); and 3 plates for Scott's 'Provincial Antiquities of Scotland' (R.189, 190 and 193). All of these were undertaken between 1816 and 1826.

34 R.205 and 206. W. G. Rawlinson (*op.cit.*, Vol. 1, p. 115) was unable to identify which project these were intended for. Another of them was engraved by William Miller and published in *The Literary Souvenir* in 1831 (R.318). See Eric Shanes, 'Turner's "unknown" London series', *Turner Studies*, 2, Summer 1981.

35 W. B. Cooke's account books for 1822, quoted in Thornbury *op.cit*, see Appendix B. The engraving, entitled *Chelsea Reach, looking towards Battersea*, was published by Cooke on 1 August, 1823. Cooke also employed Turner to touch proofs of other works by Girtin (see main text below) and Cuyp (*A group of cattle*).

36 T. Miller, *Turner and Girtin's Picturesque Views* (London, 1854), publisher's preface (n.p.).

37 Rawlinson (*op.cit.*. Vol. II, p. 364) verifies Turner's work on these plates. He testifies to seeing the etched initials *J.M.W.T.* on a privately-owned proof of Girtin's *York Minster.*

38 *The Sun*. 1 January 1823.

39 *The British Press*. 1 January 1823.

40 Thornbury, *op.cit.*, see Appendix B.

41 Cooke himself relates this story in his letter to Turner of 1 January, 1827 (see Appendix A). We only have his word for it therefore. He may have misunderstood Turner. The artist very rarely gave works away—he was a *professional* painter after all.

42 Thornbury, *op.cit.*, 1877, pp. 192-3. 'Mr. Munro' was H. A. J. Munro, Turner's patron and friend. They probably met in the mid-1820s.

43 He stayed at Farnley from 19 November-14 December, 1824.

44 Thornbury *op.cit.*, see Appendix B.

45 Finberg *op.cit.*, 1927, p. xii.

46 See Eric Shanes: *Turner's Picturesque Views in England and Wales*, (London, 1979), p. 10.

47 A note on a proof of *Hythe, Kent* (quoted in Rawlinson, *op.cit.*. Vol. 1, p. 64, No. 118) suggests that Cooke allowed Turner one preliminary etching and four proofs of each 'Southern Coast' engraving.

48 See Appendix A, p. 153. Cooke states in this letter that Turner's obsession with the proofs '. . . is like a film before your eyes, to prevent your obtaining upwards of two thousand pounds in a commission for drawings for that work' (i.e. the continuation of the 'Coast' scheme around Britain). At twelve and a half guineas for each drawing this means that at least 160 drawings were planned. As 160 is divisible by 40 (i.e. the number of drawings in the 'Southern Coast') four times *exactly*. this means that Cooke eventually planned the entire coastal scheme in four parts with 40 drawings by Turner in each part.

49 *Dover from Shakespeare's cliff* (R.125).

50 Frederick Goodall R.A., *Reminiscences* (London, 1902) pp. 161-2.

51 At this time Goodall was also working on two engravings for the 'England and Wales' series, views of *Rivaulx Abbey* (R.209) and *The Fall of the Tees* (R.214).

52 Thornbury, *op.cit.*, 1877, p. 316n.

53 John Ruskin, *The Harbours of England* (London, 1856) p. iv.

54 Thornbury (*op.cit.*, 1877, pp. 196-8) gives a detailed account of the dispute.

55 Rawlinson stated (*op.cit.*, Vol. 1, p. xliii) that the work 'failed to attract subscribers' but he also later tells us that 'only a small number of impressions . . . remained unsold from the original issue' (Vol. II, p. 378). Gambart and Lupton were hardly likely to have re-published them in 1856 if they had been a financial failure in 1828. Rawlinson is probably correct, though, in assuming that Turner may have found the tonal range of mezzotint too dark and that this led to his dissatisfaction with the scheme. The incomplete state of *Margate* (R.785) also suggests that Turner was making enormous demands upon Lupton (the print transforms an afternoon scene into one at night). This too may have led to friction.

A greater mystery concerns the fate of the drawings. Turner unquestionably hired, rather than sold, the drawings for the completed engravings to Lupton; as a result they are all still in the Turner Bequest. The drawings for all the *uncompleted* engravings were sold, though it is not known by whom. Turner is unlikely to have split up the series and, as the drawings were probably with Lupton when divided, he may well have sold them to recoup his losses. This would also explain why he did not complete the engravings, which in any case he could not do without Turner's collaboration.

56 Sunday 7 January, 1827.

57 The drawings were to be worked up from sketches made on the tour of northern France in the summer of 1826. The letterpress was to be in French and English. There is a copy of the prospectus in the Dawson Turner collection of prospectuses (London, British Library, Shelfmark/1879 b.1.).

58 Unfortunately it is now poorly displayed at the National Maritime Museum, Greenwich where it is hung at the wrong height and merely used as an

illustration in an exhibition devoted to Nelson.

59 This naturalism is also evident in the oil of *Rosehill* painted for Fuller (Ill. 2). It manifested itself in a range of major works painted between 1806-12. These include a whole series of oil-sketches *circa* 1807, *London,* exh. 1809 (Butlin and Joll, *op.cit.,* No. 97), two views of *Lowther Castle* exh. 1810 (Butlin and Joll, Nos. 111, 112) *Somer-Hill* exh. 1811 (Butlin and Joll No. 116) *Ivy Bridge Mill,* exh. 1812 (Butlin and Joll, No. 122) and other paintings of the period. All of these exhibited works are especially unusual for the fact that they contain no figures.

60 Gerald Finley, 'Turner's Colour and Optics' *Journal of the Warburg and Courtauld Institutes,* 1973, pp. 385-90. His argument is supported by W. B. Cooke's account book (Thornbury, *op.cit.,* see Appendix B) where it is recorded that *Norham Castle* was paid for in 1822. This dating would support his connection of the prismatic colouring of the picture with Brewster's ideas concerning optics which Turner may have encountered when he visited Scotland in August 1822 (see also John Gage, *Colour in Turner: Poetry and Truth,* London, 1969, pp. 90, 124-6).

61 *Views in Sussex* (bound copy) 1819, British Library, London, Shelfmark 558*.h.25.

62 The later watercolours made for Fuller are of the same size (presumably they were made so to complement Fuller's earlier drawings) although the subsequent line-engravings made from them by the Cookes are much smaller. This reflects the fact that the Cookes did not ever seem to have the time or inclination to make large line-engravings.

63 John Ruskin, *Modern Painters,* (London, 1897) Vol. V, p. 366n.

64 Finberg papers, copy of studio-inventory, British Museum Dept. of Prints and Drawings. Several of these models are now in the Tate Gallery, London.

65 John Ruskin, *op.cit.,* 1856, pp. 22-4.

66 It was only after the death of Fawkes that Turner began to take a far more bleak and tragic view of the sea. Lighthouses in particular thenceforth frequently appear in direct juxtaposition with wreckage as symbols of the futility of human aspiration (*Orfordness,* 93).

NOTES TO **THE COMMENTARIES**

1 Andrew Wilton, *The Life and Work of J. M. W. Turner* (London, 1979) gives the 'missing' picture an entry in his list of Turner's watercolours (No. 742). He also lists this work (No. 256).

2 Notably by Walter Shaw Sparrow in his essay 'Turner's monochromes and early watercolours', *The Genius of J. M. W. Turner* (London, 1903), p.M.W.vii.

3 Ms 212-1949. See J. Gage, *op.cit.,* p. 76, letter 81, dated 10 Feb., 1819 (Turner to W. B. Cooke). Turner wrote 'Just send me the vignette Helmet for an Hour or so I think I can further improve it at least Allen will be released from a little more of the coat of mail'.

4 Turner was always extremely careful to retain control over the colouring of his prints as his discussion with Charles Turner over the colouring of the mezzotint of the 1805 *The Shipwreck* makes clear (see Finberg, *op.cit.,* 1961, pp. 169-70). The drawings have been thought faded (see A. J. Finberg, *Early English water-colour drawings,* London, 1919, p. 9) but this is not the case.

5 A. Wilton, *op.cit.,* 1979, Watercolour No. 434.

6 *Ibid,* Watercolour No. 429.

7 In about 1815 Turner also made an extremely similar architectural elevation in watercolour of the home of another of his patrons, Walter Fawkes, of Farnley Hall, Yorkshire. This similarity was noted by David Hill in his catalogue of the *Turner in Yorkshire* exhibition held at the York City Art Gallery in 1980 (p. 40, No. 51). However, Hill goes on to make the ludicrous statement that '... Fawkes and Fuller were of similar political persuasion and may have known each other through their political activities'. It would be hard to imagine two men more opposed in their political beliefs than Fawkes and Fuller, the first a radical Whig, the second a die-hard Tory and there is no evidence that they ever met.

8 M. A. Lower, *The Worthies of Sussex* (London, 1865) p. 98.

9 His features are, of course, well known to us through the portrait by Sir Joshua Reynolds which was exhibited at the Royal Academy in 1788. The picture is now in the National Gallery, London.

10 This inaccuracy may explain why the work was diverted from the 'Southern Coast' scheme. Alternatively, it may have been thought that the subject was insufficiently 'coastal' in nature.

11 E. Shanes, *op.cit.,* 1979, No. 34.

12 J. Gage, *op.cit.,* letter 74 (21 July, 1818) p. 73. The letter, which is untraced, was from Turner to W. B.

Cooke informing him that the *Hastings* was almost completed.

13 A. Wilton, *op.cit.,* 1979, Watercolour No. 504. This title has been given to the work by the British Museum for many years.

14 Cat. No. 9. There has been considerable confusion as to whether the picture exhibited in 1822 is indeed this work or another drawing of Hastings in the National Gallery of Ireland entitled *Shipwreck off Hastings* (82). However, much circumstantial evidence points to *this* work being the 1822 exhibited picture (and therefore the picture entitled to be called *Hastings from the sea*). The reasons are as follows:

Size: The 1822 catalogue announced that the work was to be engraved on a large scale. As this drawing is much larger than the Dublin work it would have merited such a transcription much more readily. In addition, W. B. Cooke lists in his account books that on 31 August, 1818 (the year the work is dated) he paid Turner forty guineas for 'Hastings from the sea for Mr. Fuller's work'. It seems unlikely that he would have paid this large sum for the much smaller Dublin watercolour. Also significant is the fact that when this picture was finally published as an engraving (R.665) in 1851 it was accompanied by another work (R.666) also engraved on behalf of the same publisher, Gambart. This was the equally large *Dover Castle* (67) exhibited in W. B. Cooke's 1823 exhibition. It seems likely that Gambart purchased both works from Cooke (see Rawlinson, *op.cit.,* Vol. II, pp. 344-5). The large size of this view of Hastings also relates to the similar dimensions of the other 'Sussex' drawings. Furthermore, in the late 1850s a chromo-lithograph (R.867) of the work was published (very probably also by Gambart). This was titled *Hastings from the sea* and there seems no explanation for the identification other than that it was automatically associated with this work.

Origins: This work was based upon sketches in a sketchbook used specifically for other 'Sussex' drawings (see Concordance).

Contemporary reports: Reviews in *The Examiner* (Monday 4 February, 1822, p. 75) and *The Englishman* (24 February, 1822, p. 4) both give the impression that this was the work on display. The latter review talks of 'large masses' and 'brilliant colours' (terms hardly applicable to the Dublin drawing) in relation to the work. Neither of these reviews (or others traced by the author) refer to the view of Hastings as being in any way stormy.

Dating: Judging from stylistic characteristics the Dublin drawing was made later than 1818, almost

certainly around 1825 for the 'Ports of England' series. It shares common features of size, content and handling with those works. The 1818 dating of this drawing, though, brings it closer in date to the other Sussex drawings to which it also displays great similarities in size, content and technique.
Suitability: The continuation of the 'Sussex' work was to be under the title of 'Views at Hastings and its vicinity'. This large, symmetrically organised, and above all *optimistic* work would have started the series far more aptly than the pessimistic storm-scene alternative.

15 R.665.

16 The mizzenmast of this boat is impossibly situated. As can be seen, it would have completely obstructed the turning of the tiller to starboard. A small 'tabernacle' can be seen next to the mizzenmast. This supported the mainsail head and boom-masts when they were lowered.

17 E. Shanes, *op.cit.,* 1979, No. 78.

18 R.140. The plate was etched by W. B. Cooke in 1816 and published on 1 February, 1850 by C. Tidbury and Co. Nothing is known of its intermediate history.

19 A. Wilton, *op.cit.,* 1979, Watercolour No. 443. The title is given there as *Dartmoor: the source of the Tamar and the Torridge.* Not only is this prefix undocumented but the source of these rivers is over thirty miles from Dartmoor.

20 Catalogue No. 21.

21 J. Ruskin, *Notes on his drawings by the Late J. M. W. Turner* (London, 1878) p. 34.

22 'Devonshire Coast No. 1' Sketchbook (TBCXXIII) pp. 50a, 52a.

23 'Vale of Heathfield' Sketchbook TBCXXXVII. (1809-16) p. 1.

24 Rawlinson, *op.cit.,* 1908, No. 95, p. 51.

25 C. Redding *op.cit.,* 1852, p. 154.

26 *ibid,* p. 155.

27 R.106. The work was engraved by George Cooke.

28 The capstan and all the foreground detail is also apparent in the plate of the same subject in Clarkson Stanfield's *Coastal Scenery* published in 1837.

29 'Devonshire Coast No. 1' Sketchbook (TBCXXIII). p. 102a.

30 A. Wilton, *op.cit.,* 1979, Watercolour No. 465.

31 Rawlinson No. 60, engraved by J. Basire.

32 E. Shanes, *op.cit.,* 1979, No. 35.

33 On close examination the work might also operate on another level. The traveller who is indicating the distance is also pointing at the tower of the Anglican church of St. Andrew's in East Lulworth. From the discarded makeshift fishing-rod in the foreground it

is clear that until recently he too has also been fishing. It may be that Turner, undoubtedly aware of Weld's loyalty to the Roman Catholic faith, intended these two figures to represent Catholicism and Protestantism. In this way the itinerant, whose shoelessness may be intended to indicate the self-denial of the Protestant religion is exhorting his fishing companion to come to church, i.e. change faiths. The seated figure, however, prefers to remain fishing in much the same way as the Weld family had remained true to their beliefs. Turner's later elaborate exposition of the Catholic Emancipation issue in the 'England and Wales' drawing would support this interpretation.

34 Notably in a drawing of *Dartmouth Cove* in the 'England and Wales' series (Shanes, No. 4) where the sexual symbolism is unmistakeable.

35 A. Wilton, *op.cit.,* 1979, Watercolour No. 469.

36 Cited in Butlin and Joll, *op.cit.,* 1977, No. 174.

37 *ibid,* No. 78. The presence of the mill in that work confirms that the picture is the *Margate* exhibited at the Royal Academy in 1808. A later watercolour of the town in the 'England and Wales' series, dating from *c.*1830-1, shows that the mill was no longer in existence by that time (see Shanes, *op.cit.,* 1979, No. 47). The vertical shuttering of Hooper's Mill is very apparent in the engraving of the 'Southern Coast' *Margate* (R.113).

38 A. Wilton, *op.cit.,* 1979, Watercolour No. 486. A note on p. 35a of the 'Hints River' Sketchbook (TB CXLI) of *c.*1815-8 records a drawing of Rye being in hand in 1818. Judging from the greater sophistication of the 'Southern Coast' work I would think that Turner was referring to the drawing now in Canada and not the 'Southern Coast' drawing (as Finberg thought in the *Inventory of the Turner Bequest,* p. 407).

39 E. Shanes, *op.cit.,* 1979, No. 99. The work is now untraced.

40 William Cobbett, '1 September, 1823', *Rural Rides,* London, 1967, p. 193.

41 R.119, engraved by William Miller.

42 E. Shanes, *op.cit.,* 1979, No. 39.

43 J. Ruskin, *The Harbours of England* (London, 1856) p. 39.

44 E. Shanes, *op.cit.,* 1979, No. 38.

45 Butlin and Joll, *op.cit.,* 1977, No. 360. The painting was commissioned by Henry McConnell and it is now in the National Gallery of Art, Washington, D.C.

46 W. Thornbury, *op.cit.,* 1877, p. 634 (see Appendix B).

47 A. Wilton, *op.cit.,* 1979, Watercolours Nos. 734-7 and 739. Even more recently it has been stated

(Michael Spender, *Turner at the Bankside Gallery,* London, 1980, p. 22) that *Norham Castle* was made in 1824 even though the engraving from it was published on 1 January of that year!

47a E. Shanes, *op.cit.,* 1979, No. 4.

48 A. Wilton, *Turner Watercolours* (International Exhibitions Foundation, Washington, 1977) p. 13.

49 The scene was wrongly identified by David Hill in his *Turner in Yorkshire* catalogue (p. 90, No. 139) as a view of Redcote Bridge, below Gott's Park, Leeds. That spot is about a mile south of the scene depicted by Turner in his drawing. Despite Hill's assertion to the contrary, Turner does depict the present and only Kirkstall lock.

50 There is no record of any work taking place on the brewery in 1824-5 but the building was constructed in the 1790s and Turner visited the Abbey in 1797. Very possibly he witnessed and remembered that building-work.

51 Rawlinson, *op.cit.,* Vol. 2, p. 370, No. 766.

52 E. Shanes, *op.cit.,* 1979, No. 93.

53 It has proved impossible to identify the flag flown by this lugger and so know where it came from. The tinctures of yellow and white are those traditionally associated with the Papacy, which is not renowned for its shipping. The blue saltire on a white field is equally puzzling as it has Russian connotations. The Belgian royal coat of arms after 1830 was a gold shield charged with a black lion but in 1822 it had no significance. Extensive enquiries in Britain, Europe and the U.S.A. lead to the conclusion that this is not a marine flag but a personal or house flag. A similar yellow and white flag appears on a large fishing smack in the 1803 oil-painting *Calais Pier.*

54 J. Ruskin, *op.cit.,* 1856, pp. 51-2.

55 *ibid,* pp. 29-30.

56 Ruskin contends (*ibid,* p. 31) that both pictures represent the same scene at a *simultaneous* moment but from different viewpoints. However this argument is not supported by a close examination of the two works.

57 *ibid,* p. 31.

58 *ibid,* p. 37.

59 *The Raft of the Medusa* was displayed at the Egyptian Hall, Piccadilly between 12 June and 30 December, 1820. See Lee Johnson, 'The Raft of the Medusa in Great Britain' (*Burlington Magazine* XCVI, August 1954) and Lorenz Eitner, *Gericault's Raft of the Medusa* (London, 1972). Turner may have been one of the several Royal Academicians present at the private viewing of the painting on 10 June.

60 J. Ruskin, *op.cit.,* 1856, p. 41. Ruskin was told this

by 'a naval officer'.

61 *ibid*, p. 45.
62 *ibid*, p. 33.
63 E. Shanes, *op.cit.*, 1979, No. 26.
64 J. Ruskin, *op.cit.*, 1856, p. 44.
65 A. Wilton, *op.cit.*, 1979, Watercolour No. 474. The confusion was undoubtedly caused by Hilda Finberg's entry for the 'Southern Coast' *Ramsgate* in the Finberg card index of Turner's works in the British Museum Print Room.
66 A. J. Finberg, *op.cit.*, 1961, p. 482.
67 When the work was engraved in 1844 Turner wrote to the engraver (J. Cousen) about his concern that the net resembled a sail in the engraving (see Rawlinson, *op.cit.*, Vol. 2, No. 643).
68 R.643.
69 E. Shanes, *op.cit.*, 1979, No. 97. The watercolour is now untraced.
70 It is conceivable that Allen may have funded the project but the fact that the work was never advertised or promoted in any way suggests that it was Turner himself who financed the scheme. He had, of course, threatened to do this as Cooke's letter of 1 January, 1827 makes clear (see Appendix A, p. 153). Rawlinson initially identified the engravings (R.305-312) as being in some way connected with the 'England and Wales' series (*op.cit.*, Vol. 1, pp. 169-70) but he corrected this in 1913 (Vol. 2, Corrigenda, p. 441).
71 It is so small, it is hard to determine if it is, in fact, a ship.
72 E. Shanes, *op.cit.*, 1979, No. 76.
73 This story probably dates from Turner's 1831 trip to Scotland.
74 John Thomson, of Duddingston (1778-1840), a painter and Presbyterian Minister.
75 William Bell Scott, *Autobiographical Notes*, 2 Vols (London, 1892) Vol. 1, p. 84.
76 J. Ruskin *Modern Painters*, Part III, Sec. II, Ch. IV (1897 ed., p. 214).
77 C. Redding, *op.cit.*, 1852, p. 156.
78 W. G. Rawlinson, *op.cit.*, 1908, No. 138, p. 75.
79 *ibid*, No. 90, p. 49.
80 E. Shanes, *op.cit.*, 1979, No. 73.
80a A. Wilton, *op.cit.*, 1979, Watercolour No. 450.
81 'Devonshire Coast No. 1' Sketchbook (TB CXXIII) p. 54a.
82 W. G. Rawlinson, *op. cit.*, Vol. 1, p. 56.
83 A. Wilton, *op.cit.*, 1979, Watercolour No. 460.
84 E. Shanes, *op.cit.*, 1979, No. 63.
85 R.641.
86 A. Wilton, *op.cit.*, 1979, Watercolour No. 545.
87 E. Shanes, *op.cit.*, 1979, Nos. 90 and 91.
88 According to the entry for this work kept in the card index of Turner's pictures compiled by Mr. & Mrs. A. J. Finberg (Dept. of Prints and Drawings, British Museum, London). The note relates that Mrs. Finberg was given this information in the early 1950s by Lord Yarborough.
89 A. Wilton, *op.cit.*, 1979, Watercolour No. 506.
90 I have found similar-looking costumes in Ioanna Papantoniou, *Hellenikes Phoresies*, (Athens, 1973) Vol. 1. Plates 14 and 15 and accompanying text (in translation). The costume of the figure on the left is, furthermore, almost identical with those worn by a group of men depicted dancing in front of the Acropolis in Athens in an illustration (opposite p. 225) in Vol. 2 of *Travels in Italy, Greece and the Ionian Islands* by H. W. Williams (Edinburgh, 1820). Hugh Williams (or 'Grecian' Williams as he was known) was acquainted with Turner whom he met in Edinburgh in either 1818 or 1822. The book mentions Turner. I am indebted to John Gage for drawing my attention to this further similarity.
91 See John Gage 'Turner and the Greek Spirit', *Turner Studies* 2, Summer 1981.
92 A. Wilton, *op.cit.*, 1979, Watercolour No. 1212.
93 *ibid*, Watercolour No. 1055.
94 E. Shanes, *op.cit.*, 1979, No. 53.
95 *ibid*, 1979, No. 59.
96 A. Wilton, *op.cit.*, 1979, Watercolour No. 509.
97 A. J. Finberg *The Life of J. M. W. Turner R.A.* (London, 1961) 2nd Ed., p. 284. I am indebted to Oxford University Press for allowing the quotation of this passage.
98 Although Rawlinson (*op.cit.* Vol. 2, pp. 398-9) suggests that these aquatints date from around 1816-8, there is nothing to indicate precisely when they were produced. However, the fact that Farington saw a picture by Turner at Stadler's workshop in 1811 (see note 6, p. 156) suggests that the 1810 drawings were also with Stadler by about that time. Turner (or Stadler) would hardly have kept Fuller waiting eight years for his prints, especially in view of the fact that it was for these prints that Fuller commissioned the drawings in the first place.

CREDITS

The author and publisher would like to thank the museums, galleries and private collectors who have allowed works in their collections to be reproduced in this book. They would also like to thank the photographic departments, photographic agencies and photographers who provided illustrations. Special acknowledgements are as follows: 85 Courtesy the Borough of Blackburn, Museum and Art Gallery; 31, 67 Courtesy the Museum of Fine Arts, Boston, Gift of the Ellen Bullard Estate 59.796 and Bequest of David Kimball, in memory of his wife Clara Kimball 23.513; 8, 9, 11, 13, 16, 49-66, 68-74, 96-109, 112-114, Ills. 9-11 Courtesy the Trustees of the British Museum; 4 Courtesy the Fogg Art Museum, Harvard University, Bequest—Grenville L. Winthrop; 40 Courtesy the Guildhall Art Gallery, Corporation of London; 12 Courtesy the W.A.H. Harding Trust (on loan to Leeds City Art Galleries); 87, 89 Courtesy the Indianapolis Museum of Art, Gift in memory of Dr. and Mrs Hugo O. Pantzer; 3, 29 Courtesy the University of Liverpool, Fine Art Collections, Cat. Nos. 215 and 217; 88 Courtesy Mr and Mrs Edwin P. Rome; 1, 5, 6, 7, 10, 15, 19, 27, 45, 81, 91, 93, 94 photographed by Mick Duff; 88 photographed by Eric Mitchell; 111, Ill. 15, Ill. 16 Courtesy Office du Livre (previously published in *The Life and Work of J.M.W. Turner* by Andrew Wilton); 21 photographed by Stanley Parker-Ross; Ill. 15 photographed by Christopher Ridley; 12, 25, 35, 42, 84, photographed by West Park Studios, Leeds.